ROMAN ART

A Resource for Educators

Nancy L. Thompson

THE METROPOLITAN MUSEUM OF ART

Copyright ©2007 by The Metropolitan Museum of Art, New York
Published by The Metropolitan Museum of Art, New York

Written by Nancy L. Thompson
Lesson plans by Felicia Blum, Michael Norris, and Edith Watts

Project Manager: John Welch
Senior Managing Editor: Merantine Hens
Senior Publishing and Creative Manager: Masha Turchinsky
Design by Adam Squires

Color separations and printing by Union Hill Printing Co., Inc.,
Ridgefield, New Jersey

Photographs of works in the Museum's collections are by the
Photograph Studio of The Metropolitan Museum of Art.

Fig. 1 Vanni/Art Resource, NY; fig. 2 Dan Addison/University of
Virginia Public Affairs; fig. 3. Courtesy of the Library of Virginia;
fig. 4 United States coin images from the United States Mint

Map by Pamlyn Smith Design, Inc.

Front cover: image 25, *Sarcophagus with the Triumph of Dionysus and the Four
Seasons* (detail). *Back cover:* image 43, *Tesselated floor panel with garlanded woman
and geometric pattern* (detail)

Box, front: image 3, *Colossal portrait of Augustus.* *Back:* image 41, *Fragment of a
fresco with garlands and objects related to Dionysiac rites* (detail). *Spine:* image 42,
One of Ten fragments of fresco incorporated in a reconstruction of a cubiculum
nocturnum *(bedroom), known as the Black Room*

ISBN 978-1-58839-222-0 (The Metropolitan Museum of Art)
ISBN 978-0-300-12694-5 (Yale University Press)

Cataloging-in-publication data is available from the Library of Congress.

With the opening of the New Greek and Roman Galleries—the spectacular centerpiece of which is the Shelby White and Leon Levy Court—a new chapter has opened for the study of classical art at The Metropolitan Museum of Art. Beautiful masterworks—stone and bronze sculpture, ceramics, glass, jewelry, wall paintings, and architectural elements—have been conserved and presented in magnificent spaces that befit the aesthetic achievements of Hellenistic and Roman civilization.

Museum visitors will long enjoy the beauty of classical art in these light-filled spaces. The public will also benefit from the work of generations of scholars who have expanded and deepened our knowledge about the manufacture, meaning, and use of these objects in ancient times. Ancient artists drew on many sources for technical and design inspiration, while vibrant trade and communication linked distant regions to one another. The specific legacy of Rome was such that it inspired extension and emulation across the centuries. Ideas of cosmopolitanism and international exchange echo to the present day, while for two millennia the study of Rome and the ancient world has been a cornerstone of educational thinking in the Western tradition.

This publication, *Roman Art: A Resource for Educators,* provides a comprehensive introduction informed by recent research for teachers and students eager to explore and understand Rome's cultural and artistic legacy. As lead author, Associate Museum Educator

Nancy Thompson has worked closely with her colleagues in the Education and Greek and Roman Departments to create a practical and useful guide for teachers at all grade levels and in many disciplines. We extend our thanks to this remarkable team of scholars.

The aesthetic achievements of ancient Rome stand as a great milestone in the history of art. Presented in the context of an encyclopedic collection of great art from all eras and cultures, the Metropolitan's collection and its beautiful new installation will encourage cross-cultural comparisons of unique depth and breadth, even as students explore and enjoy these masterworks on their own terms for many years to come.

Philippe de Montebello
Director

Kent Lydecker
Frederick P. and Sandra P. Rose
Associate Director for Education

Carlos A. Picón
Curator in Charge,
Department of Greek and Roman Art

ACKNOWLEDGMENTS

Many colleagues participated in the development of this publication. Heartfelt gratitude and thanks go to the curators and staff of the Metropolitan Museum's Department of Greek and Roman Art under the guidance of Carlos Picón, Curator in Charge. During an extremely busy period of preparation for the opening of the New Greek and Roman Galleries, Seán Hemingway, Christopher Lightfoot, Joan Mertens, and Elizabeth Milleker provided invaluable guidance and curatorial expertise in the shaping of this project for which we are truly grateful. Matthew Noiseux and Mark Santangelo gave timely and indispensable assistance.

We commend Nancy Thompson for writing such a clear and informative text to meet the particular needs of teachers. Nancy would especially like to thank her partner, Dr. Guy McLean Rogers, for sharing his historical insights and for his steadfast encouragement during the writing of this resource.

Invaluable support and insight came from Metropolitan Museum educators and colleagues who helped produce this publication. Kent Lydecker, Deborah Howes, Amy Silva, and Karen Ohland offered support and guidance. Felicia Blum, Michael Norris, and Edith Watts wrote the lesson plans. Emily Roth, Naomi Niles, and Vivian Wick compiled the list of selected resources. John Welch shepherded the project together with Merantine Hens, who coordinated the many steps of editing throughout. Masha Turchinsky directed the design and supervised printing. Sarah Hornung coordinated the culminating aspects of production. Many thanks to Paul Caro, Phoebe Ford, and Jackie Neale-Chadwick for their imaging support and expertise. Tatsiana Zhurauliova offered needed administrative support. Elizabeth Bell provided welcome research and proofing assistance. Philomena Mariani edited the manuscript with care and speed. Very special thanks to Adam Squires for the handsome design of this publication.

We are grateful to Linda Seckelson of the Museum's Thomas J. Watson Library for her invaluable assistance. We extend our thanks to Barbara Bridgers, Einar Brendalen, and Paul Lachenauer of the Photograph Studio. Many thanks also to John O'Neill, Peter Antony, and Gwen Roginsky of the Editorial Department.

CONTENTS

1 Goals and Design of this Resource

3 Quick List of Images

7 Map

8 The Relevance of Rome

18 The Antecedents of Roman Art: Etruscan, Classical Greek, and Hellenistic Art

21 Roman Historical Overview: A Selective Sketch

28 Power and Authority in Roman Portraiture (images 1–12)

30 Image 1 *Ring-stone with intaglio bust of Julius Caesar*
34 Image 2 *Portrait of a man*
38 Image 3 *Colossal portrait of Augustus*
38 Image 4 *Cameo portrait of the emperor Augustus*
44 Image 5 *Portrait bust of the emperor Gaius, known as Caligula*
48 Image 6 *Five architectural fragments from the palace of the emperor Domitian on the Palatine in Rome*
52 Image 7 *Aurei of the Twelve Caesars*
58 Image 8 *Relief with the emperor Antoninus Pius and a suppliant barbarian*
62 Image 9 *Portrait of the co-emperor Lucius Verus*
66 Image 10 *Portrait of the emperor Caracalla*
66 Image 11 *Portrait of the emperor Caracalla*
70 Image 12 *Portrait head of the emperor Constantine I*

74 Roman Myth, Religion, and the Afterlife (images 13–25)

80 Image 13 *Denarius minted under Julius Caesar, showing Aeneas carrying Anchises and the Palladium*
80 Image 14 *Intaglio ring-stone showing Romulus and Remus suckled by the she-wolf*
84 Image 15 *Statuette of Jupiter*
88 Image 16 *Relief fragment with the head of Mars*
92 Image 17 *Statue of Venus*
96 Image 18 *Statuette of a lar*
98 Image 19 *Lid of a ceremonial box*
102 Image 20 *Camillus*

106 Image 21 *Statuette of Cybele on a cart drawn by lions*
110 Image 22 *Plaque with Mithras slaying the bull*
114 Image 23 *Cinerary urn with arms and war trophies*
118 Image 24 *Funerary altar* (cippus) *of Cominia Tyche*
122 Image 25 *Sarcophagus with the Triumph of Dionysus and the Four Seasons*

126 Daily Life in Ancient Rome (images 26–45)

140 Image 26 *Portrait bust of a Roman matron*
140 Image 27 *Portrait of a young woman with a gilded wreath*
140 Image 28 *Portrait bust of a veiled woman*
140 Image 29 *Portrait bust of a woman*
148 Image 30 *Funerary relief with busts of a man and a woman*
152 Image 31 *Portrait bust of an aristocratic boy*
156 Image 32 *Diploma for a sailor from Trajan's fleet at Misenum*
160 Image 33 *Transport amphora*
164 Image 34 *Gladiator cup*
164 Image 35 *Beaker with chariot race*
170 Image 36 *Stylus*
170 Image 37 *Inkwell*
170 Image 38 *Ink pen*
170 Image 39 *Papyrus with shopping list in Greek*
174 Image 40 *Frescoes from a* cubiculum nocturnum *(bedroom)*
174 Image 41 *Fragment of a fresco with garlands and objects related to Dionysiac rites*
180 Image 42 *Ten fragments of fresco incorporated in a reconstruction of a* cubiculum nocturnum *(bedroom)*
184 Image 43 *Tesselated floor panel with garlanded woman and geometric pattern*
188 Image 44 *Fragment of a large platter or tabletop*
192 Image 45 *Pair of skyphi (drinking cups) with relief decoration*

196 Lesson Plans

202 Treasure Hunt for Grades 1–4

204 Selected Resources

209 Glossary

*T*his teacher publication introduces objects in the Museum's collection of Roman art. The collection is particularly rich in art produced for the highest levels of society, and this is reflected in the objects included in this resource.

In conjunction with the reopening of the Museum's galleries of Etruscan, Hellenistic, and Roman art in April 2007, the Department of Greek and Roman Art has produced *Art of the Classical World in The Metropolitan Museum of Art*, a guide to all of the collections within its purview, spanning a time period from the third millennium B.C. to the fourth century A.D. and covering the art of Cyprus, Etruria, Greece, and Rome. This richly illustrated guide is included in this teacher resource box.

This teacher publication is intended to be used in tandem with *Art of the Classical World*. Roman art drew heavily on the inspiration of the Etruscans and the Greeks, though many of the achievements of Roman art are uniquely Roman. In writing descriptions of the artworks in this resource, where possible we have referred the reader to images in *Art of the Classical World* that are complementary to the object being discussed or that illuminate the art-historical precedent for that object. Such cross-referencing is also intended to be useful if the teacher brings his or her class to the Museum, helping to pinpoint objects not in the teacher publication that would be most useful to introduce to the class.

This teacher publication begins with a **Quick List** of the featured works of art. This is followed by a **map**, a discussion of the **Relevance of Rome** to the modern world, and a summary of the **Antecedents of Roman Art** as well as a short **Historical Overview**, provided for the convenience of teachers who want a succinct survey of the whole of Roman history. More detailed information about the emperors whose images are in this publication may be found in their individual object entries, which are cross-referenced in the Historical Overview. A **timeline poster** is included as a reference for use in the classroom.

The overviews entitled **Power and Authority in Roman Portraiture; Roman Myth; Religion, and the Afterlife;** and **Daily Life in Ancient Rome** are intended to provide information essential to an understanding of Roman society. Each overview is followed by a group of **object descriptions**. Many of the topics discussed in the overviews are covered in more detail in the object entries.

The description of each object begins with a summary of its important themes or aspects. At the end of each description is a series of questions intended to stimulate the students in looking at the objects and in placing them in a broader cultural context. The images are provided in digital format on the enclosed CD-ROM. Teachers may wish to show the images in a chronological survey, or according to the three major themes within which the objects have been grouped.

The **Lesson Plans**, based on the thematic groupings of the artworks, include classroom activities that will help the teacher create a focused unit of study around some of the key concepts associated with Roman art. The **Selected Resources** section contains bibliographies, online resources (the Museum's *Timeline of Art History* is particularly useful), and a videography. These will be helpful in gathering the additional information teachers may need to make an exploration of Roman art stimulating and relevant to their curriculum. A **Glossary** provides definitions of words that are bolded on first mention in the text.

The Benefits of This Resource to Students Studying Roman Art

- Students will acquire the basic vocabulary, concepts, and criteria for understanding, interpreting, and analyzing Roman art.

- Students will be encouraged to use higher-level thinking skills such as analysis, synthesis, and evaluation. With this resource, teachers can invite students to propose analytical questions or hypotheses, formulate conclusions or generalizations, or raise new questions and issues for further investigation.

- Students will encounter significant works of Roman art and will begin to assemble a repertoire of visual references that will serve them well when they study later works influenced by Roman art.

- Students will understand and appreciate the role of values, beliefs, and ideas in shaping Roman art.

- Students will explore the subject matter and themes of Roman art through a variety of processes, techniques, and materials to gain a better understanding of how and why Roman art was created.

Power and Authority in Roman Portraiture

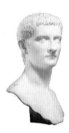

1. *Ring-stone with intaglio bust of Julius Caesar*, Roman, Late Republican, 50–40 B.C.

2. *Portrait of a man*, Roman, Late Republican or Early Augustan, late 1st century B.C.

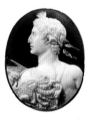

3. *Colossal portrait of Augustus*, Roman, Julio-Claudian, ca. A.D. 14–37

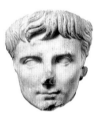

4. *Cameo portrait of the emperor Augustus*, Roman, Claudian, ca. A.D. 41–54

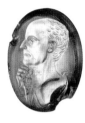

5. *Portrait bust of the emperor Gaius, known as Caligula*, Roman, Julio-Claudian, A.D. 37–41

6. *Five architectural fragments from the palace of the emperor Domitian on the Palatine in Rome*, Roman, Early Imperial, Domitianic, ca. A.D. 81–92

7. *Aurei of the Twelve Caesars*, Roman, Early Imperial, Augustan, 1st century B.C.–1st century A.D.

8. *Relief with the emperor Antoninus Pius and a suppliant barbarian*, Roman, Early Antonine, A.D. 138–161

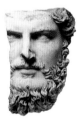

9. *Portrait of the co-emperor Lucius Verus*, Roman, Antonine, ca. A.D. 161–169

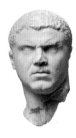

10. *Portrait of the emperor Caracalla*, Roman, Severan, ca. A.D. 212–217

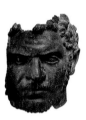

11. *Portrait of the emperor Caracalla*, Roman, Severan, ca. A.D. 212–217

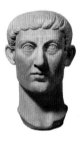

12. *Portrait head of the emperor Constantine I*, Roman, Late Imperial, ca. A.D. 325–370

Roman Myth, Religion, and the Afterlife

13. *Denarius minted under Julius Caesar, showing Aeneas carrying Anchises and the Palladium*, Roman, Late Republican, 47–46 B.C.

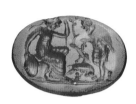

14. *Intaglio ring-stone showing Romulus and Remus suckled by the she-wolf*, Roman, Late Republican or Early Imperial, 1st century B.C.–1st century A.D.

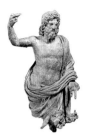

15. *Statuette of Jupiter*, Roman, Mid-Imperial, 2nd half of 2nd century A.D.

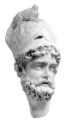

16. *Relief fragment with the head of Mars*, Roman, Mid-Imperial, early 3rd century A.D.

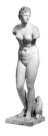

17. *Statue of Venus*, Roman, Imperial, 1st or 2nd century B.C.

18. *Statuette of* a lar, Roman, Imperial, 1st–2nd century A.D.

19. *Lid of a ceremonial box*, Roman, Augustan, late 1st century B.C.–early 1st century A.D.

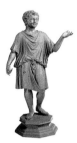

20. *Camillus*, Roman, Early Imperial, Julio-Claudian, A.D. 41–54

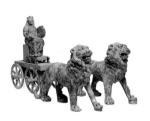

21. *Statuette of Cybele on a cart drawn by lions*, Roman, 2nd half of 2nd century A.D.

22. *Plaque with Mithras slaying the bull*, Roman, Antonine or Severan, mid-2nd–early 3rd century A.D.

23. *Cinerary urn with arms and war trophies*, Roman, Julio-Claudian, 1st half of 1st century A.D.

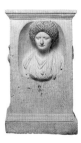

24. *Funerary altar* (cippus) *of Cominia Tyche*, Roman, Flavian or Trajanic, ca. A.D. 90–100

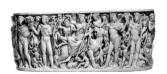

25. *Sarcophagus with the Triumph of Dionysus and the Four Seasons*, Roman, Late Imperial, ca. A.D. 260–270

Daily Life in Ancient Rome

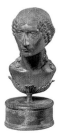

26. *Portrait bust of a Roman matron,* Roman, Julio-Claudian, ca. A.D. 20—50

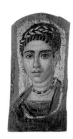

27. *Portrait of a young woman with a gilded wreath,* ca. A.D. 120—140

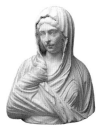

28. *Portrait bust of a veiled woman,* Roman, Mid-Imperial, Severan, ca. A.D. 200—230

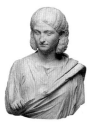

29. *Portrait bust of a woman,* Roman, Mid-Imperial, Severan, ca. A.D. 200—230

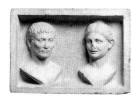

30. *Funerary relief with busts of a man and a woman,* Roman, Early Imperial, Augustan, ca. 13 B.C.—A.D. 5

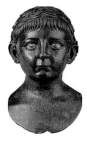

31. *Portrait bust of an aristocratic boy,* Roman, Julio-Claudian, ca. A.D. 50—58

32. *Diploma for a sailor from Trajan's fleet at Misenum,* Roman, Mid-Imperial, Trajanic, A.D. 113—114

33. *Transport amphora,* Roman, Late Republican, ca. 100 B.C.

34. *Gladiator cup,* Roman, Early Imperial, ca. A.D. 50—80

35. *Beaker with chariot race,* Roman, Late Imperial, 4th century A.D.

36. *Stylus,* Cypriot, Classical or Hellenistic, 4th—1st century B.C.

37. *Inkwell,* Roman, Imperial, 1st—2nd century A.D.

38. *Ink pen,* Roman, Imperial, 1st—2nd century A.D.

39. *Papyrus with shopping list in Greek,* Roman, Egypt, early 3rd century A.D.

40. *Frescoes from a* cubiculum nocturnum *(bedroom),* Roman, Late Republican, ca. 50—40 B.C.

41. *Fragment of a fresco with garlands and objects related to Dionysiac rites,* Roman, Late Republican, ca. 50—40 B.C.

Daily Life in Ancient Rome (continued)

42. *Ten fragments of fresco incorporated in a reconstruction of a* cubiculum nocturnum *(bedroom), known as the Black Room,* Roman, Augustan, last decade of 1st century B.C.

43. *Tesselated floor panel with garlanded woman and geometric pattern,* Roman, Mid-Imperial, 2nd half of 2nd century A.D.

44. *Fragment of a large platter or tabletop,* Roman, Julio-Claudian, 1st half of 1st century A.D.

45. *Pair of skyphi (drinking cups) with relief decoration,* Roman, Augustan, late 1st century B.C.—early 1st century A.D.

THE ROMAN EMPIRE
ca. 31 B.C.—A.D. 330

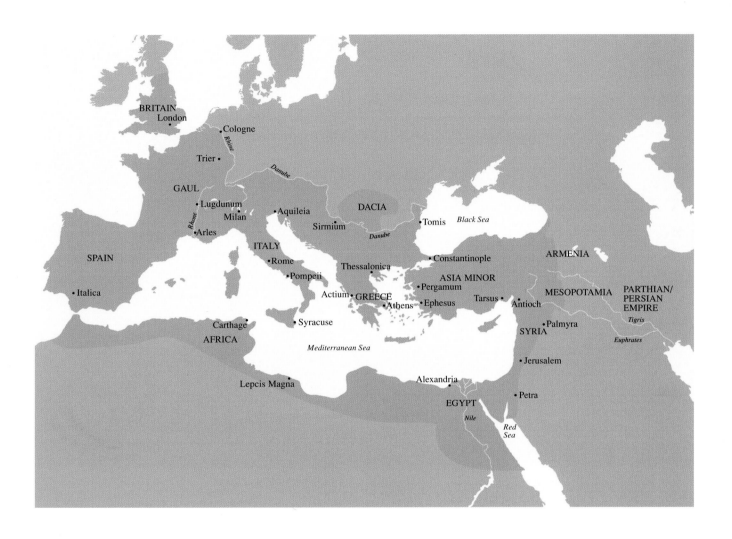

BRITAIN
London

Cologne

Trier

Rhine

Danube

GAUL

Lugdunum

Rhône

Milan

Aquileia

DACIA

Sirmium

Danube

Tomis

Black Sea

Arles

SPAIN

ITALY

Rome

Pompeii

Thessalonica

Constantinople

ARMENIA

Italica

Actium

GREECE

Athens

ASIA MINOR

Pergamum

Ephesus

Tarsus

MESOPOTAMIA

PARTHIAN/
PERSIAN
EMPIRE

Antioch

Carthage

Syracuse

AFRICA

Mediterranean Sea

Palmyra

SYRIA

Tigris

Euphrates

Lepcis Magna

Jerusalem

Alexandria

Petra

EGYPT

Nile

*Red
Sea*

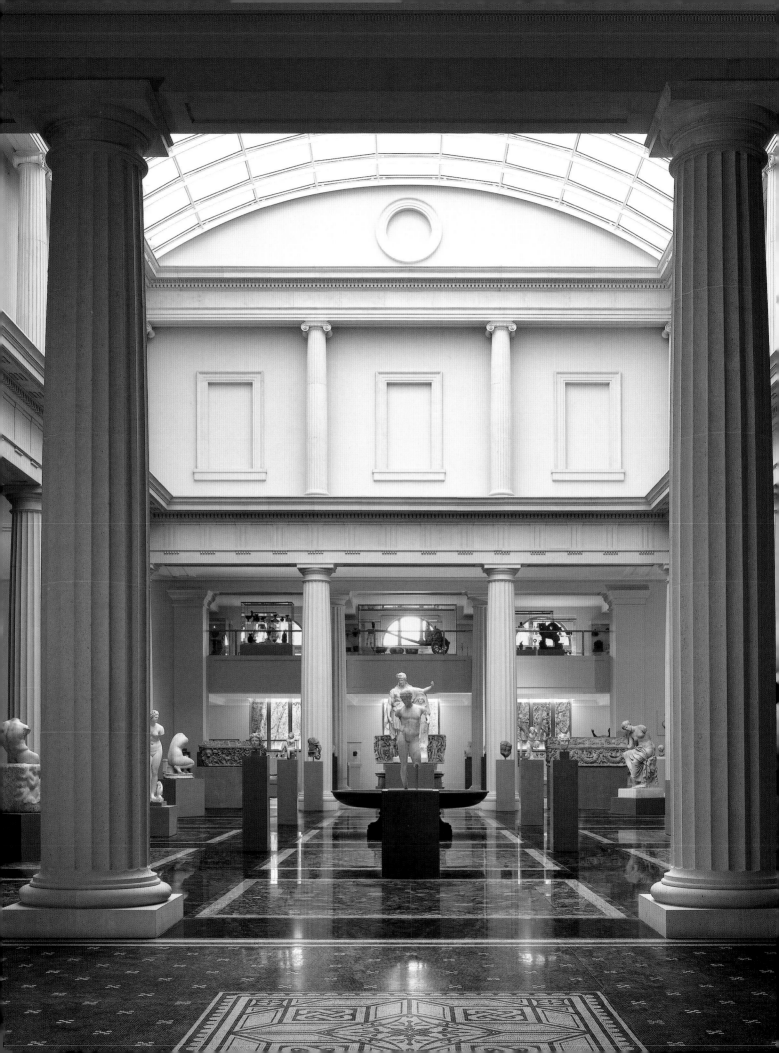

*T*his resource for educators has three principal goals: first, to introduce teachers and their students to the superb examples of Roman art contained in the collection of The Metropolitan Museum of Art; second, to inform teachers about the culture that produced these works of art; and third, to provide an educational guide that will stimulate the interest of students who are new to the study of Rome as well as those who are familiar with this civilization and its culture.

Why study Roman Art and History?

Continuing Relevance: Rome Lives!

We study Roman art and history first of all because the ancient Romans created a civilization that is intrinsically interesting, one of the most complicated, highly organized, and well-documented civilizations of ancient times. Moreover, the impact of Roman civilization can be seen and felt to this very day, in tangible physical objects as well as in institutions and ideas.

The objects discussed in this resource are physical keys to our own past and our identity. Understanding them in their context helps us to understand where we have come from and who we are. These objects are as relevant today as they were when they were created nearly 2,000 years ago.

There are two principal ways in which the relevance of Rome can be appreciated: first, in its influence on the founding fathers as they contemplated the structure of government for what would become the United States of America; and second, in the interesting parallels that can be drawn between the ancient Roman world and the modern world. Both of these will be treated briefly here.

View of the Leon Levy and Shelby White Court, New Greek and Roman Galleries, The Metropolitan Museum of Art

9

The Political and Visual Legacy: Rome and America

As a newly minted nation in the late eighteenth century, the United States of America needed a national identity and appropriate forms for its buildings, its sculpture, even its currency. The founders of the American Republic considered knowledge of ancient Greece and Rome to be a cornerstone of education (as did educated Europeans of the time), and thus they turned to the classical world to help define their new Republic. The use of classical symbols and allusions also served to identify the founders as gentlemen of high social status.

- Ancient history gave the founders important, if inexact, models for personal behavior, social practice, and forms of government. In particular, the founders esteemed Romans of the Republic for their perceived patriotism and leadership. It was not an accident that the upper house of the American legislature was named "the **Senate**" by the authors of the American Constitution: Noah Webster, James Madison, and Alexander Hamilton were all avid readers and interpreters of Roman Republican history. Their readings of this history, in particular, fundamentally shaped the American Constitution and continue to have effects upon ongoing debates about power and authority in American society.

- Scholars continue to debate exactly how the founders' conception of Roman Republican institutions influenced the formation of American government. It is clear, though, that the founders looked with great interest at Republican concepts such as the following:

 - An elective Senate

 - Laws passed by a popular assembly for which there was no property qualification

 - Two bodies with law-making powers that could "check and balance" each other

 - The veto

 - Diffusion of power

 - Elevation to citizenship

 - A written code of laws (the "Twelve Tables")

 - The powers of a dictator, a single ruler in times of crisis (in relation to the powers of a president)

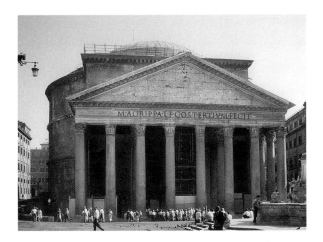

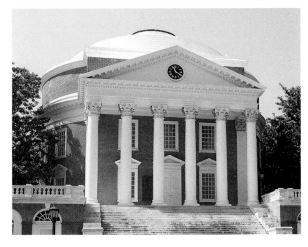

Fig. 1. Pantheon, Rome, 125–128 A.D.
Fig. 2. Thomas Jefferson, Rotunda, University of Virginia, Charlottesville, Virginia.

♦ Just as identification with the perceived values of the Roman Republic gave the founders a sense of identity and legitimacy, so they felt that the evocation of classical forms in their architecture and their political symbolism would confer legitimacy upon their fledgling nation. The notion was not unique to Americans; a revival of classical style was also in vogue in western Europe at this time, in part stimulated by excitement over the recent discovery of the buried cities of Pompeii and Herculaneum and their classical treasures.

♦ The Capitol building in Washington, D.C., was named after the Roman **Capitolium**, the temple dedicated to the three supreme gods of the Roman state, Jupiter, Juno, and Minerva. The architectural design of the Capitol, with its dome, **colonnaded** facade, and Corinthian capitals, explicitly linked American government to the visual vocabulary of Rome. (In fact, immigrant Italian sculptors carved much of the building's decoration.)

♦ Thomas Jefferson, an architect as well as a statesman, chose as his architectural models forms that had been esteemed for millennia. He modeled the Virginia state capitol building on a Roman temple at Nîmes in France, and the Pantheon in Rome served as the inspiration for the library that Jefferson designed for the University of Virginia (figs. 1 and 2).

♦ Other Roman **iconography** was adopted even though it did not necessarily embody the values of the new Republic. For example, the eagle was adopted as the national symbol of the new democracy; at Rome during the Principate, this bird had symbolized the absolute and autocratic power of the emperor. Similarly, American sculptors adopted as a motif symbolizing authority

the **fasces**, a bundle of elm or birch rods tied to a single-headed ax. In Rome, the fasces were carried by servants of Roman magistrates and were the primary symbol of magisterial power in the Republic. But they were also regarded and used as instruments of punishment, including execution, and later they were an attribute of the emperors, who were certainly despised by the American founders.

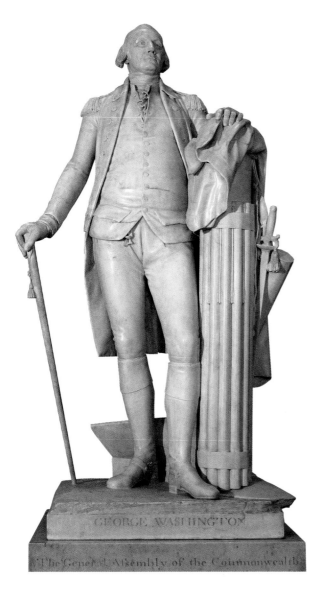

- In 1788, the French sculptor Jean-Antoine Houdon created a full-length portrait of George Washington that shows him standing with thirteen fasces, which were meant to symbolize the original thirteen colonies that became the United States (fig. 3). Washington's sword hangs from the fasces, and a plow is propped against them. This is an evocation of the Roman Republican hero Cincinnatus who, after being called away from his plough and appointed dictator, relieved a besieged Roman army, celebrated a triumph, laid down his office, and returned to his ploughing, all within fifteen days. In this sculpture, Washington wears American military dress. In another portrait by Houdon, this one a bust (a Roman form that was very popular for depicting the leaders of the new country), he is shown in a **toga**, the signifying garment of the Roman citizen that was worn on official occasions. Its use here was meant to suggest Washington's statesmanlike qualities.

- Other statesmen, such as George Clinton, an early governor of New York, were also depicted wearing the Roman toga. By dressing their subjects in Roman clothing, artists attempted to evoke the glory and virtue of the ancients.

Fig. 3. Jean-Antoine Houdon (French, 1741–1828), *George Washington*, 1788. Carrara marble, H. 78 in. (198 cm). Collection of the Commonwealth of Virginia.

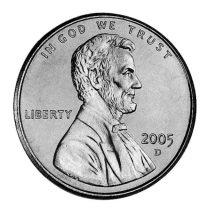

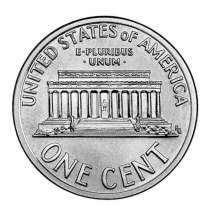

Fig. 4. United States cent (penny), minted 2005: obverse (above), with profile of Abraham Lincoln; reverse (below) with Latin motto *e pluribis unum* (out of many, one)

• The renowned Italian sculptor Antonio Canova went even further. He carved a statue of George Washington, seated, writing on a tablet in Latin, and wearing the cuirass of a Roman general along with sandals and bare legs in imitation of the ancients. (This statue, which created some uproar, no longer exists.)

• The classicizing trend in the arts penetrated popular taste as well, in both Europe and America. For example, the *sella curulis* was a particular type of Roman folding ivory or metal seat that had two hinged, S-shaped legs on each end. It was used during the Republic only by higher ("curule") magistrates when they were dispensing justice, and thus became a symbol of magisterial authority. In the late eighteenth and early nineteenth century, the form was revived in furniture design, part of a vogue for the ancient world that in this case was shorn of its symbolic associations.

• The legacy of Rome survives to the present day in American architecture. Institutions such as banks stress their legitimacy and stability by housing themselves in Neoclassical buildings. The Metropolitan Museum itself evokes the Roman classical vocabulary in its domed, colonnaded Great Hall and its **vaulted** Greek and Roman sculpture galleries (see page 8), as well as in its columnar Fifth Avenue facade.

• Finally, just as Roman coins bore the image of the reigning emperor on one side, so American currency to this day features busts of American statesmen on the obverse (fig. 4). The reverse of Roman coins often pictured monuments that were of symbolic importance to the Roman state. Similarly, the reverse side of American coins and bills features buildings associated with the foundation and principles of the new Republic, such as the U. S. Treasury and the White House. All of these buildings are designed in the Neoclassical style. In addition, our currency carries Latin mottos such as *e pluribus unum*, or "out of many, one." This motto, which was adopted for use on the first Great Seal of the United States, was based upon a line from a Latin poem, attributed to the Roman poet Virgil, which referred to mixing together many ingredients to make one dish. The motto thus provides an apt metaphor for our melting-pot nation.

Parallels between Rome and the Modern World

*T*he parallels between Rome and the modern world are approximate but instructive. By learning about the Romans, we can better understand our modern institutions and society. The following observations can be used to generate far-ranging discussions with students.

A Unique Empire

The Romans are the only people in history to have successfully united into one polity the lands and peoples of what today comprises Western Europe, North Africa, and the eastern Mediterranean. By the mid-second century A.D., Rome's empire extended from the highlands of Scotland to the Persian Gulf, from the Atlantic coast of Portugal almost to the steppes of Russia. No other empire in history has managed to unite Europe and the Middle East. The free movement of peoples and ideas across these vast territories was unprecedented until we entered the modern age of globalization.

- Though the United States does not exercise formal political control over other lands and peoples of the globe, culturally it might be said that it has exerted a worldwide influence like none other the world has known.

An Inclusive, Multicultural Empire

Within Rome's huge, long-lasting empire, some 55 million people lived and worked together, speaking dozens of languages, practicing their own religions, with minimal interference by the Roman state. One reason for Rome's success was the efficiency and professionalism of its armies; more important still was Rome's invention of a political concept of citizenship. Unlike the kingdoms of the ancient Near East and the Greek city-states, the Romans adopted an idea of citizenship based not upon blood descent but rather upon becoming a member of the Roman political community, the *populus Romanus* (Roman people), through legal cooptation. The Romans also enfranchised large numbers of their slaves, who became Roman citizens within a generation of their enfranchisement. Rome was the world's first truly inclusive, multicultural community.

- The United States is, similarly, a huge geographic area in which peoples of many different ethnic backgrounds and religions coexist.

- Many different languages are spoken in the United States, although English functions as the *de facto* official language recognized by everyone, just as Latin was in the Roman empire.

- Citizenship in the United States depends upon becoming a member of the American political community. Blood descent is immaterial.

Longevity and Prosperity

The ancient Romans dominated most of western Europe from the third century B.C. into the fifth century A.D., and they ruled sections of the Middle East into the mid-fifteenth century A.D. At times during these long periods of Roman rule, the inhabitants of the Roman empire enjoyed unparalleled stretches of peace and prosperity. They had access to clean water, a well-maintained highway system, and goods imported from all parts of the world. And the Romans reshaped their environment, with lasting effects. For example, some of the roads built by the Romans across Europe and the Middle East are still in use 2,000 years later.

- We in the United States also enjoy an unprecedented standard of living. And we, too, have left an indelible mark upon our environment. For example, what roads were in Roman times, railroads were to the United States in the nineteenth century when, gradually, the land from the Atlantic to the Pacific was consolidated into one country. The railroads made possible the efficient movement of people and goods within the enormous expanse of this country.

The Legacies of Rome: Cultural, Propagandistic, Legal, Linguistic, and Religious

Cultural

- Since Rome's fall, Roman civilization has been the source of repeated cultural revivals great and small, down through the centuries: in the era of Charlemagne; in the High Middle Ages; in the Italian Renaissance; in the northern humanist movement of the sixteenth century; and in the Neoclassical movements of more recent times. The literature, art, and monuments crafted by the Romans have inspired countless artists and thinkers.

- American culture dominates the world today. Whether it will continue to do so in 2,000 years is unknowable. But in its breadth and depth today, it is as pervasive as Roman cultural influence has been through the ages.

Propagandistic

- Rome also left a legacy in its use of propaganda. During the Republic, electoral campaigning was engaged in on a scale not known in the world of classical Athens. And the Roman emperors had images of themselves and their accomplishments disseminated throughout the empire to advertise and promote their rule. The emperors always kept themselves in the minds of their subjects.

- The Roman emperor's manipulation of public opinion comprised propaganda of a kind similar to that used by modern American politicians.

Legal

- Roman law has endured to shape Western jurisprudence to this very day. The legal codes of most European countries, for instance, are firmly based upon Roman law.

Linguistic

- The Latin language of the Romans remained the language of educated Europeans for well over a thousand years, while evolving in the lower socioeconomic levels of society into the Romance languages, including Italian, French, Spanish, Portuguese, and Romanian.

- English is widely spoken throughout the world today.

Religious

- Finally, we should remember that it was within or on the borders of Rome's empire that the three great modern monotheistic religious traditions, Rabbinic Judaism, Christianity, and Islam, either evolved or were born. These religions of the book, even as they are practiced today, bear the traces of their development within the broader context of Roman civilization.

THE ANTECEDENTS OF ROMAN ART: ETRUSCAN, CLASSICAL GREEK, AND HELLENISTIC ART

The Etruscans

Roman art did not develop in a vacuum. Stylistically it was heavily influenced by the art of Rome's Italian neighbors to the north, the Etruscans, and by the art of southern Italy, colonized by Greeks beginning in the ninth to eighth century B.C. These influences will be discussed in more detail within the context of individual objects in the resource, but a brief historical/art-historical overview of these cultures may be helpful here.

The Etruscans, who lived in west-central Italy, flourished from about the eighth to third century B.C. in twelve autonomous city-states linked by a common (non-Indo-European) language and a religion that relied upon divination to discover the will of the gods. Blessed with abundant mineral resources and rich farmland, the Etruscans traded all over the Mediterranean world and imported Greek art objects. Their material culture is primarily known from the elaborate tombs, modeled after their houses, where they buried their dead with prized possessions and painted the walls with scenes of outdoor life, funerary games, and banqueting. Archaeologists have unearthed vast amounts of painted pottery imported from Greece, as well as fine Etruscan-produced bronze-work, jewelry, and amber carving.

Although early Rome was ruled by several kings with Etruscan names, by the early third century B.C. the Etruscan city-states had been conquered and had become subject-allies of the Romans. However, their realistic funerary portraits, as well as their style of temple architecture, would heavily influence Roman forms of these arts, and some Etruscan religious rituals and symbols of authority were adopted by the Romans. In addition, it was through the Etruscans that the Romans were first exposed to certain aspects of Greek culture.

Classical Greece

At about the same time that the city of Rome was being founded by Romulus (supposedly 753 B.C.), the great Homeric epics, the *Iliad* and the *Odyssey*, perhaps came into their final oral forms in Ionia (Eastern Greece). With their famous battle scenes and tales of wandering throughout the Mediterranean, these epics had an inestimable impact on Greek civilization, inspiring writers, rulers, and artists.

By Homer's time, Greeks and their culture were spreading around the borders of the Aegean Sea. However, these Greek-speaking peoples divided themselves into a myriad of city-states that frequently warred with each other despite their shared Hellenic culture. Through active trade and colonization around the Mediterranean Sea in the eighth to sixth centuries B.C., including the establishment of colonies in southern Italy and Sicily, the Greeks were able to spread their culture even more widely, having, as noted above, a major influence on the art of the Etruscans.

In the sixth century B.C., the city of Athens began to assume a leading role in Greek politics and culture. The poet-statesman Solon's reform of the laws created the preconditions for later Athenian democracy by admitting the poorer citizens into the popular assembly and broadening eligibility for holding political office. At the end of the sixth century B.C., the Athenians adopted a new constitution that became the basis of Athenian democracy. The effect of the constitution was to achieve harmony between the individual and society.

It was in the fifth century B.C. that Athens achieved its artistic ascendancy. Empowered by its unlikely victory over invading Persian armies at the beginning of the century, Athens entered a Golden Age of culture. The great democratic leader Pericles set out to make Athens the cultural center of the Greek world with great public building projects. Artists flocked to Athens from around the Greek world to help adorn these monuments with sculpture that celebrated the ideal beauty of men and the gods, and great dramatists flourished. Greek art of the period is remarkable for its harmony, restraint, and balance. The sculptures of the fifth century B.C., with their idealized human figures, had a timeless and universal aura, their subjects eternally young, perfectly proportioned, and serene.

The moment of brilliance was brief, however. By the last third of the fifth century B.C., as a result of its long struggle against Sparta, the power of Athens was already in decline. In the fourth century B.C., the city-states entered a period of military conflict and shifting alliances that left them vulnerable to the emergence of the kings of Macedonia as the dominant power in the region.

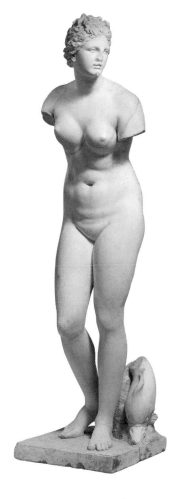

Statue of Venus. Roman, Imperial, 1st or 2nd century B.C.; copy of Greek original of 3rd or 2nd century B.C. Marble. Purchase, 1952 (52.11.5) (image 17)

Hellenistic Greece

Between 331 and 323 B.C., the Macedonian king Alexander III (the Great) and his armies conquered much of the known world. Alexander's empire stretched from Greece and Asia Minor through Egypt and the Near East. Greek culture was thus disseminated over a vast terrain, at the same time being influenced by the culture of the conquered regions.

This fusion of Greek and other cultures is the hallmark of the Hellenistic period. During this time, artistic sensibilities became much broader. Instead of archetypes, sculptors were more interested in representing the specific—boxers rather than generic athletes, children who looked like children rather than like miniature adults, and the elderly. Art became more dramatic, and more emotional. In contrast with the private austerity of classical Athenian life, in the Hellenistic period there was a lavish palace culture, and the luxury arts flourished.

Following the death of Alexander in 323 B.C., the lands he had conquered were divided into several smaller kingdoms. Three successor kingdoms— Ptolemaic Egypt, Seleukid Asia, and Antigonid Greece—would dominate the eastern Mediterranean until the Romans made their way across the Aegean, dismantling the kingdoms one by one until the last, Egypt, was conquered by Rome in 31 B.C., bringing to a close the Hellenistic period.

As they conquered the Greek lands piece by piece, the Romans became increasingly aware of Greek art. Triumphant Roman generals looted Greek cities of their artistic treasures and brought them back to Rome. A growing number of art collectors, many of them Roman, created a market for the replication of famous classical Greek artworks so that they could decorate their homes and gardens with them. As political power shifted to Rome and away from the Hellenistic kingdoms, Greek artists came to Rome to work. The Romans' great appreciation for Greek culture would help to preserve and transmit it down to us, even as the Romans would go on to produce their own unique artistic achievements in portraiture, historical relief, and architecture.

Regal Rome (753–509 B.C.)

The Foundation of an Inclusive, Multiethnic City

According to legend, the city of Rome was founded by Romulus and his twin brother Remus on the Palatine hill above the Tiber River in 753 B.C. (image 14). After killing Remus, Romulus selected the members of Rome's first Senate and offered asylum to fugitives, including paupers, debtors, criminals, and runaway slaves. Romulus' successors included kings with both Latin and Etruscan names. Regal Rome thus was an inclusive, multiethnic state from the start. After the last king (Tarquinius Superbus) was deposed, the power formerly held by Rome's kings was divided among two annually elected magistrates called **consuls**. The Romans called their new state the Res Publica, or the Republic.

Intaglio ring-stone showing Romulus and Remus suckled by the she-wolf. Roman, Late Republican or Early Imperial, 1st century B.C.–1st century A.D. Carnelian. Gift of John Taylor Johnston, 1881 (81.6.33) (image 14)

The Early Res Publica (509–264 B.C.)

The Struggle of the Orders

Two linked developments dominated Rome's early Republican history. The first was the "conflict of the orders," the struggle for power and authority between the **patricians**, who were wealthy landowners, and the **plebeians**, essentially the poorer citizens. By about 287 B.C., the plebeians achieved political, if not economic, equality within Roman society. Laws passed by the council of the plebeians were binding upon the entire citizenry. Rome's wealthier citizens still dominated the state politically, however, because voting procedures within Rome's citizen assemblies were slanted in favor of the wealthy, and the moral authority of the Senate was decisive within a traditional, family-based society.

The Conquest of Italy

The second development was Rome's gradual political domination of peninsular Italy. After 509 B.C., Rome fought a series of wars against its neighbors in Italy. Despite many setbacks, by 264 B.C. Rome was the dominant political power in Italy south of the Po River. Unlike their predecessors and contemporaries in the Mediterranean world, however, the Romans did not simply wipe out their vanquished foes. Rather, Rome established bilateral relations with many of the peoples she conquered, often granting Roman citizenship to the aristocracies of her former enemies. Even those who were enslaved were eventually given the opportunity to become Roman citizens. By such techniques the Romans bound peoples from all over Italy to Rome.

The Middle Republic (264–133 B.C.)

The Punic Wars

The political benefits of Rome's incorporation of its defeated neighbors into the state were strikingly validated after 264 B.C. when Rome fought two long and bitter wars against Carthage, the other great power in the western Mediterranean. Rome's political and strategic flexibility brought victory during the First Punic War and led to the creation of Rome's first overseas province, Sicily. In the second war, despite crushing defeats by Hannibal in Italy, Rome's superior manpower and the loyalty of her Italian allies were decisive. Rome's victory in the Second Punic War made her the dominant power of the western Mediterranean.

Mediterranean Wars

Shortly thereafter, Rome became engaged in settling various disputes among the successor kingdoms of the empire of Alexander the Great. Despite resis-

tance in areas like Spain, by the end of the second century B.C. Rome was the most powerful state in the Mediterranean world.

Hannibal's Legacy

Rome's military successes ultimately led to profound changes within Roman society. Hannibal's devastation of the Italian countryside during the Second Punic War left many Roman citizens and Italians landless and destitute. Rome's conquests overseas also led to the importation of great quantities of gold, silver, and slaves into Italy. The distribution of wealth within Roman society was dramatically altered. The old Republican political ideals of diffusion of authority and cooperation among richer and poorer citizens were put under extreme pressure.

The Late Republic (133–27 B.C.)

Reform and Resistance

Deep divisions within Roman society about the distribution of resources emerged shortly after 146 B.C. A series of reformers and self-interested generals attempted to address these divisions during the period of the late Republic. Some political reformers, such as the tribunes Tiberius and Gaius Gracchus, tried to bring about a more equitable distribution of conquered Italian lands to ensure the survival of the Roman citizen-soldier. (Only landowners could serve in the Roman army.) They also wanted to give the equestrians (an order of wealthy landowners and businessmen in both Italy and the provinces) and Rome's Italian allies political rights equal to their contributions to Rome's successes. But the reforms of the Gracchi and other "popular" politicians were violently opposed by a faction within the Senate.

The Social War

The same faction within the Senate also successfully blocked legislation that would have incorporated Rome's Italian allies into the citizen body. As a result, a "Social War" was fought between Rome and its allies. This war eventually led to the granting of citizenship to most of Rome's free Italian allies.

The Civil Wars and Julius Caesar

But the interests of the urban poor and soldiers, who often served for decades with little hope of a viable economic future, were not addressed, except by powerful military commanders. By the 40s B.C., these great commanders were at war with each other, each supported by his own army and allies. Julius Caesar won the first round of the Roman civil wars and got himself granted the title of dictator for life, but he was assassinated on 15 March 44 B.C. His assassination ignited a second, even more devastating, series of civil wars that were fought all over the Mediterranean world (image 1).

Ring-stone with intaglio bust of Julius Caesar. Roman, Late Republican, 50–40 B.C. Amethyst. Rogers Fund, 1911 (11.195.6) (image 1)

The Republic Restored?

In 31 B.C., Julius Caesar's adoptive son Octavian and his armies defeated Antony and Cleopatra at Actium, the decisive battle of the civil wars. Within a year, Antony and Cleopatra committed suicide in Egypt, and it became a Roman province. All of Alexander the Great's successor kingdoms now were ruled by Rome, and Octavian essentially was left as the sole ruler of Rome's empire. After nearly half a millennium of Republican government, Rome once again embraced a form of autocratic rule, but one that was set within a constitutional framework.

Although Octavian claimed to have restored the old Republic, no one was fooled. The oligarchic system of the Republic was dead. Most Romans, though, were only too happy to go along with the fiction of a Republic restored, as long as peace prevailed.

The Principate (27 B.C.–A.D. 337)

Augustus and the Julio-Claudians (27 B.C.–A.D. 68)

In 27 B.C., a decree of the Senate awarded Octavian the honorific title of Augustus. The epithet was intended to suggest that its holder was a figure of awe and someone positioned to gain the favor of the gods on behalf

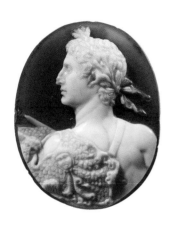

Cameo portrait of the emperor Augustus. Roman, Claudian, ca. A.D. 41–54. Sardonyx. Purchase, Joseph Pulitzer Bequest, 1942 (42.11.30) (image 4)

of the Roman people. Augustus also gained political control of most of the provinces in which soldiers were stationed. A few years later, he was given a combination of legal powers within Rome and the provinces that made him the most powerful authority in Rome and the preeminent citizen of the state, the *princeps.* All of Augustus' successors up to the early fourth century A.D. were given a similar package of powers. For this reason, the period from the rule of Augustus to the reign of Constantine is known as the Principate, or rule of the first citizen.

Augustus was the first ruler in Roman history to create a wholly professional army, and during his reign the conquests of this army roughly doubled the size of the Roman empire: the rest of Spain, the Alpine regions, the Balkan peninsula up to the Danube, and portions of Germany from the Rhine to the Elbe were acquired as new provinces. To pay the soldiers who protected the empire, the taxation system was regularized and a special military treasury was created. Augustus personally appointed legates and equestrian governors to administer the provinces ceded to his control, and he had the ability to influence who was appointed to govern those provinces not directly under his legal authority (images 3, 4).

Augustus' direct imperial descendants, the so-called Julio-Claudians, tried to maintain the facade of Augustus' restored Republic, and some of them involved the Senate in the governance of Rome's vast empire. However, tensions between individual emperors and senators, which became most acute at times of succession, gradually led to a diminution in the power and overall role of the Senate. The emperors progressively relied upon members of the equestrian class and their own private secretaries, many of them recruited from the Eastern provinces, to carry out the day-to-day work of administering the empire (image 5).

Precisely because of the empire's huge size and the diversity of its languages and peoples, the government of imperial Rome functioned passively, in response to stimuli from the provinces. By and large, the government was content to raise taxes and keep the peace. Peace and prosperity were maintained as much by diplomacy as by force of arms. Security for the approximately 55 million inhabitants of the early Roman empire was maintained by a citizen army of no more than 150,000 soldiers, supported by locally recruited, noncitizen auxiliary troops totaling an additional 150,000 soldiers.

The Year of Four Emperors (A.D. 68–69) and the Flavians (A.D. 69–96)
The so-called Year of Four Emperors followed the suicide of Nero, the last Julio-Claudian, as various generals jockeyed to become emperor. The last of them, Vespasian, a member of the equestrian order rather than of the aristocracy, consolidated power in A.D. 69 (image 7.10).

Vespasian was a great military leader whose troops annexed northern England, moved into Scotland, and pacified Wales. He used tax money in part for public projects for the benefit of the Roman people, such as the Flavian **Amphitheater**, or Colosseum (completed in A.D. 80), which was the first permanent venue for gladiatorial contests at Rome (and which served as the model for our modern sports **stadiums**).

The eruption of Mount Vesuvius in southern Italy occurred during the Flavian period, burying the cities of Pompeii and Herculaneum under lava and ash and preserving virtually intact a treasure trove for the archaeologists who later discovered the buried cities (images 40–42).

In addition, the last Flavian, Domitian, built a great imperial residence on the Palatine Hill (the origin of our word "palace"), and it continued to be the imperial residence for subsequent emperors (image 6).

Architectural fragment from the palace of the emperor Domitian on the Palatine in Rome. Roman, Early Imperial, Domitianic, ca. A.D. 81–92. Marble. Gift of J. Pierpont Morgan, 1906 (06.970B) (image 6)

Nerva and the "Five Good Emperors" (A.D. 96–180)
The period from the death of Domitian's successor, Nerva, through the reign of Marcus Aurelius later became known as the period of the "Five Good Emperors," rulers who were chosen on the basis of merit rather than on the basis of heredity.

The appointment of men of proven ability, many of whom came from the provinces (Trajan's family came from Spain, for example), helped to accelerate the pace of integration between the provinces and Rome. Below the level of the imperial succession, large numbers of wealthy and ambitious provincials made their way into the equestrian and senatorial orders. These provincials spent freely on their cities, and they in effect became the administrators of the empire itself. In addition, emperors such as Trajan and Hadrian founded many new cities in the provinces (image 32).

The first half of the second century A.D. was the time when the power, economic might, and artistic accomplishment of the Roman empire were at their greatest. Unfortunately, the borders of such a vast empire proved difficult to defend, and by the latter part of the century uprisings were occurring in many border areas (images 8, 9).

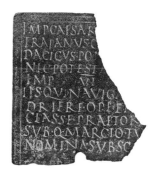

Diploma for a sailor from Trajan's fleet at Misenum. Roman, Mid-Imperial, Trajanic, A.D. 113–114. Bronze. Rogers Fund, 1923 (23.160.52) (image 32)

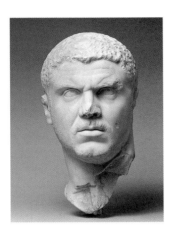

Portrait of the emperor Caracalla. Roman, Severan, ca. A.D. 212–217. Marble. Samuel D. Lee Fund, 1940 (40.11.1a) (image 10)

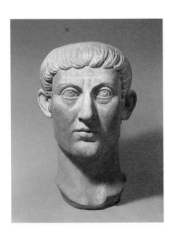

Portrait head of the emperor Constantine I. Roman, Late Imperial, ca. A.D. 325–370. Marble. Bequest of Mary Clark Thompson, 1923 (26.229) (image 12)

The Severan Dynasty *(A.D. 193–235)*

In A.D. 193, Septimius Severus, whose father's family was of Punic (North African) origin, seized Rome and established a new dynasty. He rested his authority overtly on the support of the army, and he substituted equestrian officers for senators in key administrative positions, thereby broadening imperial power throughout the empire. Septimius Severus and his son Caracalla spent most of their time away on military campaigns that severely depleted the imperial coffers.

In A.D. 212, an imperial edict by Caracalla extended Roman citizenship to all free inhabitants of the Roman empire. The motive for this seemingly generous extension of Roman citizenship seems to have been not to benefit his subjects but to increase tax revenues so that he could pay the enlarged Roman army of the early third century A.D. (images 10, 11).

The Crisis of the Roman Empire *(A.D. 235–284)*

After A.D. 235, the Roman empire was subject to invasions from both the north and the east; these compelled the Roman emperors to spend much of their time and energy fighting, and many of them died violent deaths after short reigns. No less than eighteen "legitimate" emperors claimed to rule on behalf of the Roman people during this period, and there were many pretenders as well.

By A.D. 284, security within the empire largely had been restored. Near-constant warfare had created other problems, however. To pay the growing numbers of soldiers who were enlisted to fight the invaders during the third century A.D., taxes were continually increased. Eventually, runaway inflation caused the Roman state to demand revenues from its subjects in kind or in terms of service (rather than in cash). Overall, during the crisis of the third century A.D., the state became far more intrusive in the lives of its citizens. Especially within the old, wealthy cities of the Eastern provinces of the empire, competitive, philanthropic subsidization of public amenities, such as the construction of public buildings, either slowed down dramatically or ceased altogether.

Christianity, on the other hand, became deeply entrenched within imperial society during the crisis, as Christians won respect both for their charitable endeavors and for the way that many of them nobly bore the government's spasmodic persecutions.

Diocletian and the Tetrarchy (A.D. 284–305)

As the greatest period of the empire's instability subsided in A.D. 284, the army chose Diocletian, a former imperial bodyguard, as emperor. He perceived that the empire was under siege on all sides and thus could not be governed by a single person. Accordingly, in 293 he instituted a new form of government known as the **Tetrarchy**, or four-man rule. The empire was divided into four parts, each with a different capital and a ruler responsible only for that section. Within this four-part system, there were two senior emperors, or Augusti, and two junior members, or Caesari. The junior rulers were intended to succeed to Augustan status when the senior partners retired or died.

Constantine and Christianity

Constantine, the son of a tetrarch, grew up at the court of Diocletian and had a distinguished military career. His father had been appointed Augustus in the West after Diocletian's abdication, but died a year later while both father and son were on campaign in Britain. The troops declared Constantine to be an Augustus, but this set off war among the tetrarchs. After much political and military maneuvering, Constantine became the sole ruler of the Roman world in A.D. 324.

Constantine used the remainder of his largely peaceful reign to reorganize the army, restore senatorial prestige, and establish an imperial succession. Most significantly, Constantine founded a "New Rome" on the site of the old Greek city of Byzantium on the Bosporus, and it was renamed Constantinople (present-day Istanbul). No longer would the emperors reside at Rome.

Looking back upon the conquest of his imperial rivals, particularly in the key Battle of the Milvian Bridge against Maxentius in Rome in 312,

Constantine later became convinced that his victory had been assisted by the god of the Christians; he claimed to have been led by a vision of a cross. During the remainder of his reign, thus, he actively supported the growth of the Christian Church and the expansion of Christianity, though without actually penalizing polytheists or polytheism. Constantine was baptized on his deathbed in 337. Thereafter Christianity became the official religion of the Roman empire (image 12).

Julian, Theodosius, and the Later Roman Empire (A.D. 337–1453)

With the exception of the emperor Julian, Constantine's fourth-century successors were far more aggressively pro-Christian in their programs, and polytheism gradually was replaced by Christianity as the dominant religion of the state. In A.D. 391, the emperor Theodosius I ordered the closing of all pagan temples and banned all forms of pagan cult.

After the death of Theodosius, for security reasons the empire was again divided between Western and Eastern Roman emperors. Civil authority in the West had been severely weakened by barbarian invasions by this time, and in 476 the German Odovacer served as the last commonly recognized Western Roman emperor. In A.D. 493, an Ostrogothic kingdom was established at Rome by Theodoric the Great. The Eastern Byzantine empire, however, survived and flourished until the fall of Constantinople to Ottoman Turkish troops in 1453. More than two millennia after Rome's foundation, the Roman empire was no more.

POWER AND AUTHORITY IN ROMAN PORTRAITURE

*A*lthough we may view the portrait busts of the ancient Romans as works of art, the Romans usually commissioned them as objects of commemoration. Portraits of private individuals were displayed in the home or in a funerary context. Public figures, such as emperors, generals, and statesmen, were memorialized through the erection of portraits in public places.

The development of realistic portraiture is often said by art historians to have originated with the Romans. In fact, many other ancient cultures, including those of the Egyptians and the Etruscans, can lay claim to having fashioned realistic likenesses of individual rulers or statesmen. And not all of Roman portraiture was completely realistic—the history of Roman portraits reveals an alternation between "veristic" and more idealizing modes of representation. It is with the Romans, however, that portraiture became widespread among all levels of society.

The portraits in this resource have been chosen because they reflect the major changes in portrait style and taste that occurred from the later Republic until the removal of the capital of the empire to Constantinople.

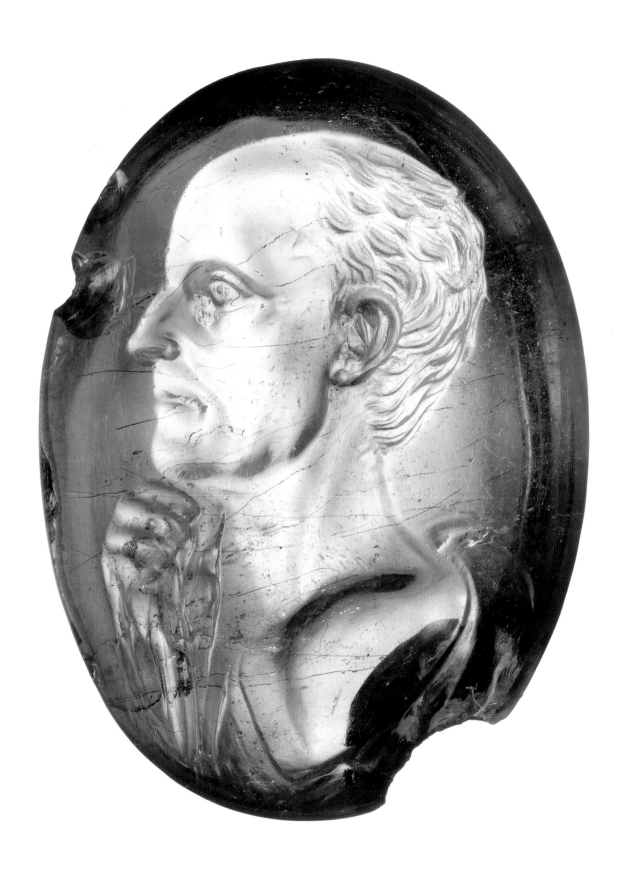

1. *Ring-stone with intaglio bust of Julius Caesar*
Roman, Late Republican, 50–40 B.C.
Amethyst; 1⅛ in. (2.9 cm)
Rogers Fund, 1911 (11.195.6)

POINTS TO CONSIDER

- Julius Caesar was the first Roman to have his image depicted on coins during his lifetime. The coins, issued to pay his troops, reminded them that he was the person who provided their livelihood. Coins thus carried a powerful propaganda message. In the empire, every emperor similarly used coinage for propaganda purposes.

- Very often at Rome, coin portraits were copied, carved in relief on gems or sealing ring-stones. The Museum's amethyst ring-stone is carved with a portrait very similar to that on Julius Caesar's coin.

- Even in the absence of identifying inscriptions, archaeologists can sometimes identify a Roman portrait as that of an important individual if they find multiple representations with the same facial characteristics. Many other replicas of the portrait on the Museum's amethyst are known, so it must be that of a famous person. Therefore it probably represents Caesar.

- This ring-stone would have been worn by a relative or admirer of the dictator.

The Innovative Coinage of Julius Caesar

During the late Republic, the Roman mint began to produce coins with portrait busts of the deceased ancestors of Romans. The busts on the coins were based on earlier sculpted likenesses of the subjects. In 44 B.C., however, Julius Caesar revolutionized Roman practice when he issued coins with his own image on them. This was the first time that a living person had been depicted on Roman coinage. The issuing of these coins reflected Caesar's unique status in Roman history: he was the first Roman to be declared "dictator in perpetuity." After Caesar's assassination in March of 44 B.C., the Roman emperors who succeeded him followed the example Caesar had set, seeing to it that coins struck with images of themselves were produced and disseminated throughout the empire.

The first example of a coin depicting Julius Caesar while he was living was probably a silver *denarius* struck at the mint in Rome by Marcus Mettius in 44 B.C. It shows Caesar looking to the right. He has a lined forehead, a large nose and eyes, lined cheeks, and a long thin neck, with a prominent Adam's apple. He seems to have a receding hairline, and hair is brushed forward from the back of his head. He wears a laurel wreath. His name and the abbreviated title "dic"(tator) are inscribed on the coin. This realistic physical appearance accords well with a description of Caesar provided by the historian Suetonius, who said "his baldness was a disfigurement

which his enemies harped on … but he used to comb the thin stands of hair forward from his poll, and of all the honors voted him by the Senate and People, none pleased him so much as the privilege of wearing a laurel wreath on all occasions …" (Suetonius, *The Lives of the Twelve Caesars*, I: 45).

The Museum's Ring-Stone with a Portrait of Julius Caesar

Coin images were often reproduced on ring-stones, and it is possible that the Marcus Mettius *denarius* was the source for the Museum's large and fine amethyst ring-stone, which bears a portrait very similar to the coin's. The bust of a beardless and partially bald man faces to the right; he has a thin face, prominent nose, and long neck. A mantle is draped around his right shoulder; he grasps a fold of it in one hand. Although this image lacks the laurel wreath or any other attribute usually associated with Julius Caesar, as in the *denarius* described above, there is a strong facial resemblance between the two images. Many other gemstones are replicas of the Museum's

amethyst, making it clear that the subject is a famous man. Such a ring-stone probably belonged to an admirer or follower of the dictator and was worn as a sign of respect, as well as serving as a seal for letters.

The portrait of a man (image 2) in this section bears, as has been noted, a strong resemblance to the image on the amethyst, although it is not a portrait of Caesar.

DISCUSSION QUESTIONS

- Describe the appearance of the man in this portrait image. Is he old or young? What expression does he have? Can you tell anything about his personality from this image?

- Julius Caesar became the first Roman to have his portrait put on the coins he issued. Why do you think he did that?

- In today's world, many of us wear T-shirts with images of famous people, like rock stars, on them. Why do you think a private individual would have wanted the image of Caesar on his ring-stone?

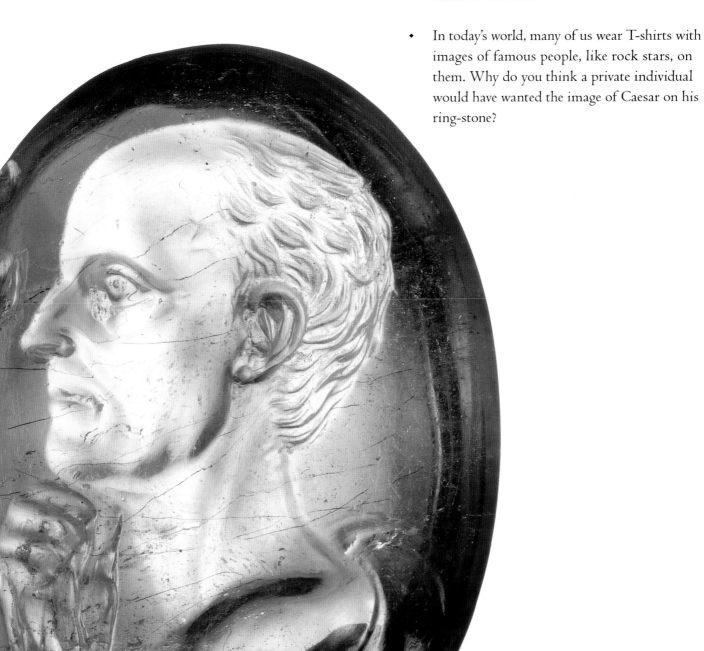

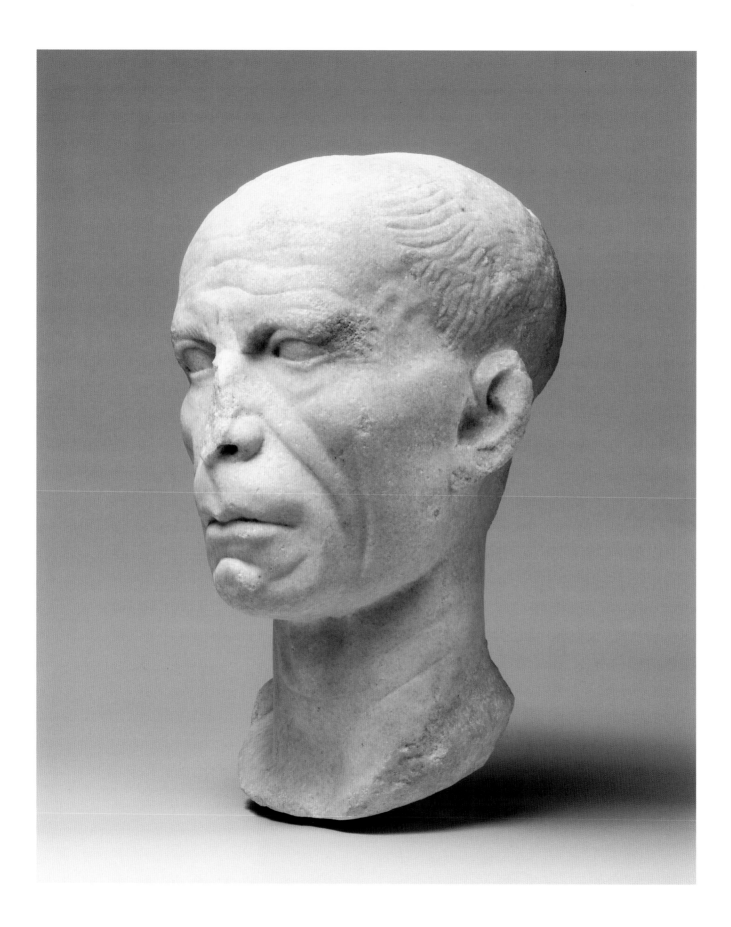

2. *Portrait of a man*

Roman, Late Republican or
Early Augustan, late 1st century B.C.
Marble; H. 12⅜ in. (31.5 cm)
Rogers Fund, 1921 (21.88.14)

POINTS TO CONSIDER

• During the later Republican period, aristocratic Romans kept wax portrait masks of their ancestors in domestic shrines. These portraits, reflecting the aristocratic interest in genealogy and heritage, were displayed in public places.

• By the first century B.C., Greek marble and bronze sculptors were flocking to Rome to work for wealthy patrons who commissioned these artists to create stone honorific portraits of themselves and their family members.

• In contrast with Greek taste in portraiture, in which portrayal of the body was important to the characterization of the person, for the Romans depiction of the facial features was sufficient.

• Classical Greek portraiture had valued an idealizing depiction of the individual. In Hellenistic art, portraiture became more naturalistic. Republican Romans desired portraits that would express the individual's identity by stressing his age, experience, and lack of vanity. Thus men were depicted with wrinkles, baldness, and physical imperfections that were thought to convey a sense of their *virtus*, the quality of selfless duty and sober morality.

• During the Principate, periods of hyperrealism in portraiture would alternate with more idealizing tendencies.

Realistic Portraiture in the Republican Period

Aristocratic Romans of the later Republic were historically self-conscious and very aware of their genealogies—real or imagined! From at least the mid-Republic (second century B.C.), they kept *imagines*, wax portrait masks of their illustrious ancestors, in household shrines. These masks were carried or worn during funerals.

By the first century B.C., wealthy Romans were employing sculptors from Greece and elsewhere to create ancestor portraits made out of more durable materials, such as marble. At least some of these patrons also began to commission marble portraits of themselves for the adornment of their eventual tombs. Moreover, in the course of the first century B.C., the practice of erecting portraits filtered down from the wealthier Roman orders into the lower economic and social orders, including those of freedmen, who were former slaves. At the same time, dedicatory statues were erected to honor triumphant generals (and sometimes businessmen) in Roman public places. These statues tended to be full-length, and often paired the realistic face of the subject

with an idealized body type borrowed from a Greek sculptural prototype.

The Romans believed that a person's individuality inhered wholly in his facial features; it was physiognomy that revealed character. Therefore they often commissioned portraits that consisted only of the head and the bust. This marked a dramatic departure from Greek practice, where depiction of the body was considered to be an essential element in an accurate portrayal of the individual.

By the first century B.C., there were two basic portrait styles in use around the Mediterranean. One was a youthful, dashing, and idealized type of image, favored by Hellenistic kings. The other was a more sober, realistic style. Aristocratic Romans favored the second style, because they perceived that it reflected Republican values such as *virtus*, which implied duty to the state, military bravery, public responsibility, and sober morality. These were qualities which many, such as the writer Cato the Elder, feared were under assault from the alleged decadence and frivolity of the Greek world. Thus, the typical aristocratic Roman portrait type of the late Republic emphasized such characteristics as wrinkles, thinning hair, and a grim expression, features meant to convey maturity, wisdom, experience, responsibility, and the determination to uphold strict Republican moral values. In other words, Roman artistic verism was employed to express socially approved values.

The Late-First-Century Portrait of a Man

This portrait of a man exemplifies the late Republican veristic portrait style. The subject has a thin, egg-shaped head, high cheekbones, a straight nose (partly broken off), and a thin mouth set in an unsmiling line. His bald forehead is deeply lined; there are strong nasal-labial lines running from the bottom of his nose to the bottom of his face, and creases in his cheeks. His now-damaged ears protrude slightly, and his sparse hair is simply arranged. His eyelids are rendered as if slightly puffy, perhaps suggesting that he is weary due to his loyal service to the Roman state. The neck is long, thin, and also deeply lined. Such details, while probably accurate, were also intended to convey the message of the subject as a staunch upholder of *virtus*. With its balding forehead, deep facial wrinkles, and stern expression, the portrait is squarely in the veristic tradition of late Republican portraiture.

This head bears such a strong resemblance to coin and sculptural portraits of Julius Caesar (see image 1) that for some time it was identified as being the great general. However, the portrait probably was carved after Caesar's death, and more likely represents a follower who wished to commemorate his sympathies with Caesar by emphasizing his physical resemblance to the dictator.

In the early empire, the emperor Augustus adopted a more youthful and classicizing portrait type than the hyperrealism that was favored in Republican portraiture. However, veristic Republican-style portraiture continued to be popular in private circles for decades to come.

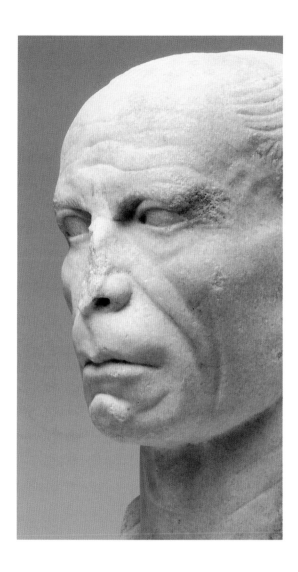

DISCUSSION QUESTIONS

- Describe the appearance of this portrait. How old do you think the subject is? Why do you think so? What expression does he wear?

- What kind of personality do you think this person had? Do you think you would have enjoyed spending time with him? Why or why not?

- Compare this portrait with the bronze head of a man illustrated in *Art of the Classical World*, no. 381. This portrait, intended to be inserted into a tapering pillar called a herm that would have replaced the body, is from the same time period as image 2. What differences can you see between the two portraits? What similarities? Which is more lifelike to you? Why?

- When you pose for a photograph, you usually want to make sure that your hair is combed, that you are wearing clothes that flatter you, and that you are smiling. Do you think that the subject of this portrait had the same concerns as you have? What qualities does this portrait convey?

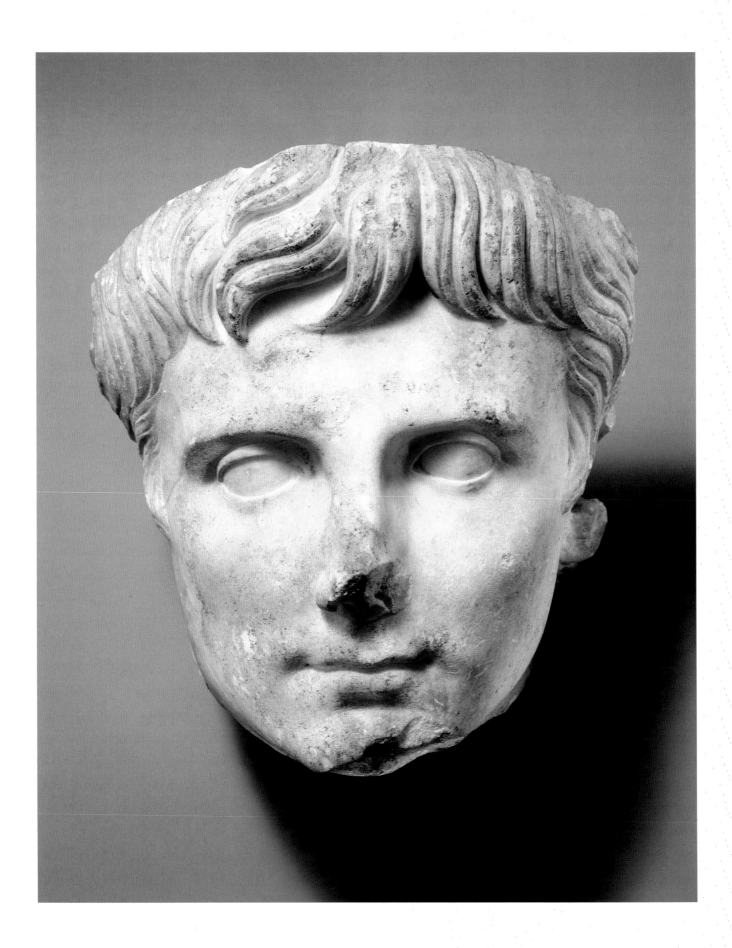

3. *Colossal portrait of Augustus*
 Roman, Julio-Claudian, ca. A.D. 14–37
 Marble; H. 12 in. (30.48 cm)
 Rogers Fund, 1907 (07.286.115)

4. *Cameo portrait of the emperor Augustus*
 Roman, Claudian, ca. A.D. 41–54
 Sardonyx; H. 1 7/16 in. (3.7 cm)
 Purchase, Joseph Pulitzer Bequest, 1942
 (42.11.30)

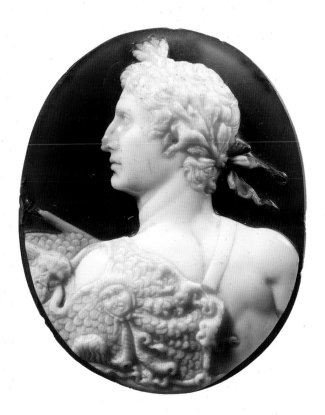

- Augustus, the first Roman emperor, realized that his portrait image could serve as an important instrument of propaganda. Court sculptors fashioned a prototypical portrait type that was then copied. The copies were dispersed throughout the Roman world so that further copies of them could be made and installed in public places. Through these statues and busts, as well as through coins with the emperor's image, everyone in the empire was aware of what he looked like and was reminded of his power and authority.

- The portraits of aristocrats of the late Republic were veristic: they documented the baldness, wrinkles, and facial imperfections of their models. Augustus looked to Greece and chose a more idealized, classicizing portrait image that, while it captured his individual features, never aged or changed throughout his fifty years in power.

- In the public sphere, Augustus emphasized that he was the first citizen among many equals, although he might be represented in any of his roles: in a toga, as a statesman and citizen; wearing armor, since he was the commander of the army; or veiled, since he was the chief priest and responsible overall for maintaining good relations with the gods on Rome's behalf.

- In the private sphere, on the other hand, it was not uncommon for the emperor to be shown with the attributes of gods. After his death, Augustus was deified, and public representations of him might also show him with divine characteristics.

Augustus' Cultural Achievements

Even before Octavian became Augustus, Rome was the largest, richest, and most powerful city in the Mediterranean world. During his reign, however, new building projects transformed it into a truly majestic city. Gleaming marble buildings and monuments replaced earlier structures made of brick, as Augustus ordered the construction of grand public spaces. Temples were rebuilt, and the emperor encouraged a renewal of pious observance of the old rites. The water supply of the city was improved, and great bath complexes were built. The food supply for the urban population was regularized. Craftsmen from many fields flocked to Rome, and the engineering and artistic advances that they achieved made Rome the most livable city of its day. Augustus also made the imperial image known across the empire through portrait busts and coinage. Writers like Livy and Virgil were inspired to pen histories and poetic epics that presented Rome's ascendancy as one that was preordained by the gods. The arts flourished under Augustan patronage, and he shrewdly utilized them as a propaganda tool in his quest to make Rome the new Athens, the cultural as well as political center of the Mediterranean.

For a summary of the political career of Augustus, the first Roman emperor, please see the Historical Overview.

Augustus and the Imperial Portrait Image as a Propaganda Device

Augustus skillfully used his own official portrait image as an instrument of propaganda, disseminating sculpture, coins, and sculptural reliefs across the empire. Thousands of coins with his image survive, and more than 150 three-dimensional portraits of him are extant.

The image Augustus wished to project, an image that was inseparable from his vision of Rome as the new Athens, is exemplified in the Museum's overlifesized portrait head, executed in a scale reserved for depictions of rulers or gods (image 3). It is an example of the emperor's official portrait type, which differs from the craggy, individualized type preferred by late Republican aristocrats. Instead, it consciously adopts the idealizing tradition of classical Greek sculpture as a subtle way of identifying the emperor with the glories of classical Athens. He is shown as relatively youthful in all his portraits, no matter when in his reign they were produced. The cheeks are smooth, the features even, and the eyebrows straight. Certain features do individualize him: the long nose, the small mouth, and especially the careful arrangement of the locks of hair on his forehead. This arrangement of the hair was used on all his portraits and became a sort of signature for him.

In addition to portrait busts, the emperor's image

was displayed in full-length statues that showed him dressed appropriately for the fulfillment of his various roles: for example, in the toga, as a statesman; wearing armor, an allusion to his status as *imperator* (commander); or veiled, in reference to his role as chief priest, *pontifex maximus*, responsible for overseeing Rome's relationship with the gods. The public images of Augustus that were erected during his lifetime never showed him with the regalia of kingship; he was presented simply as the *princeps*, the first citizen.

The Imperial Image in a Private Context

Sardonyx is a form of quartz that occurs in nature with alternating layers of white and colored bands. Artists carved them in such a way that a figure of one color was set against a background of the other color. Such carved stones are called **cameos**. The craftsmen used a drill and a bow that was wrapped around the drill shaft and drawn back and forth to make the drill rotate. The art of cameo carving, which served a wealthy, luxury-loving clientele, flourished especially in the Hellenistic period and in the early empire.

The Museum's sardonyx cameo portrait of Augustus (image 4) is an image of the emperor meant for private rather than public display. It most likely belonged to a member or loyalist of the Julio-Claudian court, since it portrays Augustus with divine attributes. The date is based upon style, and upon the fact that during the reign of Claudius there was a revival of Augustan imagery.

Here, Augustus' figure is white, in profile against a dark background. He wears only a laurel wreath and an aegis, a scaly cape commonly associated with Zeus/Jupiter and with the goddess Athena/Minerva. Augustus' aegis is decorated with the heads of a wind god and a gorgon. A baldric, the strap for holding a scabbard, crosses his chest, and he carries a spear.

Such elevating imagery came to Rome from Hellenistic kings who, following the example of Alexander the Great, were depicted with heroic and divine attributes during their lifetimes. A public image of Augustus would never have depicted him in this way, since he wished to present himself to his subjects simply as *primus inter pares*, first citizen among equals. In a private context, however, such elevating imagery was perfectly acceptable. In addition, after his death Augustus was deified, making such imagery more appropriate.

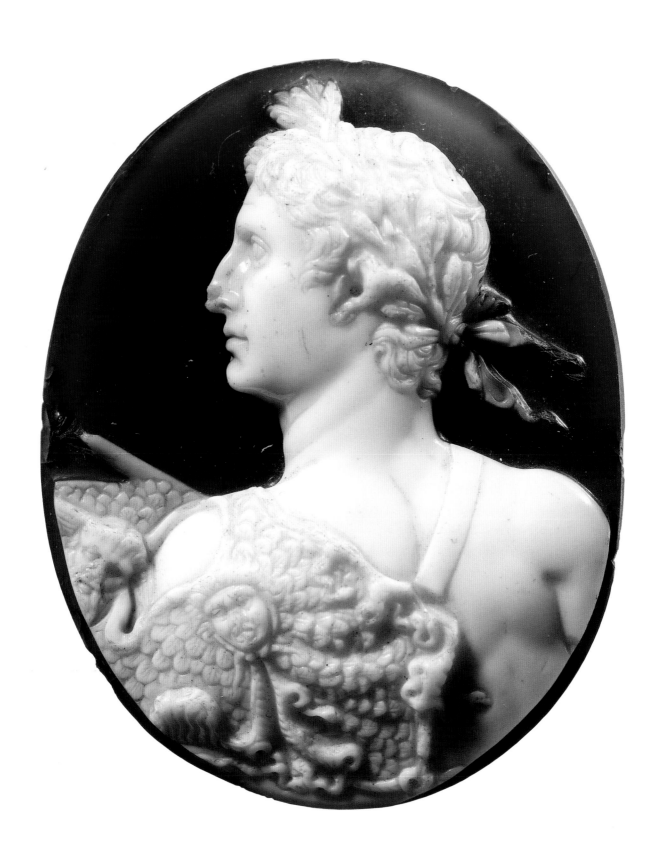

DISCUSSION QUESTIONS

- Look at the marble portrait of Augustus (image 3). Does this look like a real person to you? Why or why not?

- Compare this portrait with the Republican portrait in image 2. Now, in *Art of the Classical World*, look at the statue of Diadoumenos (no. 135), a Roman copy of a classical Greek sculpture of the fifth century B.C. Which does our portrait of Augustus more closely resemble? Why do you think Augustus chose to have himself represented in this way?

- Suetonius (ca. A.D. 69–140), a Roman lawyer and biographer, described Augustus' appearance in the following terms: "He was negligent of his personal appearance ... hair yellowish and rather curly. His eyebrows met above the nose, he had ears of normal size, a Roman nose ..." (*The Lives of the Twelve Caesars*, II: 79). How does that description compare with the image that you see here? Why do you think there are some differences?

- This portrait was actually made after the emperor had died at the age of seventy-six. Do you think it represents a man of that age? Why or why not? Why do you think the portrait shows Augustus at this age?

- What image of yourself would you like to be remembered by?

- What expression does the emperor wear in this portrait? Does he look menacing or friendly? Discuss some of the reasons why he might want to project this kind of image.

- Why do you think the artist made this portrait in such a large scale?

- Why do you think the Roman emperor Augustus had portrait likenesses of himself erected all over the empire?

- Look at the sardonyx cameo of Augustus (image 4). What is he wearing? The emperor carries a spear. Which of the emperor's roles in society do you think this alludes to? Why do you think he would be shown this way?

- Look at an American quarter. Whose portrait is represented? Why do you think a country would put the image of one of its founding fathers on a coin? What kind of image do these coin portraits project?

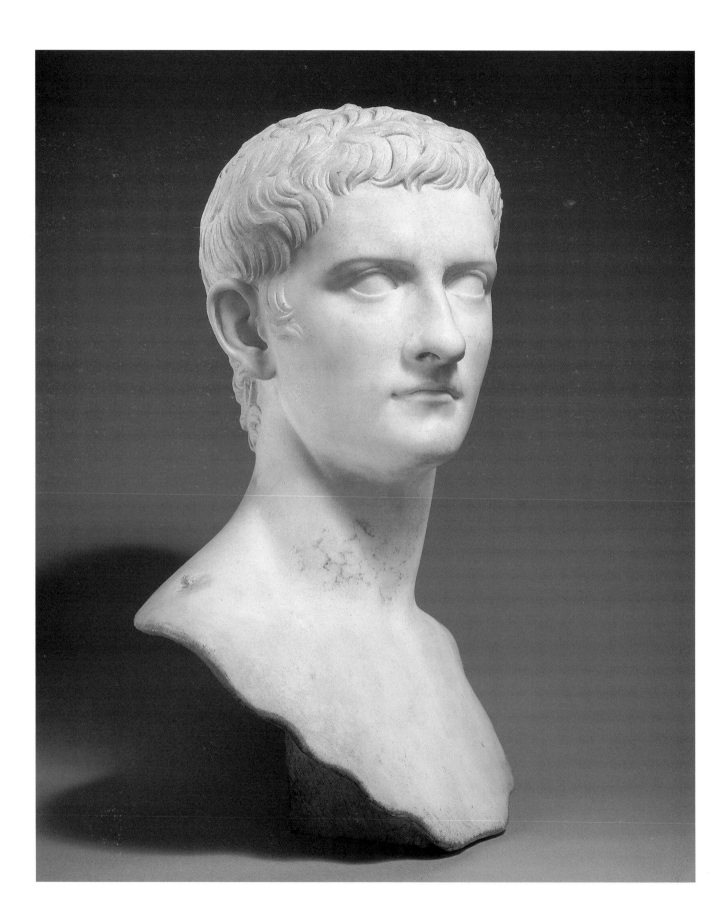

5. *Portrait bust of the emperor Gaius,
known as Caligula*

Roman, Julio-Claudian, A.D. 37–41

Marble; H. 20 in. (50.9 cm)

Rogers Fund, 1914 (14.37)

POINTS TO CONSIDER

- The Julio-Claudian successors of the first emperor, Augustus, continued to use the imperial portrait image as a propaganda tool that was distributed widely around the empire. In so doing, they adopted portrait types whose facial features and hairstyles were similar to, though distinguishable from, his. This was done to stress dynastic continuity, with the implication that the rule of these successors was as effective and beneficial to Rome as that of Augustus had been.

- Ancient descriptions of Caligula give us some idea of what he actually looked like. There are similarities between these descriptions and the emperor's portrait, but there are notable differences as well. This dichotomy is evidence of the fact that conscious choices were made in creating the imperial portrait type and that it was not simply a matter of replicating an actual likeness.

- Caligula's portrait type clearly stresses his resemblance to Augustus, and yet he is also given characteristics that individualize him.

The Emperor Caligula

Gaius Julius Caesar Germanicus (A.D. 12–41) was the great-grandson of the first emperor, Augustus, and therefore was a member of the Julio-Claudian dynasty. He earned his nickname at an early age due to the fact that as a small boy, living with his parents during a military campaign on the Rhine, he was dressed in a military uniform, including little boots (*caligae*). He became emperor in A.D. 37 after the death of the second emperor, Tiberius. The populace was very enthusiastic about his accession because of their admiration for his father, the general Germanicus.

Unfortunately, Caligula had had little training in public administration, and he quickly alienated the Senate and the praetorian guard (an elite corps of soldiers) because he insisted on receiving honors at Rome and because of his brutal and autocratic rule. Ancient sources, in fact, depict him as a cruel and unbalanced person. He did, however, undertake many building projects that improved Rome's roads and water supply, and he constructed a circus near the present-day site of the Vatican.

Caligula was always at great risk of assassination because of his harsh and arbitrary rule and because he had no male successor who might be able to avenge him. He, his fourth wife, and his infant daughter were assassinated in January A.D. 41.

The Museum's Portrait of Caligula

The portraits of Augustus' successors in the Julio-Claudian dynasty bore a strong resemblance to his own. This was a calculated choice made for reasons of propaganda. The portraits were intended to evoke in the viewer memories of the benefits of Augustan rule, as well as to stress the continuity of the family lineage.

Like those of his predecessors, portraits of Caligula would have been disseminated around the empire. Few of them survive, however, due to both his short reign and his unpopularity. Many of his portraits were undoubtedly destroyed or recarved after his death.

The Museum's portrait of Caligula shows him as a young man. He has a broad and high forehead, protruding ears, straight eyebrows, close-set eyes, a straight nose, and a narrow mouth. All of these are features similar to those of the portrait of Augustus discussed earlier (image 3). Like Augustus, he has locks of hair brushed over the forehead, but these are arranged differently, which is one way of distinguishing the two emperors from each other. Caligula's bangs are brushed to the right, and his head is turned slightly in that direction. While readily identifiable as Julio-Claudian, then, he retains distinguishing features.

Suetonius described Caligula as a tall, pale, ungainly, balding man with a hairy body, broad forehead, and hollow eyes. We know that Caligula was so self-conscious about his baldness that it was legally forbidden for anyone to look down on him (Suetonius, *The Lives of the Twelve Caesars*, IV: 50). Caligula's portrait bears some similarity to this description but it also differs, notably in his abundant hair, confirming that the imperial portrait type represented a combination of fact and fiction.

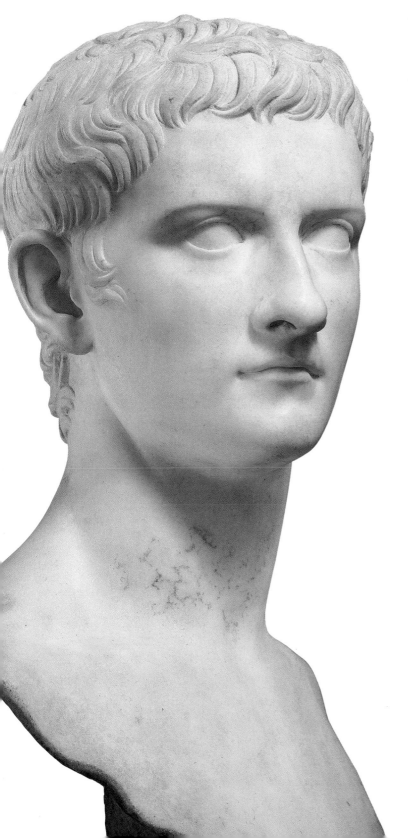

DISCUSSION QUESTIONS

• Describe the appearance of this portrait. What age do you think the subject is?

• Compare this portrait with images 3 and 4. Which one does it resemble? Why do you think this is the case?

06.970a

06.970b,c

06.970e,d

6. *Five architectural fragments from the palace of the emperor Domitian on the Palatine in Rome*

Roman, Early Imperial, Domitianic,
ca. A.D. 81–92
Marble; a: H. 19 in. (48.3 cm), b: H. 19 in.
(48.3 cm), c: H. 29 in. (73.6 cm), d: H. 10 in.
(25.4 cm), e: H. 16 in. (40.7 cm)
Gift of J. Pierpont Morgan, 1906
(06.970a–e)

POINTS TO CONSIDER

- The creation of practical architectural forms, such as bath complexes, and their rapid construction across the Roman world was one of the great achievements of the Imperial period. The presence of these Roman buildings helped to create a Roman culture in parts of the empire beyond Rome.

- The rapid and inexpensive construction of public buildings across the empire was made possible through the use of Roman **concrete**.

- The Roman emperors built their imperial residences on the Palatine Hill, which has given us the word "palace."

- Domitian's great palace, constructed toward the end of the first century A.D., made use of concrete but was decorated with rich materials. Its lavishness was meant to impress viewers with his wealth and power, as well as his taste.

- The Museum's architectural relief sculpture, though fragmentary, gives a sense of the opulence with which Domitian's palace was decorated inside and out. This palace continued to be a home of emperors until the seat of imperial power was removed to Constantinople in the early fourth century A.D.

The Roman Palace of Domitian

The meaning of our word "palace" as a kind of grand house derives from the fact that the Roman emperors built their houses in Rome on the Palatine Hill, where Romulus, the traditional founder of the city, was said to have built huts for himself and his followers.

Domitian, the last of the Flavian emperors, commissioned the famous architect Rabirius to build him a colossal residence and hall of state on the Palatine, overlooking the Roman **Forum** and the Circus Maximus. The immense complex was built using Roman concrete, the material that had revolutionized Roman architecture because it was cheap, easy to make and use, and resistant to the elements. Concrete also proved to be far more durable than many other materials previously used for monumental architecture. (See the discussion on Roman concrete in the overview to the Daily Life section.) As befitting its function as the home of the emperor, though, the concrete core of Domitian's palace was lavishly decorated with architectural sculpture, freestanding statuary, **frescoes**, **mosaics**, and colored marbles. Such an opulent building was intended to advertise the emperor's tremendous wealth and power.

The palace complex consisted of two main parts, one for public rooms and one for the private residence. Among the public rooms were an audience hall, or Aula Regia, and a **basilica**. Each of these had an **apse** at the south end so the emperor could sit in

a vaulted niche to look down upon visitors. The Aula Regia had an interior facade of three stories and a ceiling over 100 feet from the floor. It was decorated with colored marble paneling and statues of gods and heroes. Behind the audience hall was a colonnaded, peristyle courtyard, and a huge dining room, flanked by curvilinear fountains, for holding official dinners.

The residential part of the palace was notable for its three peristyle gardens, one with an elaborate curvilinear fountain. A third wing, set at a lower level, also included a peristyle with a curved end, called a *stadium* because of its shape like a racetrack. It functioned as a sunken garden. At one end was the imperial box, from which the emperor and guests could look down into a real *stadium*, or circus, the Circus Maximus, to watch chariot races.

After Domitian's death, the Senate damned his memory and ordered that his name be erased from inscriptions, his portraits pulled down, and his buildings rededicated to someone else. Even so, Domitian's palace continued to serve as the imperial residence until Constantinople became the new capital of the empire in the fourth century A.D. In the Middle Ages, the imperial palace was stripped of its lavish marble decoration, and today the remains consist mostly of brick-faced concrete substructures.

The Museum's Architectural Fragments from the Palace of Domitian

A century ago, the Museum acquired some of the architectural decoration from Domitian's palace complex. The fragments include an architrave lintel block from between two **columns**, a cornice block with dentils and egg-and-dart motifs, a fragment of a frieze depicting a sphinx, a cornice block with palmettes, and a fragment of a frieze with ox heads supporting swags. These fragments comprise different elements of the entablature that decorated the upper part of the building. They were probably painted. The decorations reflect both a Greek style of ornamentation, as in the egg-and-dart pattern, and an interest in the natural world, as seen in the multiplicity of floral and plant forms. An interest in natural forms is characteristic of architectural ornament in the late first century A.D. The high quality of the carving and the intricacy of the forms is testimony to the luxurious decoration that made the palace such an imposing monument to imperial wealth and power.

DISCUSSION QUESTIONS

• What different motifs are used in the architectural fragments from the palace of Domitian?

• What do you imagine the effect to be of a whole palace decorated in such detail?

• Why do you think the artist used stone for the decoration?

• Why do you think that Domitian was motivated to build such a spectacular residence for himself? What message do you think he was trying to convey to his subjects? Is this the message that he is just first among equals?

• On a visit to the Greek and Roman galleries of the Museum, see whether you can find similar kinds of decoration either in some of the objects or in the architecture of the Museum itself. What does this tell you about the popularity of this kind of decoration?

• Is there architectural decoration on the inside or outside of your home? What kinds of decoration do you see? What materials are these decorations made of?

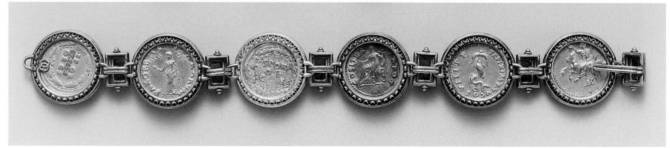

7.1–7.6 (67.265.7a–f), obverse (above), reverse (below)

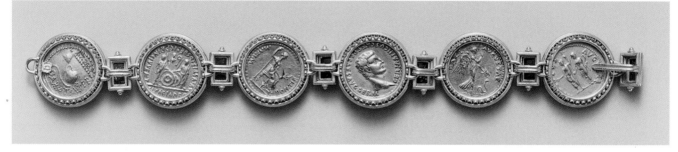

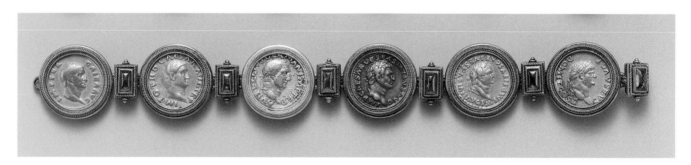

7.7–7.12 (67.265.8a–f), obverse (above), reverse (below)

7. *Aurei of the Twelve Caesars*
Roman, Early Imperial, Augustan,
1st century B.C.–1st century A.D.;
the bracelets were probably assembled
in the 19th century
Gold, amethyst
Gift of C. Ruxton Love Jr., 1967
(67.265.7a–f, .8a–f)

POINTS TO CONSIDER

+ Roman imperial coinage, dispersed throughout
the empire, bore the image of the emperor. Most
of his subjects would never see him in person, so
this is how they learned what he looked like.

+ The coins of Roman emperors were inscribed
with their names as well as faces. These firm iden-
tifications have made it possible for archaeologists
to identify unnamed sculptural portraits based on
their resemblance to a given emperor's coin type.
This is especially useful in the case of rulers for
whom few sculptural images survive.

+ The reverse of imperial coins also served their
propaganda purpose by sending a desired message
from the emperor. The reverse might picture a
favored deity, personification, or family member;
it might show an important building that the
emperor had erected or commemorate a battle he
had won; or it might advertise imperial virtues.

+ The portrait types on the coins of the Julio-
Claudian emperors all bear a strong resemblance
intended to emphasize the successors' dynas-
tic ties to Augustus. Later emperors sometimes
favored a more realistic portrait type if it suited
their propaganda purposes.

Roman Coinage as Propaganda

In addition to their value as instruments of economic
exchange within Roman imperial society, coins served
the Roman emperors as important propaganda tools.
Following the precedent set by Julius Caesar (see the
discussion under image 1), Roman emperors, beginning
with Augustus, routinely issued bronze, silver, and
gold coins with their own portraits or those of family
members on the obverse. The reverse of the coins
pictured deities or spouses; commemorated the erec-
tion of a temple or a military victory; or advertised
an emperor's virtues, such as *pietas* (piety), through
inscriptions. These coins circulated throughout the
provinces of the Roman empire and served to famil-
iarize the inhabitants with an emperor that most of
them would never see in person. They also served as
a reminder of his achievements and his power.

The Museum's Coins

The two bracelets shown here (the bindings are
modern; the coins were probably assembled piece-
meal) are composed of *aurei*, the standard Roman
gold coins. The bracelets' manufacture was probably
inspired by Suetonius' biographical work, *The Lives
of the Twelve Caesars*, since these particular coins were
produced during the dictatorship of Julius Caesar
and the reigns of the first eleven emperors of Rome.

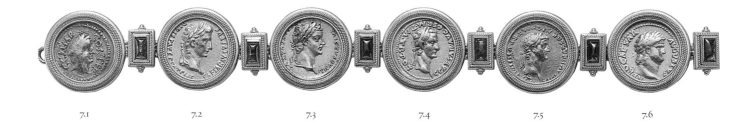

7.1 7.2 7.3 7.4 7.5 7.6

The first bracelet assembles coins minted under Julius Caesar, Augustus, Tiberius, Caligula, Claudius, and Nero. The second bracelet features coins of Galba, Otho, Vitellius, Vespasian, Titus, and Domitian. (Refer to the Timeline for their dates.) Each coin, save that of Caesar, features a portrait bust of the issuing emperor, facing to the right, on the obverse.

The Coin of Julius Caesar (image 7.1). Julius Caesar's *aureus* was minted in 44 B.C. as part of the first large gold coin series to have been issued at Rome. The obverse carries a veiled female head, probably his legendary ancestress Venus, and Caesar's name and title; the reverse carries the name of the moneyer and images of sacrificial implements.

The Coin Portrait of Augustus (image 7.2). Although Julius Caesar had issued a coin with his portrait on it in 44 B.C., it was Octavian, later Augustus, who launched portrait coinage as an effective political tool for imperial propaganda. Augustus' coin portrait shows him as youthful (just as in his sculptured portraits; see image 3) and wearing a laurel crown, associated with victory and with the god Apollo (his personal protector). The reverse, intended to commemorate Augustus' planned imperial succession, shows his grandsons, Gaius and Lucius Caesar, together with honorific shields and spears. The young princes died before Augustus did, and the succession passed to his wife Livia's son Tiberius, whom the emperor adopted.

The Coin Portrait of Tiberius (image 7.3). Tiberius' coin portrait is meant to emphasize his connection with his deified predecessor Augustus, although they were not actually related by blood. Thus he is shown with a similar hairstyle and features, though his forehead is broader. He looks youthful (although he was fifty-six when he became emperor), and he wears a laureate crown. The reverse shows a woman, probably a combination of Pax (peace) and the emperor's mother Livia, seated on an elaborate chair and holding a branch and inverted spear or scepter.

The Coin Portrait of Caligula (image 7.4). This coin shows him in laureate crown, easily identifiable as a member of the Julio-Claudian dynasty by virtue of his broad cranium, deep-set eyes, and brushed-over hairstyle. The reverse image is his father Germanicus; during Caligula's brief reign, many coin issues were struck in honor of his dead relatives.

The Coin Portrait of Claudius (image 7.5). Unlike his predecessors, the emperor Claudius adopted a coin type that showed him as middle-aged, but it also emphasized his physical resemblance to them. The reverse shows the winged goddess Nemesis (retribution) pointing a staff at a snake, a reference to an imperial military victory. This *aureus*, like those of the other Julio-Claudian emperors up to this point, was minted at Lugdunum in Gaul (modern Lyon in France), where Claudius himself was born.

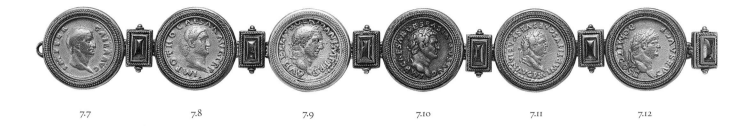

7.7　　　　　7.8　　　　　7.9　　　　　7.10　　　　　7.11　　　　　7.12

The Coin Portrait of Nero (image 7.6). After Nero's death, the Senate declared a *damnatio memoriae* (damning of memory), which led to the wholesale destruction of statues of him as well as an attempt to obliterate his name from inscriptions. Thus, few portraits survive, which makes the numismatic record even more valuable to scholars. Nero had five different coin portrait types as he aged. This issue was minted at Rome to celebrate the *decennalia,* or tenth year of his rule. The reverse shows him standing, wearing the radiate crown associated with the sun god Sol and holding a libation bowl and scepter, an overt divinizing reference at odds with the usual Julio-Claudian depiction of the emperor as just another citizen. Next to him stands the empress, holding a shallow libation bowl and cornucopia.

Coin Portraits from the Year of Four Emperors. Were it not for their coin portraits, there would be little evidence for the appearance of the next three emperors. Their brief and turbulent reigns gave little time for three-dimensional portraits to be produced. Soldiers had to be paid, though, and thus each of these short-lived emperors issued coinage. Galba (image 7.7), in his seventies when he became emperor in June of A.D. 68, ruled for only seven months. His coin type shows him as a wrinkled, tough military commander with short hair thinning at the brow. This portrait is the antithesis of the idealizing Neronian image. The reverse bears an inscription honoring his military service.

Galba's immediate successor, Otho (image 7.8), whose family came from Etruria, ruled for only three months. In his thirties, Otho was renowned for his vanity and his fastidious grooming, as well as for his lavish toupee. His idealized coin portrait lacks a laurel crown, which would have obscured the curly locks of his wig. On the reverse, a personification of Pax holds an olive branch and staff.

The next emperor, Vitellius (image 7.9), was a notorious glutton and reprobate; his coin type, with its, furrows, fat face, and double chin, reflects his coarse appetites and his middle age at the time of his short-lived accession. The reverse, like that of Galba, bears an inscription within an oak wreath.

The Coin Portrait of Vespasian (image 7.10). Vespasian, whose reign ushered in more than twenty-five years of dynastic stability, adopted a coin type that signified a return to austere Republican values. He is shown as a tough old warrior, almost bald, with a broad face and deep wrinkles, a hooked nose, and thin mouth. On the reverse, a draped seated Pax holds a branch and a winged staff, a reminder that Vespasian restored stability to Rome after a period of turmoil.

The Coin Portrait of Titus (image 7.11). Coin portraits of Vespasian's son Titus strongly resemble those of his father, although his broad face is less wrinkled, and he wears a slight beard. The reverse bears an anchor with two dolphins.

The Coin Portrait of Domitian (image 7.12). Most of Domitian's coins were issued before his accession to the throne. The Museum's *aureus*, minted in A.D. 73, shows him with a laurel crown and a beard. The reverse shows him on horseback, perhaps commemorating an *adventus*, or arrival back in Rome after a journey. Since travel was long and hard in antiquity, completion of a trip was no small matter.

Summary

Considered together, these coins help to chart the changing tastes in imperial portraiture during the first century of the empire, alternating between youthful idealization and more realistic depictions and conveying different kinds of propaganda messages to those who used the coins.

- Why do you think it was so important in the ancient world for emperors to issue coins that had their own portraits on them? Does this practice have anything in common with the way our coinage looks today?

- Look at the coins of Augustus, Tiberius, and Caligula (images 7.2–4). Do the portraits resemble each other? Why do you think this might have been the case?

- Compare the coin portrait of Vespasian with that of Augustus (images 7.10, 7.2). How do they differ?

- Look at the coins of Galba and Vitellius (images 7.7, 7.9) and compare the representation of these emperors with the image of Augustus (image 7.2). How are they different? What message do you think they might have been trying to convey?

- Why do you think it is so important to archaeologists to find imperial coins that carry both the image and the name of a given emperor?

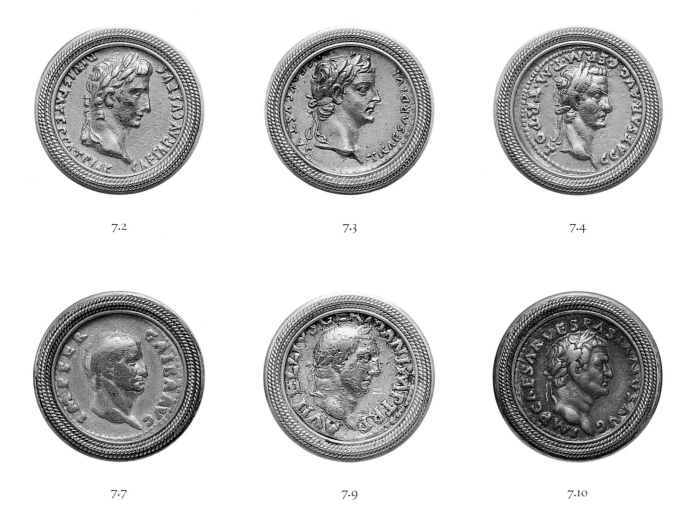

7.2 7.3 7.4

7.7 7.9 7.10

8. *Relief with the emperor Antoninus Pius and a suppliant barbarian*

Roman, Early Antonine, A.D. 138–161
Stucco; H. 8¼ in. (20.9 cm)
Rogers Fund, 1909 (09.221.37)

POINTS TO CONSIDER

- Relief sculpture on public buildings was used at Rome to depict important events, such as sacrifices to gods, victories at war, or addresses by the emperor. This type of documentation is crucial to scholars of Roman history.

- Occasionally reliefs depicting public personages and events are found in private settings. That is the case with this piece of stucco, decorated with an image of the emperor Antoninus Pius granting mercy to a captured enemy. Although the scene is allegorical, it does refer to the emperor's actual achievements in war.

The Museum's Stucco Decoration

Roman homes were often decorated with ceilings or friezes of molded or carved stucco (a form of plaster). Usually the scenes depicted Dionysian gaiety, floating nymphs, and similar lighthearted themes. This fragmentary relief is exceptional in that it shows the kind of historical scene normally found on a public triumphal monument, namely the benign emperor offering *clementia*, or mercy, to a vanquished foe.

To the right, in front of a tent, stands the emperor Antoninus Pius. (The Senate had granted Antoninus the epithet "Pius" in acknowledgment of his loyalty to his predecessor, his adoptive father Hadrian, as well as to Italy and the Senate.) The standing figure is identifiable as Antoninus by the short neat beard he wears, a style first made fashionable by his predecessor Hadrian. (Please refer to *Art of the Classical World*, no. 447, for a full-sized portrait of Antoninus Pius.) The emperor is shown wearing a short-sleeved tunic and cloak over his left shoulder. Below him kneels another bearded man, identifiable as a "barbarian" (non-Roman) by the fact that he wears trousers rather than a tunic or toga. He casts a pleading look at the emperor. A tent is visible in the background.

The troops of Antoninus Pius had put down native revolts in Germany and Dacia, and this scene probably refers to the Roman victory in one of those conflicts, even though the emperor in reality did

not physically participate in them. Thus the scene is allegorical rather than historical.

This kind of honorific scene, commemorating the achievements of the emperor, is familiar from many public monuments, notably triumphal arches and columns, in Rome and throughout the empire. Perhaps most notable is the Column of Trajan, which depicts that emperor's two wars against the Dacians (people living in what is now Romania) in hundreds of narrative scenes. (See the discussion of historical relief in the Daily Life overview.)

It is extremely rare, however, for such a subject to be depicted in a private context. We can only speculate about the reasons that such a scene decorated a

private residence, and about whether it was part of a much larger historical narrative. Just as followers of Augustus might wear a gemstone with his image on it (see the discussion under images 3 and 4), so this stucco might have graced the home of a staunch ally of the emperor, or even of a member of his family. It may have been copied from an imperial narrative monument which no longer survives.

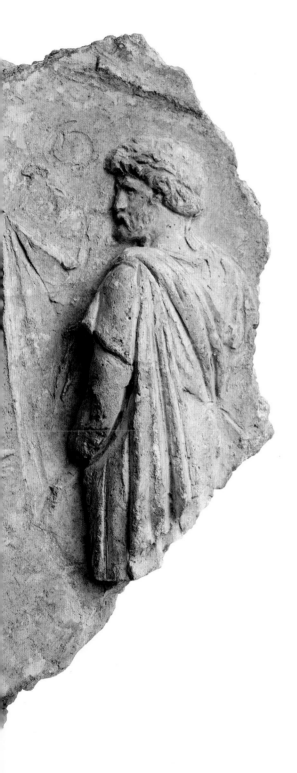

DISCUSSION QUESTIONS

• Describe the scene before you. What do the poses of the two men tell you about their relationship?

• How does the clothing worn by the two men in this relief differ?

• Why do you suppose a person would have a scene from a war as part of private interior decoration?

EXERCISE

Based on the scene before you, write a story focusing on what is happening between these two men.

Shown actual size

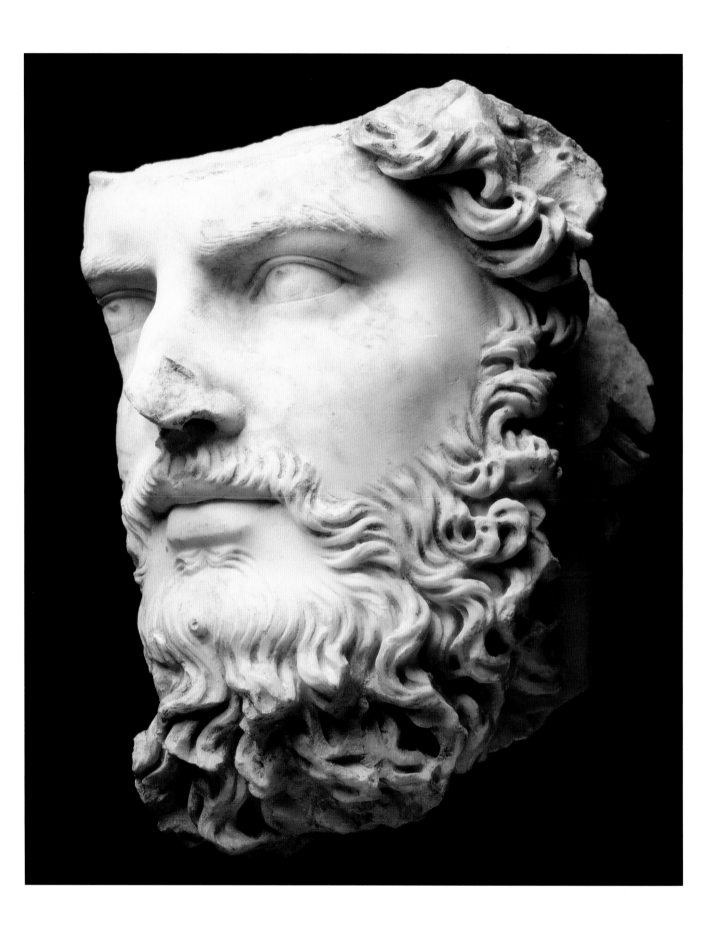

9. *Portrait of the co-emperor Lucius Verus*

Roman, Antonine, ca. A.D. 161–169

Marble; H. 14 ½ in. (36.8 cm)

Rogers Fund, 1913 (13.227.1)

POINTS TO CONSIDER

- Beginning with Hadrian in the early second century A.D., emperors began to wear beards. Hadrian made this choice to show his admiration for Greek culture, since Greek philosophers, poets, and statesmen wore beards. His successors continued the fashion as a way of expressing their dynastic continuity with the past.

- Also beginning in the second century A.D., sculptors took advantage of the longer hairstyles by increasing their use of the drill to carve deeply textured locks of hair that created a dramatic contrast with the smoothness of carved flesh. They also began the practice of incising the pupils and irises of their subjects' eyes rather than simply indicating them through paint.

- Lucius Verus and Marcus Aurelius were the first emperors to rule the Roman empire jointly. Although they were related only by marriage, both had been adopted by the emperor Antoninus Pius to serve as his successors, and their portrait types give them a physical resemblance to each other and to their adoptive father.

- Like his co-ruler Marcus, Lucius' portrait shows him with very curly hair and beard. It individualizes him, though, with hooked nose and plump lips, just as the portraits of the Julio-Claudians resembled those of Augustus and yet retained distinguishing characteristics.

- In the Antonine period, sculptors attempted to portray the psychological state of their subjects through the turn of the head, the gaze of the eyes, the set of the mouth, and other attributes meant to convey expression.

The Co-Emperor Lucius Verus

Lucius Verus was the first Roman emperor to rule jointly with another man. He and Marcus Aurelius had been adopted as heirs by Antoninus Pius, and upon the latter's death they both became emperors.

Historians have not judged Lucius Verus' competency very kindly, especially in comparison with Marcus. Lucius was neither a good administrator nor a good general, and ancient sources portray him as idling away his time in Antioch rather than actively governing.

The joint rule of Lucius and Marcus coincided with a period in which the borders of the empire began to be challenged by invaders. When the Parthians invaded the empire from the east, Lucius was put in charge of the ensuing Parthian War (A.D. 163–166), although it was in fact his generals who

waged and won the war. In A.D. 168, he and Marcus went to the Danubian provinces to prepare for an attack against German tribes that were threatening them. However, to avoid a plague that was spreading in that area, he and Marcus attempted to return to Rome early in 169. Lucius suffered a stroke and died on the journey; Marcus continued to rule as sole emperor until his death in 180.

The Museum's Portrait of Lucius Verus

The imperial fashion of wearing a beard began with the second-century A.D. emperor Hadrian, who was a great admirer of Greek culture and grew a beard in emulation of Greek philosophers, poets, and statesmen. The fashion spread, in the private sector as well as the public one, and emperors continued to wear beards, of varying lengths, until the fourth century. At the time that Lucius Verus ruled, these beards were worn quite long and full.

The wearing of beards opened new possibilities to sculptors, allowing them to contrast the texture of wavy or curly hair and beards against the smoothness of skin. They began to make increasing use of the running drill, which enabled them to carve deep channels in the marble. Starting with Hadrian, sculptors also began the practice of drilling the pupils and irises of the eyes rather than indicating them through paint. This practice would continue until the end of the empire.

Portraits of Lucius Verus resemble those of Marcus Aurelius and their adoptive father, Antoninus Pius (please refer to the portrait of Antoninus illustrated in *Art of the Classical World*, no. 447), although none of them were related by blood. This was a conscious propaganda decision to draw the link between the rulers for reasons of dynastic stability.

The Museum's fragmentary and overlifesized portrait of Lucius shows a man with an oval face, rather straight eyebrows, almond-shaped eyes, a distinctively hooked nose, and small, plump lips. He wears a luxurious mid-length beard of parallel rows of curls and a rather flamboyant mustache. The deeply drilled hair creates a dramatic contrast with the smooth flesh of his face. Lucius looks upward, giving him a rather reflective expression, in keeping with the trend in Antonine portraiture to document the psychological state as well as the physical appearance of the emperor. Based on what the ancient sources tell us about Lucius Verus, however, this expression may be part of his carefully manufactured image rather than a reflection of his real character.

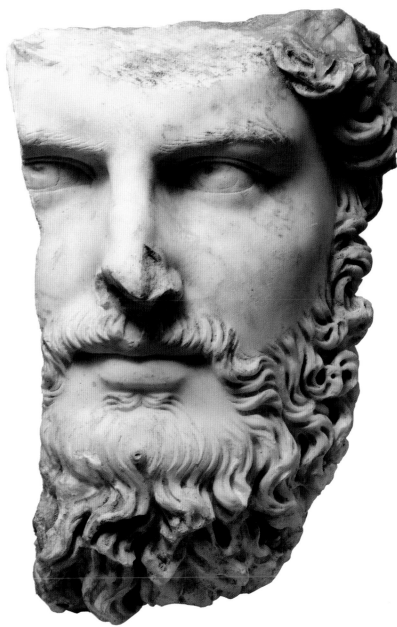

DISCUSSION QUESTIONS

• Describe the appearance of this portrait. How old do you think the subject is? What kind of nose does he have? What kind of mouth? Where is he looking? What do you think this implies about what he is thinking or doing?

• Compare this portrait with the marble portrait of Augustus (image 3). Do they resemble each other? What differences do you notice? Does one portrait appeal to you more than the other? Why or why not?

• Compare this portrait with the portrait of Antoninus Pius illustrated in *Art of the Classical World*, no. 447. What is different about the carving of their beards? Which one looks more like real hair to you?

• Ancient Greek philosophers and statesmen wore beards. Why do you think Lucius Verus wore one?

• What do beards signify in portraits today? Are hairstyles still used to convey political messages?

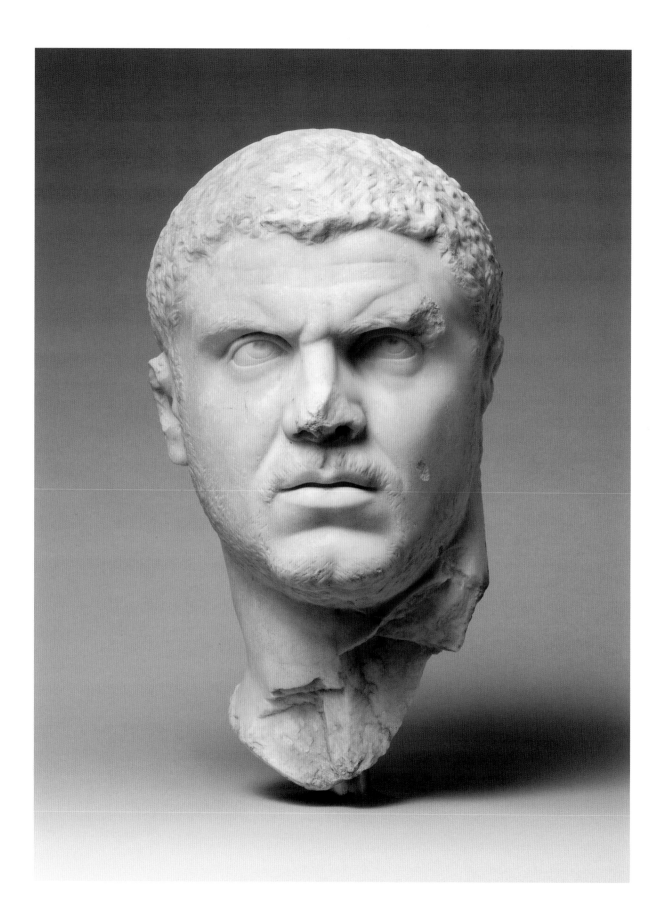

10. *Portrait of the emperor Caracalla*

Roman, Severan, ca. A.D. 212–217

Marble; H. 14¼ in. (36.2 cm)

Samuel D. Lee Fund, 1940 (40.11.1a)

11. *Portrait of the emperor Caracalla*

Roman, Severan, ca. A.D. 212–217

Bronze; H. 8½ in. (21.6 cm)

Gift of Norbert Schimmel Trust, 1989

(1989.281.80)

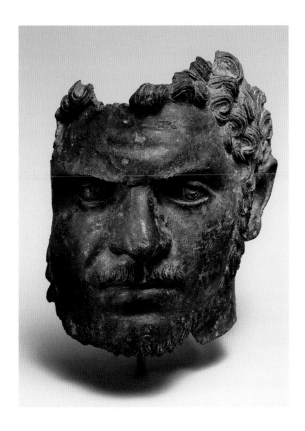

POINTS TO CONSIDER

- Roman imperial portraits were images of the ruler carefully crafted to convey a chosen message. After half a century of bearded emperors who harked back to a Hellenic model, the emperor Caracalla adopted a simple hairstyle that reflected the reality that he spent most of his reign actively at war and had no time for personal grooming.

- Caracalla's marble portrait shows a man with short-cropped hair and stubbly beard, his head turned dramatically to the left, his brow furrowed. The viewer is given the impression of a man of quick and decisive action.

- In antiquity, bronze statues were just as common as marble ones. However, because bronze was often later recycled by being melted down and reconstituted, far fewer bronze statues have survived to this day.

- Although they are based on the same imperial prototype, the two portraits of Caracalla are not identical. Different levels of workmanship may help to account for the differences.

The Emperor Caracalla

Caracalla was one of two sons of the emperor Septimius Severus, whose family was of North African origin, and of his Syrian wife Julia Domna. Severus had intended for the two brothers to rule the empire jointly. However, after Severus' death, Caracalla had his younger brother Geta slain so he could assume sole rule.

Caracalla spent much of his time on military campaigns, and he heeded his father's words to keep on good terms with the army. Perhaps his most important act was to issue the Edict of A.D. 212, which extended Roman citizenship to all free inhabitants of the empire. However, Caracalla's motive for this seemingly generous extension of Roman citizenship seems to have been not to benefit his subjects but to increase tax revenues so that he could pay the enlarged Roman army of the early third century A.D. A fervent admirer of the Hellenistic ruler Alexander the Great, Caracalla emulated him by attacking Media (in Persia), but he was murdered before he could conquer Persia.

Caracalla's most notable building project was a massive bath complex at Rome. Much of the complex is still standing, and its design inspired many post-antique architects. (For example, the domed and vaulted Great Hall of the Metropolitan Museum is based on the design of the baths.)

The Museum's Two Portraits of Caracalla

Though presented in different media, each of these portraits conveys a powerful image of the emperor. The marble head (image 10) is from a statue of which only fragments remain. The head and neck were worked for insertion into the statue body, a common practice at Rome. Not uncommonly, a portrait head would be carved from a finer quality of marble than the body, and would have been carved by the master of the workshop, while less accomplished artists did the body.

Caracalla is shown with a broad face, a cleft chin, a lined forehead, and strong nasal-labial lines. There is a V-shaped crease between his eyes as he scowls in concentration. The sharp turn of the head to the left gives the portrait an air of immediacy and is reminiscent of portraits of Alexander the Great, to whom he wished to compare himself. In his portrait type, Caracalla discarded the long beard and deeply curled locks that had been in fashion among the previous emperors and is instead shown with close-cropped hair and beard. This was thought to be the style of grooming characteristic of an emperor/ military commander who did not have too much time to worry about his hair or beard. The artist has achieved the intended effects of the closely cropped hair and beard by stippling a chisel across the surface of the stone, so that the hair is incised rather than modeled. This technique is called negative carving. Overall, this forceful presentation is meant to show Caracalla as an energetic military leader. The emperor's portrait also projects an image of ferocity, and in fact that seems to be an accurate reflection of this fratricide's personality.

The Museum's fragmentary bronze portrait of Caracalla (image 11), part of a hollow-cast bust or statue, is one of a series said to have been found in a temple of the imperial cult in Asia Minor. Although far fewer bronze statues survive today, in antiquity they were just as common as marble ones. This head presents the emperor looking straight ahead with an intense stare and furrowed brows; he seems lost in thought rather than actively engaged with the world. The treatment of the hair differs somewhat from that of the marble head. Here he is shown with curls modeled in relief and with sideburns leading to a somewhat longer beard. This head lacks the

dynamism and coiled energy projected by the marble head, a reminder that even in imperial portraiture the quality of production might vary.

Despite his reputation for ferocity, in many ways Caracalla set the iconographic style for his imperial successors during the third century A.D. After A.D. 235, when the Roman empire was subject to unprecedented and sustained invasions by German "barbarians" and the Sasanian Persians, the Roman emperors who eventually drove the Germans and the Persians back across the empire's borders also liked to represent themselves as dutiful, hardworking soldiers.

DISCUSSION QUESTIONS

• Compare the Museum's two portrait images of Caracalla. What similarities do they have? What differences? Do you think they represent the same person? Why or why not? How do you account for the differences between them?

• Does Caracalla look like a sympathetic person? Why or why not?

• Describe the way the artist has carved hair on the marble portrait (image 10). Then describe the appearance of the hair in the bronze portrait (image 11). Which do you think looks more realistic? Why or why not?

• What image do you think the emperor is trying to project in these portraits? How does the presentation compare with that of the overlifesized head of Augustus (image 3)?

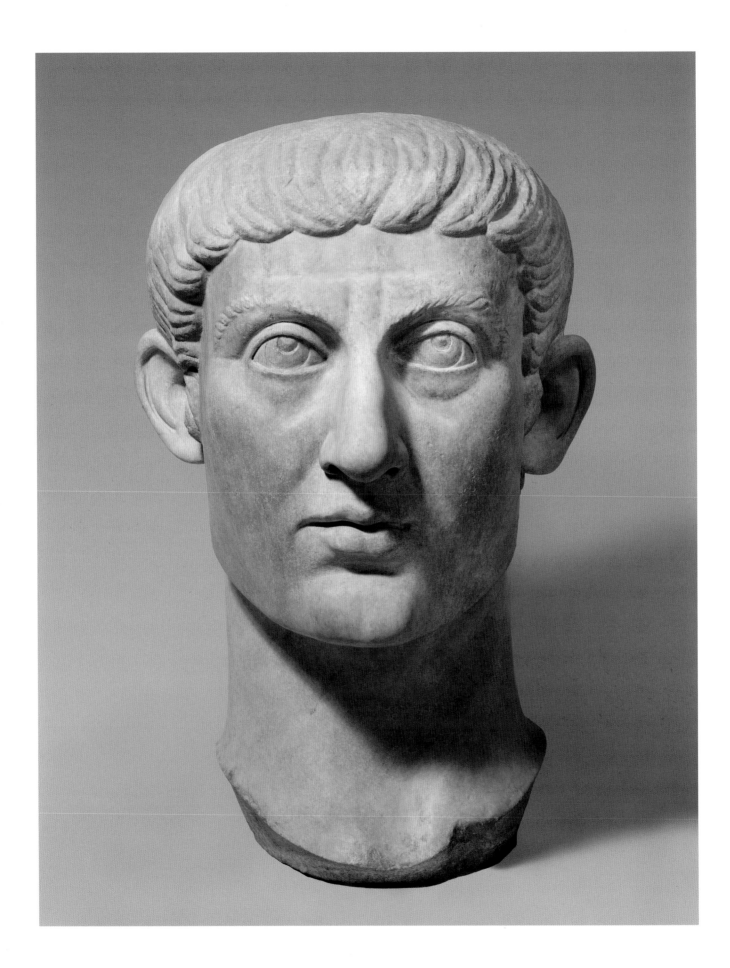

Roman, Late Imperial, ca. A.D. 325–370
Marble; H. 37 ½ in. (95.25 cm)
Bequest of Mary Clark Thompson, 1923
(26.229)

POINTS TO CONSIDER

- The emperor Constantine came to power as a tetrarch, one of four rulers of an empire that had been divided into pieces. He systematically moved to consolidate power and gradually eliminated his co-rulers, becoming sole emperor in A.D. 324.

- Constantine later claimed that he had achieved a key victory in his struggle for power after he had seen the image of a cross in the sky. Accordingly, in 313 he and his then-co-ruler issued the Edict of Milan, which granted religious freedom to Christians. Although Constantine was not baptized until he lay dying, he used his power and resources to support Christianity throughout the empire. He also created a "New Rome," Constantinople, to be the capital of the empire, and sanctioned the building of the first overt churches in Rome and the Holy Land.

- The portrait type of Constantine, the first Roman ruler officially to tolerate Christianity, was intended to remind viewers of the earlier emperors Augustus and Trajan and, by analogy, of their successful reigns. Constantine's clean-shaven portrait type, with bangs brushed over his forehead and an unlined face, bore a marked resemblance to those of his deified predecessors.

- However, Constantine's portrait type differs in important ways from those of his models. The huge, upward-looking eyes and the extreme simplification of the facial planes give the portrait an abstract and detached quality that represents not so much a specific or even idealized individual but a sense of power bolstered by a spiritual vision.

Constantine and the Official Adoption of Christianity at Rome

Constantine, the son of one of Diocletian's tetrarchic colleagues, rose to power within the tetrarchic system of government (see the Historical Overview). Constantine eventually sought sole power, however, and one by one he defeated the other tetrarchs in battle. He defeated one of his rivals, Maxentius, at the Battle of the Milvian Bridge in Rome in A.D. 312. Later he would claim that he had seen an image of a cross in the sky, accompanied by the inscription "In this sign you shall conquer." As a result, the following year Constantine and his then co-ruler Licinius issued what became known as the Edict of Milan, granting religious freedom to Christians. After more dynastic struggles, Constantine took sole imperial authority in A.D. 324. After that date, although Constantine was not baptized until he lay on his deathbed, he progres-

sively threw the full power, prestige, and resources of his position behind Christianity. In addition, he created a "New Rome," Constantinople, on the site of the former Greek city of Byzantium (now Istanbul). The new foundation was inaugurated using both pagan and Christian rites. From now on the Roman emperors lived here rather than in Rome.

A New Portrait Type for a New Empire

During the period of time that Constantine was a tetrarch, his coin portraits depict him with the stubbly beard and blocklike body that characterized the iconography of official tetrarchic art.

Following Constantine's consolidation of power, however, his portrait style changed, and he adopted a mode of self-presentation that evoked comparison with his most esteemed predecessors, Augustus and Trajan. This portrait type is evoked by the Museum's portrait of Constantine.

This head was probably recut from an earlier portrait of Trajan. The practice of "recycling" sculpture or architectural elements was not uncommon, especially in late antiquity, both for reasons of economy and as a way of reflecting glory on the present emperor by connecting his reign with those of his most illustrious predecessors. For example, the **Arch** of Constantine in the Roman Forum is decorated with reliefs that originally had been part of monuments to Trajan, Hadrian, and Marcus Aurelius. The imperial heads on some of these reliefs have been recarved to more closely resemble Constantine.

The Museum's head is impressively large, and the neck is worked for insertion into a seated statue body, not otherwise preserved. Such a colossal scale was reserved only for images of gods or imperial family members. The emperor is shown with a square face, prominent nose and chin, and a small mouth with

lips slightly parted. There is a large horizontal crease in his forehead, but otherwise his face is unlined, and the expression is calm, in line with the classicizing tendencies of official Augustan and Trajanic portraiture. The eyes are incised so that the pupils look upward. Whereas third-century A.D. emperors usually had been depicted with short hair and beards (see the portraits of Caracalla, images 10, 11), Constantine is shown clean-shaven, with locks of hair carefully combed over the forehead, a fashion similar to hairstyles worn by the Julio-Claudians and Trajan.

Like Augustus, Constantine's portrait did not age as he did. And, just as Augustus' Julio-Claudian successors did, Constantine's successors would adopt portrait images that strongly echoed his in appearance.

However, Constantine's portrait image differs significantly from those of earlier emperors in the degree of abstraction of both form and content. Whereas portraits of both Augustus and Trajan show them with some individualized features, in Constantine's case the facial planes are smooth and undifferentiated, the features almost schematic. The emperor, with his overlarge eyes directed upward, seems connected not to a material world but a spiritual one.

The head and fragmentary limbs of a much larger colossal statue of Constantine survive at Rome and are displayed in the courtyard of the Museo del Palazzo dei Conservatori. The absence of the torso suggests that the body and drapery were worked in another medium and that the marble limbs and heads, their creamy white hue suggesting human flesh, were inserted into them. The statue originally portrayed Constantine seated and holding in one hand an orb, the symbol of global power, and in the other hand a scepter. Such overtly monarchical imagery is quite at odds with the image that Augustus and his successors had tried to convey. The Rome statue probably once stood in the main hall of the Basilica of Maxentius,

an audience hall in the Roman Forum that was fin-
ished by Constantine. The Museum's statue probably
comes from a similar setting.

The dramatic change in Constantine's portrait
style from his early career to the time period when
he embraced Christianity reflects far broader changes
within the Roman world: the detachment of the state
from its Augustan and even Republican institutional
roots; a shift in the center of imperial gravity from
Rome to Constantinople and the East; and, finally,
the supercession of polytheism by Christianity as
the dominant system of religious belief within the
Roman empire. Constantine's portrait style is that of
a man who not only had the vision but also the power
to bring about a revolution within the Roman world.

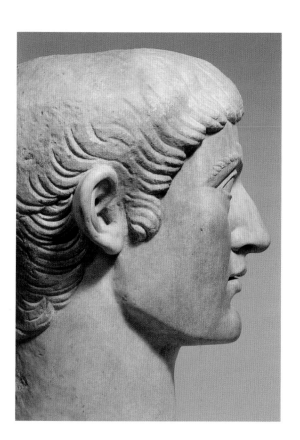

• Study the Museum's portrait of Constantine.
Which of his features do you notice first? What
expression does he wear? Is he looking at us, the
viewers? Why do you think he looks where he
does?

• Do you think that the artist was looking at a real
man when he made this portrait? Why or why not?

• What details make this a less-than-naturalistic
portrait? What qualities do you think the emper-
or wished to convey?

• Compare this image with the colossal portrait of
Augustus (image 3). How are they similar? How
are they different? Which is more lifelike?

• What effect on you, the viewer, does the large
scale of Constantine's portrait have? Do you
think this was intentional?

• Compare this portrait with any or all of the other
portraits that are pictured in this resource. Discuss
the similarities and differences among them.

EXERCISE

Based on his portrait type, write a biography
of each of the men whose portraits are in the
resource. Describe what you imagine each
emperor's personality to be like.

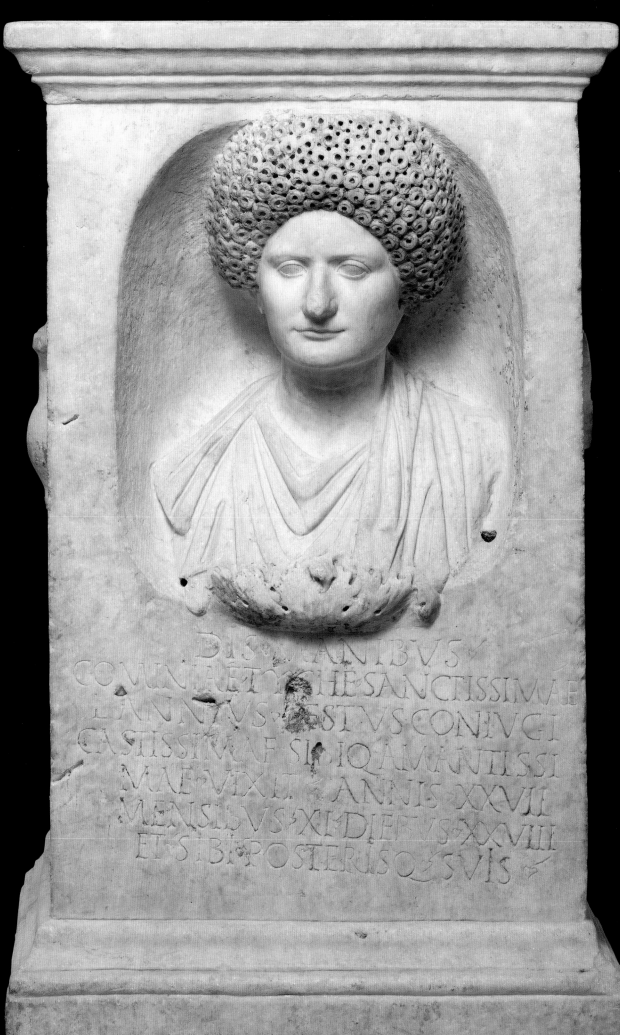

DIS MANIBVS
COMIN AE TYCHE SANCTISSIMAE
IANNIVS FESTVS CONIVGI
CASTISSIMAE SIBIQ AMANTISSI
MAE VIXIT ANNIS XXVII
MENSIBVS XI DIERVS XXVIII
ET SIBI POSTERISQ SVIS

ROMAN MYTH, RELIGION, AND THE AFTERLIFE

Religion and Communal Ritual in Ancient Rome

*T*he Latin word *religio*, which is often translated as our word "religion," really meant the proper performance of what was due to the gods. What was due was justice. Justice was done through the correct performance of rituals, including especially sacrifices, to the many deities that the Romans believed to exist. Ritual was also used to understand the will of the gods, to propitiate them, or to solicit their help.

As long as they observed the proper rituals, individual Romans could believe whatever they wanted to about the gods. Within Roman *religio*, there was no dogma, no moral code, no orthodoxy. It was perhaps for that reason that the Romans were so open to the incorporation of new deities within their system of ritual observance.

Nor was there only one fixed religious authority in Rome. Rather, responsibility for giving justice to the gods was shared among individuals on behalf of the Roman people. Finally, the goal of making sure that the gods received justice was the well-being of the entire community, rather than of individuals. In short, Roman *religio* was a form of civic religion in which the salvation of individuals, especially after death, was not as important as the health and prosperity of the community of Roman citizens in the present.

Over the course of the Roman Republic and empire, the Romans exported their ritual observances to other peoples, but also imported the beliefs and ritual practices of those they encountered into their system of observances. Indeed, one of the sets of beliefs and practices that the Romans encountered, Christianity, finally became the official religion of the Roman state itself during the late fourth century A.D. In many ways, the triumph of Christianity within the Roman empire was the direct outcome of the Romans' essential receptivity to new gods and systems.

Relief fragment with the head of Mars.
Roman, Mid-Imperial, early
3rd century A.D. Marble. Rogers
Fund, 1918 (18.145.49) (image 16)

Plaque with Mithras slaying the bull.
Roman, Antonine or Severan,
mid-2nd–early 3rd century A.D.
Bronze. Gift of Mr. and Mrs.
Klaus G. Perls, 1997 (1997.145.3)
(image 22)

The Gods of the Romans

Like the Greeks, the Romans recognized many gods. Each deity had his
or her own particular functions and areas of influence, although none was
all-powerful or could do everything. Mercury, for instance, was a patron
of merchants, and Mars was the supporter of the army, but neither was
much help with people's love lives.

The Roman gods included a mixture of native Italic, Etruscan, and
Greek deities. For example, the twelve Olympian gods of the Greeks all
had Roman cognates:

Greek ⟶	*Roman*
ZEUS	JUPITER
HERA	JUNO
ATHENA	MINERVA
ARTEMIS	DIANA
APOLLO	APOLLO
ARES	MARS
POSEIDON	NEPTUNE
HERMES	MERCURY
DEMETER	CERES
DIONYSOS	DIONYSUS/BACCHUS
HEPHAESTOS	VULCAN

Other gods, including Cybele, Mithras, and Isis, were imported into
Rome from the East, including Asia Minor and Egypt. Please refer to
images 15–17, 21, 22, and 25 for detailed discussions of various deities.

Men Becoming Gods

After the assassination of Julius Caesar in March of 44 B.C., the Romans began to elevate some imperial family members to the status of demigods after their deaths. Such demigods were called *divi* or *divae* and were assigned temples, priests, festivals, and public cults. In fact, in the cities and provinces of the Roman empire, cults for the emperors and their family members were organized as a way of defining the power of the emperors. Please refer to image 4 in the Power and Authority section for a posthumous portrait of an emperor shown with divine attributes.

Divination, the Sibylline Books, and Entrails

Perhaps the most characteristic way the Romans approached their gods to discover their will was the interpretation of natural signs through divination. Divination also took place during sacrifices through the reading of the *exta* (entrails) by an official called a *haruspex*.

When alarming events occurred, the Romans also consulted the so-called Sibylline books, which consisted of a thousand or so lines of ancient prophetic poetry. The poetry supposedly provided the explanation for such events and also advice about how to restore the situation.

The Essential Roman Ritual: Sacrifice

The fundamental act by which the Romans did justice to their gods was sacrifice. Sacrifice could take many forms: it might involve the burning of incense; or pouring a liquid; or the dedication of various kinds of plants; or the ritual slaughter of domestic animals such as cattle, pigs, sheep, and goats. Please refer to image 19 for more information about the practice of sacrifice.

Priests

Unlike, for example, modern Christian priests or nuns, Roman priests were not in general men or women called to the lifelong service of a deity or deities. The Vestal Virgins were exceptional, as these were priestesses with a minimum length of service of thirty years. Most Roman priests were simply Roman citizens elected by their peers or by the Roman people, for terms as short as a year, to perform specific cultic functions at specific times and places for specific reasons. When they were not performing such functions, they had no special quality of holiness. They did not advise people on how to live; rather, they were charged with ensuring that rituals were enacted properly. Women were not excluded from participating in religious life, but they could not officiate in cults for the Roman people as a whole, or for their families.

Public priests belonged to the priestly colleges, but there were also priests of individual deities and Latin communities. By the end of the Republic, all of the major Roman priests were senators and about half were patricians, although at least some of the members of the main colleges were elected by the Roman assembly of tribes.

After the conclusion of the Roman civil wars, Octavian (later Augustus) received the right to nominate candidates for all vacant priestly posts. Eventually the Roman emperors became members of all of the priestly colleges simultaneously. The consolidation of religious authority into one person (the emperor) was a sign of the transition to a society in which power and authority were increasingly centralized.

Please refer to image 20 for an example of a priestly attendant.

Sacred Space

The Romans believed that the gods and men had divided up the spaces of Rome and its territory into precincts that were sacred and those that were not. The gods often selected groves, caves, pools, or river sources as their own residences. Other sacred areas were dedicated to the gods by men. Such spaces had to be legally consecrated, which transferred them from public property to the possession of the gods. Within such sacred space there might be erected an altar and/or a temple belonging to the god(s). Such a building was considered to be the residence of the divinity.

Many sacred spaces included areas where worshippers could leave offerings, which might include small altars or even statues. Some sanctuaries included places where visitors could stay the night, prepare food for themselves, and bathe.

Tombs for the dead were situated outside the city itself and belonged to the *di manes* (divine sprits of the dead). It was the responsibility of family relations of the dead to manage such tombs, and the tombs could not be altered without permission from officials.

Festivals

In the Roman world, there were essentially two calendars in overlapping operation. There was a natural calendar, established according to the rising and setting of the signs of the zodiac, that determined the sequence of agricultural labor; and there was a civic calendar created by the magistrates.

The Roman calendar did not operate on a fixed week of seven days with five working days and a weekend. Rather, the ancient Romans divided up the days of the civic year into three categories. Two hundred thirty-five days were designated as *fasti*, when public business such as the meeting of public assemblies could take place; 109 days were *nefasti*, during which the activities of mortals in public places had to stop to make room for the performance of religious ceremonies that honored the gods. The 109 *nefasti* are roughly equivalent to the 104 days a year that are Saturdays and Sundays in our modern calendar. *Intercisi* days, or half-and-half days, were those when some hours of the day were set aside for public business and some hours for honoring the gods.

It was during the *nefasti* days that most of the major public Roman festivals took place. These included agricultural festivals that celebrated either the beginning or the conclusion of the cycle of food supply, and civic festivals that celebrated important aspects of the political or military organization of the city. It was not a duty but a right of Roman citizens to attend or take part in these major public festivals.

In addition to the public festivals linked either to the agricultural or civic year, Romans also celebrated innumerable private festivals and rites. Roman magistrates, families, the army, colleges of merchants and artisans, and many other associations conducted sacrifices and festivals to honor the gods throughout the year. The celebration of such private festivals was open to citizens and noncitizens alike.

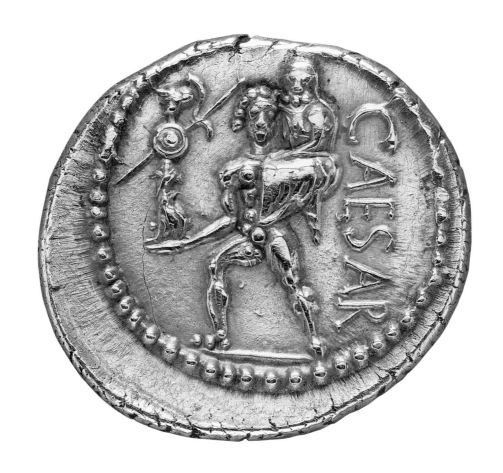

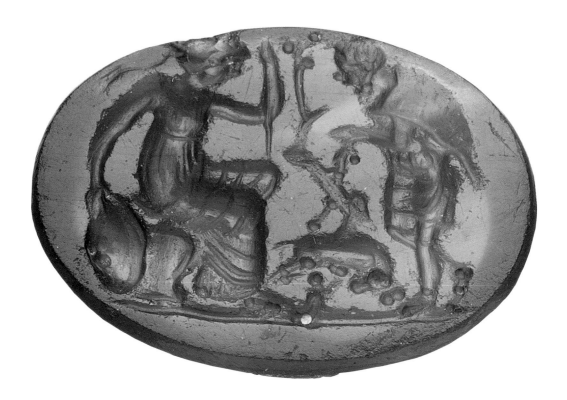

13. *Denarius minted under Julius Caesar, showing Aeneas carrying Anchises and the Palladium*
Roman, Late Republican, 47–46 B.C.
Silver; overall: ¾ x ⅛ in. (1.9 x 0.3 cm)
Rogers Fund, 1908 (08.170.80)

14. *Intaglio ring-stone showing Romulus and Remus suckled by the she-wolf*
Roman, Late Republican or Early Imperial, 1st century B.C.–1st century A.D.
Carnelian; ½ in. (1.3 cm)
Gift of John Taylor Johnston, 1881 (81.6.33)

POINTS TO CONSIDER

• The Romans possessed a great historical self-consciousness. The stories that explained their origins as a people and the foundation of their city were very important to them and were regarded as historical fact.

• The stories of the origin of Rome were reproduced on coins and dispersed throughout the empire to emphasize the historical roots of the Romans. Such images were also reproduced on ring-stones, used by their owners to seal important documents.

• The story of Aeneas cemented the Roman connection with the great civilizations of Troy and Greece and with the goddess Venus, the hero's mother. Julius Caesar presented himself as the descendant of Aeneas and thus of the goddess Venus, as did his adopted heir, the first emperor, Augustus.

• The story of the she-wolf and the twins Romulus and Remus helped to explain the origins of Rome on the Palatine Hill. As descendants of Aeneas, son of Venus, the twins carried a divine genealogy closer to the historic Romans.

Foundation Myths of Ancient Rome

These two objects portray scenes related to the foundation of Rome. While we might consider these scenes to be mythological, the ancient Romans believed that the foundation of their city was a real historical event.

The Myth of Aeneas

Aeneas first appeared in the *Iliad*, the epic poem attributed to the eighth-century B.C. Greek poet Homer, as a Trojan warrior, the son of Aphrodite (the Roman Venus), notable for his piety to the gods. The scene of Aeneas escaping from Troy after its destruction about 1200 B.C. appears in Greek vase paintings from the sixth century B.C. onward, and by the fourth century B.C. it had begun to appear in Italic art as well. In the *Aeneid*, the epic poem by the first-century B.C. Roman poet Virgil, Aeneas eventually made his way to Italy, where he founded the city of Lavinium. Hundreds of years later, in 753 B.C., Aeneas' descendant Romulus founded the city of Rome.

Roman Coinage of the Republic

Roman coins of the Republican period were struck with symbolic designs that ranged from personifications of cities and virtues, mythological scenes and figures, to various images that held special significance for the issuer. In the second century B.C., moneyers began to imprint their names on their coins, perhaps as a mark of authenticity, and eventually they struck issues commemorating their notable ancestors. By the mid-first century B.C., portrait heads were depicted on coins, although these images were restricted to depictions of famous ancestors and legendary figures.

The Coinage of Julius Caesar

When Julius Caesar crossed the River Rubicon in 49 B.C. to vindicate the rights of Roman tribunes, he also began to strike enormous amounts of his own coinage, in opposition to that of the state. The issuance of his own coins was an announcement that Caesar presented himself as an authority independent of and parallel to the state. He seized Rome shortly after crossing the Rubicon and began to use its moneyers to issue his coins, creating a parallel fiscal structure to that of the state.

The Museum's silver *denarius* (image 13), the dominant coin denomination in circulation in the Mediterranean world in this period, comes from a series issued by Caesar in the early 40s B.C. The coin represents one of the legendary ancestors of the Roman state, the Trojan warrior Aeneas, fleeing the burning city of Troy. He carries his father Anchises on his shoulder and the palladium, a wooden statue of the armed goddess Athena, in his outstretched hand. A crowned head of Aphrodite/Venus, Aeneas' divine mother, appears on the reverse.

Caesar's family, the *gens Iuliae*, claimed descent from the goddess Venus and her son Aeneas. By representing Venus and Aeneas on his coinage, Caesar reminded the Roman public of his divine ancestry and his association with the foundation legends of Rome. This helped to legitimate his power at Rome.

The Myth of Romulus, Remus, and the She-Wolf

The carnelian ring-stone (image 14), probably used as a seal, features one of the most famous scenes from the complex foundation story of Rome. At least by the fourth century B.C., the story of how Aeneas' descendants, the infant twins Romulus and Remus, had been saved from death by a she-wolf was known in Rome. According to that story, the baby twins were set adrift on the Tiber River by their uncle, who had usurped power from their grandfather in the town of Alba Longa. The infants drifted ashore and were found by a she-wolf, who suckled them until a royal herdsman found them and raised them. After they grew up, they slew the usurper and restored their grandfather to the throne. The twins then returned to the place on the Tiber where they had been saved. Accounts of what transpired next differ, but Remus was slain and it was Romulus who ultimately established the sacred boundary of the city of Rome.

The story of the twins and the she-wolf was so popular in Republican Rome that it became one of the most important symbols of the city. A bronze statue of the she-wolf suckling the twins is known to have been dedicated at Rome as early as 296 B.C., and the scene was represented on coins throughout the Republican and Imperial periods.

Sealing ring-stones, though made for private use, draw from the same sources of imagery as coins. This ring-stone, one of several in the Museum representing aspects of the wolf suckling the twins,

shows them flanked by the shepherd who reared them and by the armed goddess Roma, the personification of the city itself.

- Look at the coin image. How many figures are there? What is each doing? Can you tell who is the most important figure? How?

- The coin shows a scene related to the foundation of Rome, a story that we today believe is mythical but which the ancient Romans believed to be fact. Why do you think such a scene would be appropriate to put on a coin issued at the city of Rome?

- What kinds of objects are represented on the coins that we use in daily life? Why do you think these images were chosen? How are they similar to, or different from, those that we see on the Roman coin?

- Look closely at the ring-stone and describe the figures and what they are doing. Is this a realistic scene?

- This ring refers to ancestors of the Romans. Do you ever wear jewelry with references to your family on it, such as a ring with a monogram of your family name? If you do, does it remind you of your family, as the Roman ring would have reminded the wearer of his?

- Why do you think a Roman ring would have a myth represented on it? Do some of the rings we wear have symbolic meaning too?

- Do we have myths about our own American history? Think of George Washington and the cherry tree. Can you think of some others?

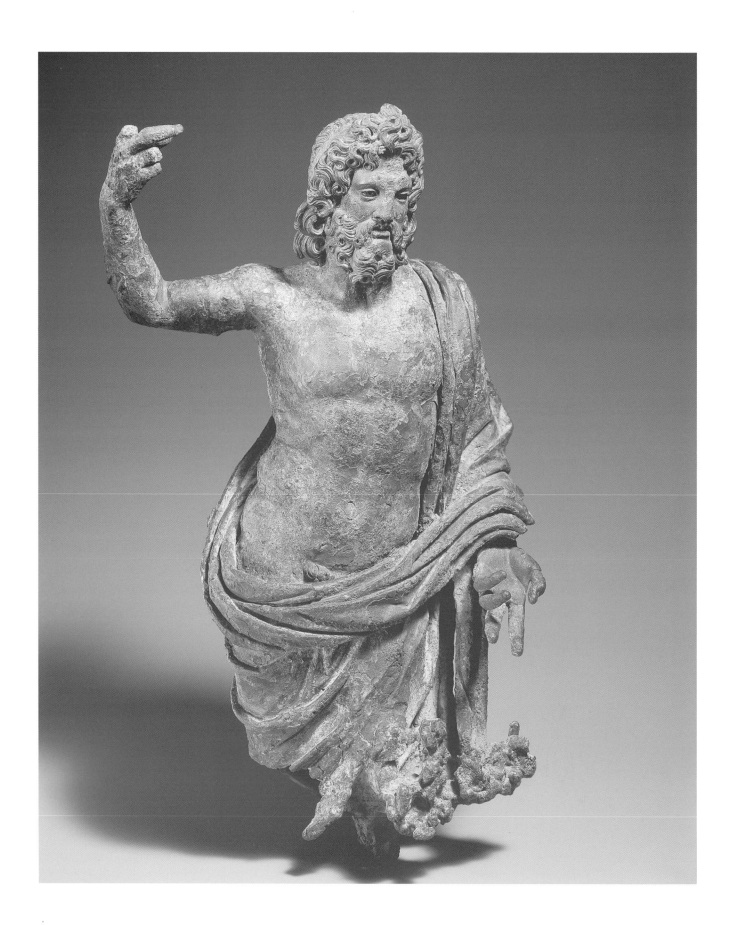

15. *Statuette of Jupiter*

Roman, Mid-Imperial, 2nd half
of 2nd century A.D.
Bronze; H. 11⁹⁄₁₆ in. (29.3 cm)
Purchase, The Charles Engelhard
Foundation Gift and Rogers Fund, 1997
(1997.159)

POINTS TO CONSIDER

- The most important god in the Roman pantheon was Jupiter Optimus Maximus, the best and greatest of all. As the god of power and authority, he occupied the most important temple in Rome, the Capitolium on top of the Capitoline Hill, which he shared with his wife Juno and with the goddess of wisdom, Minerva.

- The Romans represented Jupiter as the Greeks did their comparable god Zeus: as a mature, bearded man, often carrying a scepter and a thunderbolt and accompanied by an eagle.

- As the Greeks had done, the Romans placed cult statues of their deities inside their temples. Worshippers might also keep images of the god in their homes for private devotion, or make offerings of these statues to the god himself.

Jupiter, Ruler of the Gods

Jupiter was the sovereign god in the Roman pantheon. His power and authority were expressed and articulated through natural phenomena such as storms and lightning. Before the Romans took any important public action, such as declaring war, they consulted auspices (signs such as thunder and lightning) to determine his will. Generals departing for war visited his temple to make vows for victory; and they ascended to his temple upon their triumphs. Jupiter was the patron of the state, and bore the epithet (nickname) *optimus maximus* (the best and greatest of all). The games that were celebrated in his honor every year were among the major festivals of the Roman state, and his temple was the most important in Rome.

Jupiter's Temple at Rome

According to tradition, it was the Etruscan kings who introduced the cult of Jupiter Optimus Maximus to Rome. A temple was built to him and to the goddesses Juno and Minerva on the Capitoline Hill in 509 B.C. It was built in the Etruscan style, with a high podium, a deep-pitched roof, and three *cellae*, or interior chambers, one for the cult statue of

each of the deities. It was much larger than any other temple at Rome, and its form was duplicated later in other Roman cities all over the empire. It became a *de facto* symbol of Rome and was often illustrated on coins. Parts of the foundation and the podium survive to this day.

The Representation of Jupiter

Jupiter was traditionally represented as a bearded, powerfully mature man, whose associated attributes included the eagle, the scepter, and the thunderbolt (from his association with the sky). In imperial times, rulers often represented themselves with these attributes of Jupiter.

The Museum's bronze statuette of Jupiter preserves about three-quarters of the original, from the head down to about thigh level, where the figure has been fused, apparently by an intense heat. The pose, with raised right hip, suggests that he was putting his weight on his left leg. He wears only a mantle that is draped over his left shoulder, down his back, around his right hip, and over the outstretched left arm. Originally he probably held a thunderbolt in this hand. His raised right arm is held up; it probably once held a scepter. His head, with its abundant curly hair and full beard, turns slightly to the left. The muscular body, the forceful pose, and the mature face all mark this as an image of a powerful being. The Museum's statuette may have been a private cult image, or it may have been a votive offering.

For another representation of Jupiter, please refer to the fragment of a cameo with Jupiter astride an eagle, illustrated in *Art of the Classical World*, no. 418.

Shown actual size

DISCUSSION QUESTIONS

- Look carefully at the statue and describe the way the figure stands and what he is holding. Does he look young or mature? Why?

- In fact, this is a representation of Jupiter, king of the Roman gods. What about this sculpture suggests that it represents a powerful being?

- Many of the gods worshipped by the Romans were associated with Greek gods. Does this statue remind you of any Greek god you may have studied? Which one? What are his characteristics?

- Where do you think an image like this one might have been placed? How do you think it might have been used?

16. *Relief fragment with the head of Mars*

Roman, Mid-Imperial, early 3rd century A.D.

Marble; H. 14⅞ in. (37.8 cm)

Rogers Fund, 1918 (18.145.49)

POINTS TO CONSIDER

- Mars was the second most important Roman god after Jupiter. This is not surprising since he was the god of war, and war is what brought Rome her empire.

- Early in Roman history, the mythology of the Greek god Ares was assimilated with that of Mars.

- The important festivals associated with Mars were held at the times of year that marked the beginning and end of the traditional military campaigning season.

- The first emperor, Augustus, elevated Mars to a new importance as Mars Ultor, who had helped him to avenge the death of Augustus' adopted father Julius Caesar. A temple to Mars was erected in the Forum of Augustus, and Mars Ultor frequently appeared in the relief decoration of triumphal arches and other monuments that commemorated imperial military successes.

- As a war god, Mars was typically shown wearing armor and a helmet.

Mars, the God of War

Next to Jupiter, Mars was the most important Roman god, and a very ancient one. Not much is known of his original character, but he was sometimes interpreted as a god of vegetation. By historical times, he had developed into the god of war, with a mythology borrowed largely from the Greek Ares. In literature, he was portrayed as the protector of Rome.

The Romans named the month we call March after him, and festivals were celebrated in his honor in that month as well as in October. These months marked the beginning and end of the farming season and also the end and the beginning of the military campaigning seasons, since Rome's citizen army could only campaign when its soldiers were not busy growing food. The ceremonies were linked to preparations for war. In March, members of the priesthood of the Salii, who were associated with Jupiter, Mars, and Quirinus, performed a ceremonial war dance in their old-fashioned armor while chanting a hymn to the gods. Two other festivals were held in October, one involving a two-horse chariot race and the other the purification of weapons before they were stored for the winter.

There were only two temples to Mars in Rome until the time of Augustus, one of them in the

Campus Martius, or "field of war," which was the army's exercise ground. There was also a shrine in the *Regia*, originally the king's house, where the god's sacred spears were kept (in fact, these spears may have been the earliest embodied form of the god). Before embarking upon a campaign, a general was supposed to shake these sacred spears and say *"Mars vigila!"* ("Mars, wake up!").

In the Imperial period, worship of Mars was almost as important as that of the Capitoline Jupiter, since the emperor owed his power and popularity to the army and its military success. Under Augustus, Mars was given a new epithet, Ultor (the Avenger), as the personal guardian of the emperor and the avenger of Caesar's death. Augustus consecrated a temple containing a colossal statue of Mars Ultor in his forum, and this statue was frequently copied thereafter. Temples, shrines, and altars were dedicated to Mars all over the empire.

Many of the public monuments erected at Rome, especially the uniquely Roman triumphal arches, commemorated military victories. Mars was frequently depicted on these monuments.

The Museum's Relief Head of Mars

The Museum's fragmentary relief head of Mars represents the canonical sculptural type of Mars Ultor. It probably comes from a triumphal arch or from a similar monument commemorating an imperial military success, possibly from the now-lost Portico of Septimius Severus in Rome.

Here the god is shown as a mature figure with curly hair and beard and a deeply furrowed brow and forehead. His mouth is open, and a prominent mustache droops over it. His eyes are heavily lidded, and he looks up and to his left. The pupils are carved in the typical style of the period, with two drill holes beside each other forming a sort of kidney-bean shape. His hair is also deeply drilled. Appropriately for a war deity, he wears a helmet of the Corinthian type pushed back on his forehead. The pose is very similar to a representation on an Antonine-era panel that showed the emperor's return and that was later incorporated into the Arch of Constantine in the Roman Forum. The god's expression is a rather menacing one of focused alertness.

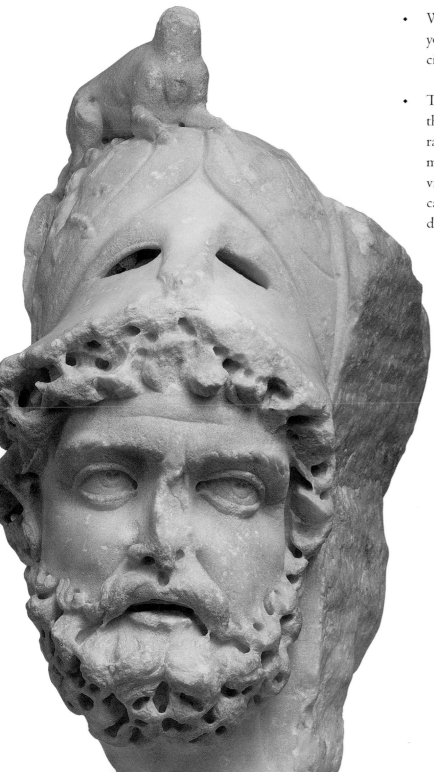

DISCUSSION QUESTIONS

♦ Describe the appearance of Mars. Why is he depicted the way he is? What is his expression?

♦ What are the aspects of this sculpture that help you to identify what function this god was associated with?

♦ This head probably came from a relief sculpture that decorated a Roman monument commemorating an imperial victory. Have you ever seen monuments commemorating American military victories—in Washington, D.C., in your state capital, in parks that you have visited? If so, describe them.

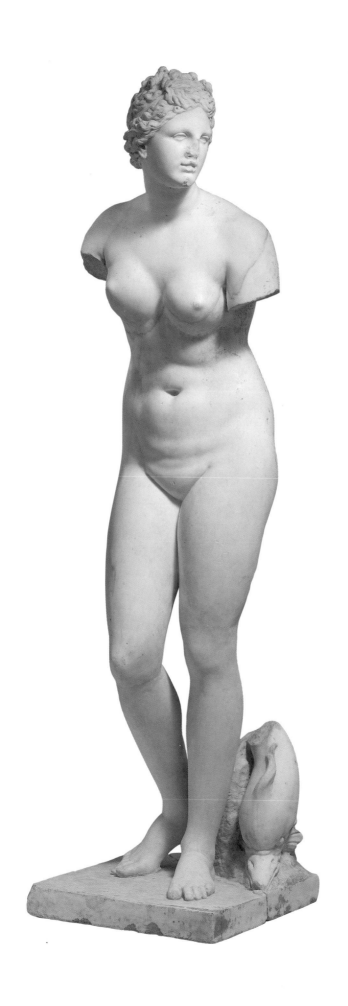

17. *Statue of Venus*

Roman, Imperial, 1st or 2nd century B.C.
Copy of Greek original of the 3rd or
2nd century B.C.
Marble; H. as restored (with plinth)
5 ft. 2½ in. (128.3 cm)
Purchase, 1952 (52.11.5)

POINTS TO CONSIDER

- The goddess Venus was considered to be the ancestress of the whole Roman people because she was the mother of the Trojan hero Aeneas, whose descendant Romulus founded the city of Rome. Julius Caesar claimed her as an ancestor, and thus she was very important to the first imperial dynasty, the Julio-Claudians, which began with Caesar's adopted son Octavian/Augustus.

- The Roman representation of Venus was based on Greek depictions of her counterpart Aphrodite, who was visualized as the sensual goddess of love. A famous statue of the goddess by the fourth-century B.C. sculptor Praxiteles, showing her naked as if taking a bath, became wildly popular in the Greco-Roman world. Other sculptors created their own versions of the naked goddess, and all of these were copied many times over in the Roman world and used to decorate Roman bath complexes and private gardens as well as serving as cult images.

- Roman copies of Greek statues are a rich store of information for art historians, since many copies of a single statue may survive, and very often the original does not.

Venus, the Goddess of Vegetation and of Love

The ancient Italic deity Venus was regarded as the protectress of vegetation and gardens. Her cult began in Lavinium, a city in Latium which, according to legend, had been founded by Aeneas, her son. The oldest known temple to her was built there in 293 B.C.

At an unknown date, the Roman Venus became identified with the Greek Aphrodite, the goddess of erotic love. In this role, she was awarded a temple on the Capitoline Hill in 217 B.C. As the mother of Aeneas, associated with the foundation of Rome, Venus/Aphrodite became regarded as the ancestor of the *gens Iuliae*, the family of Julius Caesar and the Julio-Claudian dynasty of the Roman Imperial period. She was called Venus Genetrix, goddess of motherhood and domesticity. Caesar built a grand temple in his Roman forum and dedicated it to her, and the goddess played an important role in many Roman religious festivals and in the imperial cult.

Sensual Representations of the Goddess Venus

The fourth-century B.C. Greek sculptor Praxiteles was the first artist to make a full-scale statue depicting Aphrodite as an unclothed and fully sensual goddess

of love. According to Pliny the Elder, the first-century A.D. Roman writer whose book *Natural History* is a key source of information about Greek artists and their works, Praxiteles was commissioned by the inhabitants of the island of Kos to sculpt a statue of the goddess. Most freestanding sculptures during the classical period were cast from bronze, but Praxiteles created his Aphrodite from marble in order to simulate creamy white flesh. (As was typical for ancient marble statues, certain details, such as the pupils and irises, would have been highlighted with paint.)

Praxiteles made two statues of the goddess, one clothed, the other nude, as if she had been surprised by an onlooker while bathing. The people of Kos selected the more modest statue, but residents of the nearby peninsula of Knidos promptly purchased the nude statue and installed it in a special circular shrine where its beauty could be seen from all sides. (The Museum's bronze statuette based on the Praxitelian original, dated to 150–100 B.C., is illustrated in *Art of the Classical World*, no. 241.) People flocked from far away to view the statue. Praxiteles' reputation as a sculptor was assured, and subsequent sculptors began to carve naked Aphrodites as well, picturing her in a variety of poses: crouching, washing her hair, and so on. (Compare, for example, the Museum's statue of Venus crouching and arranging her hair, a Roman imperial copy of a second-century B.C. Greek original, illustrated in *Art of the Classical World*, no. 437.)

Just as they assimilated the Roman goddess Venus to Aphrodite, so Roman representations of Venus, based on Greek statues of the goddess of love, were placed in temples; but they were also used as decorative objects in public buildings (such as the baths) or in the gardens of their private **villas**. The Roman copying habit has proven invaluable to archaeologists and art historians, since few original classical Greek statues, whether in bronze or marble, survive to this day. The bronzes were often melted down so that the material could be recycled for other uses. The marbles might be hacked up for foundations or used to make quicklime. The Romans, however, made so many marble copies of their favorite statues that some were destined to survive to the present day.

The Museum's Venus with a Dolphin

The Museum's statue of Venus with a dolphin is very similar to a Roman copy, the so-called Medici Venus, which is itself a copy of a lost Greek original. It is unknown whether the original was made of bronze or marble. Our statue, nearly lifesized, is carved from white marble. The goddess is, as usual, represented as if she has been surprised at her bath. Her arms, now missing, probably would have been placed across her body to shield her from the onlooker. Her weight is on her left foot, and her right leg is bent forward as she looks to her left. Her oval face has smooth cheeks, a straight nose, and rather small almond-shaped eyes. Her curly hair is pulled across the tops of her ears and into a bowlike bun at the back of her head. A fillet, or headband, is almost concealed by her curls.

Venus is often represented with a dolphin, a reference to the Greek tradition that she was born from the foam of the sea. This dolphin, only partially preserved, rests on its long, beaklike snout with the back of its body raised up. The tail is missing, but it has fins (which a real dolphin does not have) on its back and left side. Often Roman copyists made small changes in the compositions they were copying, and it is possible that this accounts for the idiosyncratic appearance of this dolphin.

This statue was probably used to decorate a bath complex or the gardens of a private home. However, it is impossible to know whether it still carried religious connotations for individual Roman viewers.

DISCUSSION QUESTIONS

♦ Describe the appearance of this statue. Is the figure young or old? How is she posed? What is she doing?

♦ Do you think this statue was meant to be seen only from the front? Why or why not?

♦ This statue is carved from marble. Do you think that this is a realistic material to use for the representation of human flesh? Why or why not?

♦ This statue actually represents Venus, the goddess of love, rather than a mortal woman. Are there any clues in this representation suggest that she is divine?

♦ The Romans believed that Venus had been born from the foam of the sea. Is there anything about this sculpture that suggests her association with the ocean?

♦ Compare this representation of Venus with the ones illustrated in *Art of the Classical World* (nos. 241, 437). How are they similar? How are they different?

Shown actual size

18. *Statuette of a* lar

Roman, Imperial, 1st–2nd century A.D.
Bronze; overall: 9¾ x 4⁹⁄₁₆ x 2⅛ in.
(24.8 x 11.6 x 5.4 cm)
Rogers Fund, 1919 (19.192.3)

(See also poster)

POINTS TO CONSIDER

+ In addition to the gods recognized by the state, Romans worshipped personal gods to whom they built shrines in their homes. These included the *lares*, who were guardians of the household and its members. Unlike gods such as Jupiter, *lares* did not have elaborate mythologies connected with them.

+ Though each household had its own personal pair of *lares*, they were all represented the same way: as youthful dancing males with curly hair wearing short tunics and carrying drinking horns and bowls.

The Roman Household Guardian Spirits

Lares were Roman guardian spirits, possibly the ghosts of ancestors. They were worshipped as the protecting spirits of crossroads, in the city as guardians of the state, and most importantly as protectors of the house and its inhabitants (the *lares familiares*). *Lares* had no clear personalities or mythologies associated with them.

Nearly every Roman household possessed statuettes of the *lares*, usually in pairs that were placed in a **lararium**, or shrine, that was built in the central court (**atrium**) of the home or in the kitchen. These shrines sometimes contained paintings rather than statuettes of the deities. Offerings, sacrifices, and prayers were made to the *lares* and to other household gods (the *penates*, guardians of the cupboard, for example). The *lares* of the crossroads, associated with the emperor's household gods beginning in the era of Augustus, were worshipped publicly.

The Museum's *Lar* Statuette

The Museum's statuette is probably one of a pair whose partner would have been a mirror image, with its left arm raised and the right one lowered. The curly-haired figure is shown dancing on his toes, a goat-headed *rhyton* (drinking horn) in his raised right hand and a *patera*, or bowl for making liquid offerings (libations), in his lowered left hand. The figure wears a short tunic with a stitched design, a cloak, and soft boots. Similar statues have been found all over the empire, commemorating a type of deity less clearly defined than the major gods of the Roman pantheon, such as Jupiter and Venus, and yet universally venerated.

DISCUSSION QUESTIONS

+ Describe the appearance of the figure. Is he young or old? How can you tell? What is he wearing? Is he standing still? What is he holding?

+ This figure represents a *lar*, a god who protected the household. Every Roman family worshipped the *lares* in the home rather than in a communal house of worship. Why do you think this was the case?

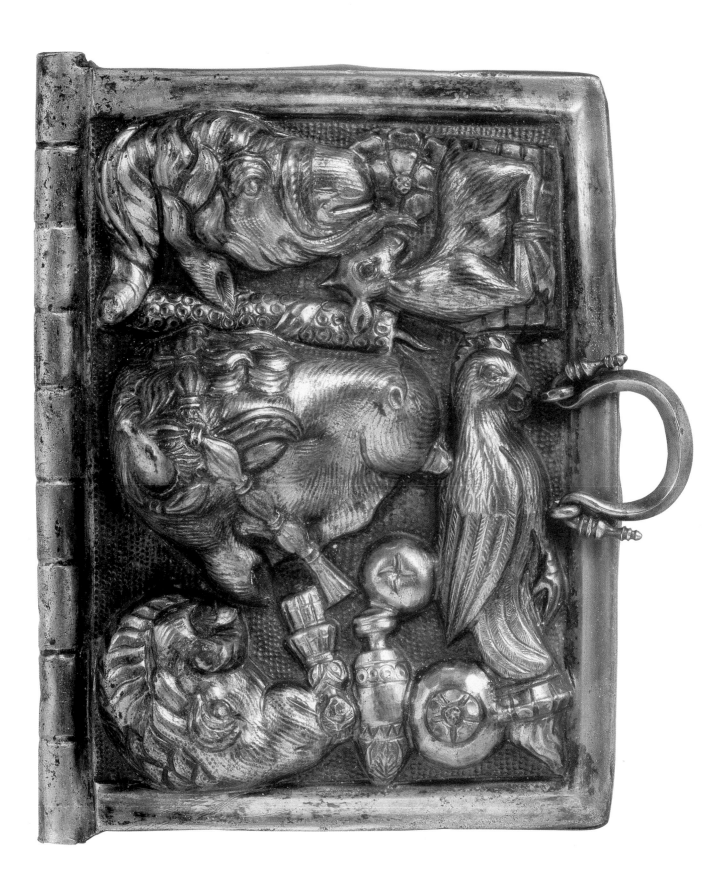

19. *Lid of a ceremonial box*

Roman, Augustan, late 1st century B.C.–
early 1st century A.D.

Gilt silver; 1 x 3¼ in. (2.5 x 8.3 cm)

Purchase, Marguerite and Frank A.
Cosgrove Jr. Fund and Mr. and Mrs.
Christos G. Bastis Gift, 2000 (2000.26)

POINTS TO CONSIDER

- The making of sacrifices to the gods was one of the key ways in which the Romans interacted with their gods. Offerings to the gods could include the sacrifice of animals, the pouring of libations, or the burning of incense.

- Roman sacrifice followed highly specific procedures. The sacrifice was carefully inspected to make sure that the gods accepted it. Otherwise the sacrifice had to be repeated.

- It is impossible to know whether the Museum's ceremonial box lid refers to a specific god, since it was the prayers that accompanied a given sacrifice that identified for which god it was intended.

- The design of this box suggests that it was used in some religious ritual. It is decorated with representations of animals typically used in sacrifices and with resprestations of ritual objects.

The Essential Roman Ritual: Sacrifice

The fundamental act by which the Romans did justice to their gods was through sacrifice. Sacrifice could take many forms: it might involve the burning of incense; or pouring a liquid; or the dedication of various kinds of plants; or the ritual slaughter of domestic animals such as cattle, pigs, sheep, and goats.

Most sacrifices, whether they were private or communal, took place in open, public spaces, near an altar, and were presided over by those who held authority within the community making the sacrifice. Before the sacrifice, the participants marched in procession up to the altar of the deity to be honored and poured incense and unmixed wine into a fire burning in a round hearth as a flute was played.

According to the traditional Roman practice for making animal sacrifices, which the Romans believed went back to the time of Aeneas, salted flour was sprinkled on the victim's back, wine was poured on its brow, and a sacrificial knife was run along its back. The victim was thereby consecrated to the deity. Larger animals such as cows or bulls were then struck and bled. Smaller animals had their throats cut. The animals were then laid on their backs and, after they were cut open, their internal organs (liver, lungs, gall bladder, peritoneum, and heart) were examined by a *haruspex*, or diviner, to see whether the innards were

intact and normal. If so, the sacrifice was deemed acceptable to the gods. If something was missing or abnormal, the sacrifice was repeated until one acceptable to the gods could be effected.

After the innards were examined, the victim's body was divided up. The entrails, after boiling, were given to the gods while prayers were recited. The Romans recited these prayers to make clear who was conducting the sacrifice, to which god the sacrifice was being carried out, and why. The rest of the victim was declared profane, and thus, after being cooked, could be eaten by humans. Usually the most eminent members of whatever social group was conducting the sacrifice received the best portions of the meat and ate first.

The Museum's Ceremonial Box Lid

This small but highly refined rectangular box lid is decorated in high relief with the miniaturized heads of a bull, goat, and ram, the animals commonly sacrificed at public religious ceremonies. Below the heads are objects of religious cult that include a flaring torch, libation bowl, bundle of wood, sheathed knife, floral garland, and pomegranate. The libation bowl would have been used to pour liquid offerings; the garland might have been draped on the altar or on the sacrificial victim. The pomegranate, a fruit associated with death, might have been used in a ritual in honor of the dead. The knife would have been used to dispatch the animal victim, while the torch would have illuminated a nocturnal ritual. Two smaller animals, a bound kid and a rooster, partly conceal some of the cult objects; they, too, must have been intended as offerings. The objects are worked in high relief in repoussé, and the details are gilded. The shapes are packed into a framed rectangular panel. The decoration is of the highest quality.

The nature of the decoration suggests that the box that this lid covered was used for some religious function. Perhaps it held incense that would have been used in a sacrificial rite. It is impossible to know, however, whether the lid and its box were priestly possessions or private ones.

DISCUSSION QUESTIONS

- Describe the objects hammered into the decoration of this box. Do the images look realistic to you? Why or why not?

- Do you think all of these objects would have been used in a single sacrifice, or do you think the box lid is making a general reference to religious ritual? Why or why not?

- What do you suppose the box that this lid covered was used to hold?

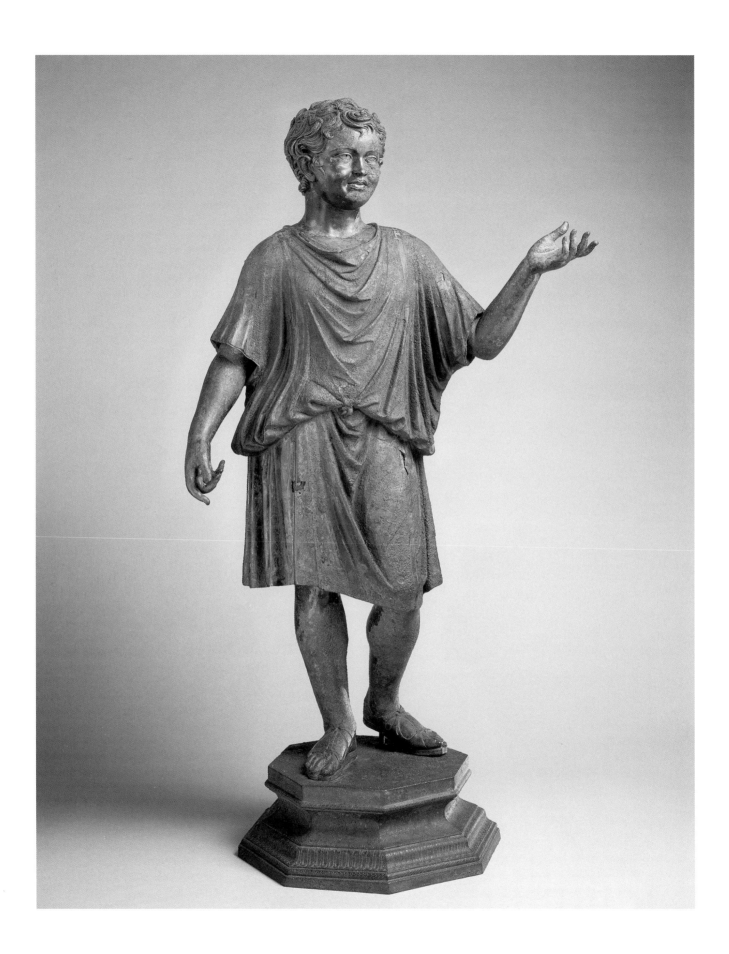

20. *Camillus*

Roman, Early Imperial, Julio-Claudian,
A.D. 41–54
Bronze; H. 46⅛ in. (117.2 cm)
Gift of Henry G. Marquand, 1897
(97.22.25)

POINTS TO CONSIDER

- Roman religion was based on the performance of public rituals of sacrifices to the gods. Among the participants in carrying out those rites were children who met certain qualifications of age and social status.

- Romans erected statues of important people in their public spaces. Many of these statues, identified by inscriptions, had very individualized features that identified them as portraits of specific people. The generalized features of the boy here suggest that the statue does not represent a specific person but rather the position of the *camillus*, or priestly attendant.

- The materials chosen by the craftsmen who created this hollow-cast bronze statue were intended to make it look as lifelike as possible. When burnished, the bronze surface would have looked like tanned flesh, while the copper lips would have looked red and the eyes white.

The Position of *Camillus*

In Rome, a *camillus* was a youthful acolyte who assisted priests in the performance of Roman religious rites. These acolytes, who could be either boys or girls, served many different priesthoods in carrying out the public rituals of sacrifice that were vital to the observance of Roman religion.

It was an honor to serve in this position; to qualify, a youth must have been free-born, below the age of puberty, and had two living parents. Often one of the parents of the acolyte participated in the ceremonies in which the *camillus* served.

The Museum's Statue

The Museum's statue may be a generalized representation of a typical male *camillus* rather than the portrait of a specific child. This boy, hollow-cast in bronze, stands with his weight on the right leg. His head is turned slightly to the left. The eyes are inlaid with silver and the lips with copper. When the statue was new, and burnished to a bright sheen, these effects would have given it an amazingly lifelike appearance.

The *camillus* is dressed in the typical tunic and sandals of his office. The tunic is inlaid with copper strips to suggest bands of color in the garment. He probably held an incense box in his left hand, as *camilli* are shown doing in other representations of them, such as the reliefs of the Ara Pacis, the Altar of Peace erected by the emperor Augustus. The lid of such a box, decorated with sacrificial implements and animals, is discussed under image 19. Sometimes decorations on the box help scholars to identify which priestly college the acolyte served. Unfortunately, since the box is missing from this sculpture, no such specificity is possible in this case. We do not know in what context the statue was displayed; it might have been votive or commemorative.

DISCUSSION QUESTIONS

◆ Describe the appearance of this figure. How old do you think he is? What is he wearing? What do you think he is doing?

◆ Do you think that this is a portrait of a specific child? Why or why not?

◆ Describe the material from which the statue was made. Do you think the use of this material makes him look more, or less, lifelike? Why?

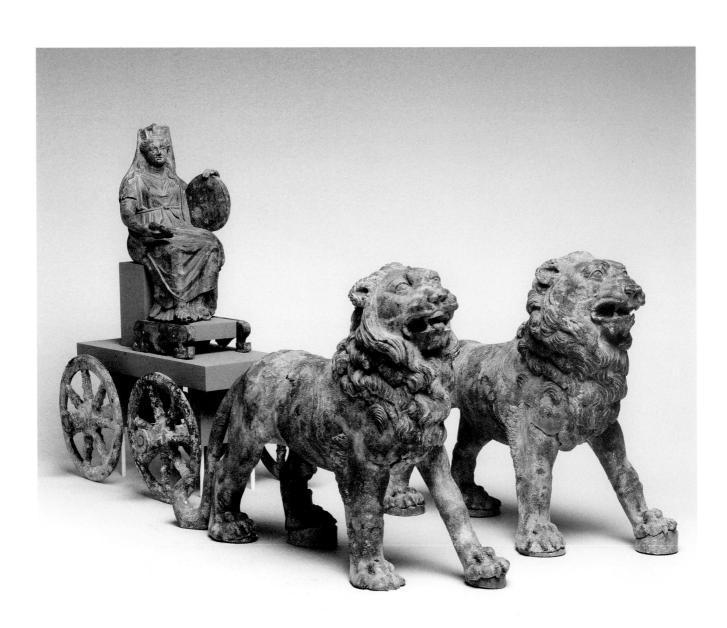

21. *Statuette of Cybele on a cart drawn by lions*
Roman, 2nd half of 2nd century A.D.
Bronze; L. 54¾ in. (139.1 cm),
W. 12 in. (30.5 cm)
Gift of Henry G. Marquand, 1897
(97.22.24)

POINTS TO CONSIDER

- Roman religion was polytheistic, and it incorporated deities from all over the ancient world. Cybele was not a goddess known in earliest Rome, but her cult image and worship were brought to Rome in the late third century B.C.

- Unlike many of the "oriental" deities that were introduced to Rome, Cybele received rites as part of the official Roman cult. She also was worshipped in private "mysteries" by some of her followers.

- Roman gods and goddesses have attributes, that is, details of dress or presentation that were always associated with them and that help us to identify them. In Cybele's case, the attributes include a crown that is shaped like fortress walls, in reference to her role as protector of her people, and lions, since she is the mistress of untamed nature.

- A cult statue of the goddess was placed in any temple dedicated to her, and worshippers might keep a private image of her in their homes for personal devotion. In this case, the representation of Cybele had a decorative purpose, since it was part of a fountain complex. It still may have carried a religious connotation, however.

- The difference in scale between Cybele and her lions suggests that she is represented as a cult image rather than as the goddess herself.

The Introduction of the Goddess Cybele to Rome

In addition to deities associated with the Greek pantheon, like Jupiter, Rome's polytheistic religion incorporated many gods and goddesses of Eastern origin. One of the most prominent was the Phrygian goddess Magna Mater, or Cybele. She had long been known in Greece, but her cult was introduced into Rome during the Second Punic War in the late third century B.C. The cult remained popular until early Christian times. Unlike many of the deities that were not Italic in origin, whose worship was tolerated but who did not receive official recognition from the state, Cybele was given a temple on the Palatine Hill, in the most sacred part of Rome. In part this was because her origins in Asia Minor linked her to Rome's Trojan ancestors. At times limitations were placed on the cult because some of its practices, such as the self-castration of Cybele's priests, were viewed with suspicion by the authorities. But her festivals and games were part of the official calendar, and she received official cult. By the time of the emperor Augustus, she had entered the visual, cultural, and intellectual repertoire of the Roman world alongside such traditionally revered gods as Jupiter.

The Representation of Cybele

Cybele was the goddess of fertility, protection in war, and untamed nature. Her worship was especially popular among women and farmers. She is frequently shown with lions to symbolize her role as mistress of nature, and she wears a crown made of turreted walls in reference to her protection of the people in times of war. She is often shown enthroned and flanked by her lions, or with one in her lap. Here she is seated in a cart (now missing, except for the wheels) drawn by two maned lions.

The goddess is shown wearing a chiton, a loose linen dress with buttoned sleeves that is belted beneath her breasts, and a cloak that is drawn up over her turreted crown like a veil. Her ears have been pierced for earrings that are now missing. She carries a libation bowl in her right hand and a large drum in her left. Her feet rest on a footstool. All that is left of the original cart are the four seven-spoked wheels.

Each year, the festival of Cybele at Rome ended with a procession that carried the silver cult image of the goddess to a river for ritual bathing, symbolic of the earth's fertilization by rain. Since the Museum's Cybele is of a much smaller scale than the lions, it has been suggested that this ensemble represents the procession of the goddess' cult image to the river, rather than the living goddess herself.

The Museum's Cybele and lion group was originally part of a fountain, with the mouths of the lions serving as waterspouts. While the group had a decorative function, we cannot be sure that it no longer had any religious significance for the Romans.

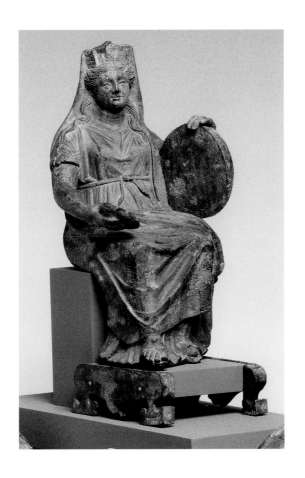

- Describe the figures in this sculptural ensemble. What is the seated female wearing? What is she carrying? Do you think she is a powerful figure? Why or why not?

- In fact, we know that this figure is Cybele, goddess of fertility, protection in war, and of untamed nature. Does this sculptural ensemble visually refer to any of those powers? Which ones?

- Why do you think the lions are on a much greater scale than Cybele?

- We know that this sculptural ensemble originally functioned as a fountain (the lions' mouths are waterspouts). Today, would we be likely to represent a revered figure in the form of a fountain sculpture? Why would this be inappropriate for us? Why do you think it was acceptable for the Romans of the second century A.D.?

- A cult statue of Cybele was carried to the river by the Romans every year to be ceremonially bathed. In many modern religions, there is a similar tradition of processions of sacred images (think of Catholic processions of saintly images, or similar Hindu practice). If you are a member of a religion or a religious tradition, is there a similar practice that you can think of? Describe it.

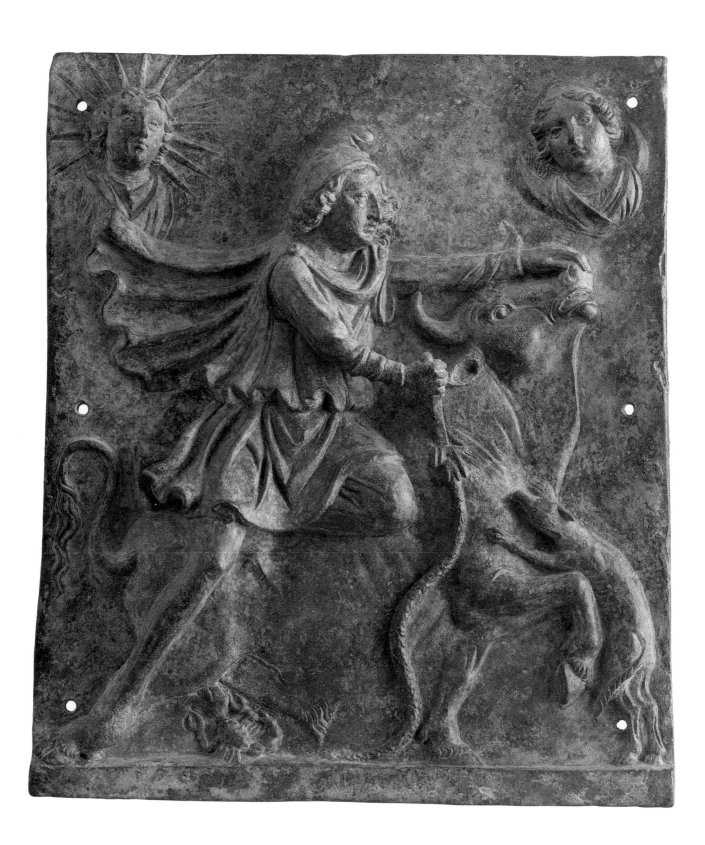

22. *Plaque with Mithras slaying the bull*

Roman, Antonine or Severan,

mid-2nd–early 3rd century A.D.

Bronze; 14 x 11⅝ in. (35.6 x 29.5 cm)

Gift of Mr. and Mrs. Klaus G. Perls, 1997

(1997.145.3)

POINTS TO CONSIDER

- Mithras was one of the most popular gods in the Roman pantheon. Of Iranian origin, his religion rapidly spread across the Roman empire in the second and third centuries A.D., in part because it was popular with soldiers, who carried it with them as they traveled around the empire. His adherents were exclusively male.

- Mithraism was a mystery religion whose worship was carried out in underground chambers called *mithraea*. More than fifty of these have been found at Rome and its port city, Ostia. Probably these "caves" were used for communal dining, alluding to a divine banquet supposedly enjoyed by Mithras and the sun god, Sol.

- The chambers were decorated with statues of Mithras, whose imagery is very specific. The god wears a tunic, cloak, and conical hat, and is accompanied by a dog, snake, scorpion, and raven. He sits atop a bull and slays it with a dagger. Heads of Sol and Luna, the moon, float in the background.

- The Museum's plaque is a typical representation of Mithras slaying the bull.

The God Mithras

Mithras was an ancient god, probably of Indo-Iranian origin, who became popular in the Roman empire during the second and third centuries A.D. as a deity with exclusively male adherents. The original Iranian Mithra was a god of concord, cattle herding, and the dawn light. In his Roman form, Mithras was given the epithets of sun god, bull killer, and savior of the sworn members of his cult.

It is not known precisely how the cult of Mithras made its way into the Roman empire, as the surviving evidence for the cult is archaeological rather than textual. However, by the middle of the second century A.D., the religion was well established, and over 400 places associated with it have been unearthed, along with more than 1,000 dedicatory inscriptions and more than 1,000 pieces of sculpture. Evidence of the cult has been found from Hadrian's Wall in Britain to Dura-Europos on the Euphrates River in Syria. A great many remains are preserved from Rome and its port of Ostia; extrapolating from the some fifty *mithraea*, or underground places of worship, that have been uncovered at these two cities, there may have been more than 700 shrines in them alone.

Mithraism was particularly popular among civil functionaries and members of the military. It was also popular with freedmen or slaves, possibly

because it seemed to offer the hope of redemption and salvation.

The Mithraeum

The Mithraic religion was a so-called mystery cult. Its believers were organized into small autonomous cells who met for worship in small chambers, called "caves," many of which were in fact set in underground caves. Each *mithraeum* consisted of a rectangular room with a central aisle flanked by platforms on which the initiates reclined and dined communally. This meal was conceived of as the human counterpart of a divine banquet enjoyed by Mithras and the sun god, Sol.

The Representation of Mithras

Every *mithraeum* had a representation of Mithras in it, usually at the far end of the room. Typically the god is shown astride a bull, killing it with a dagger. He wears "Persian" dress consisting of tunic, cloak, and conical cap, and is accompanied by a dog, snake, scorpion, and raven, and also by two minor gods in "Persian" clothing, each carrying a torch. The scene takes place in front of a cave, and in the background float the heads of Sol, the sun god, and Luna, the lunar deity. Precise interpretation of this mysterious scene of sacrifice has not been established. Scholars debate whether it shows the creation or the end of the world. It has also been interpreted as an astrological allegory of the soul's celestial journey.

Although this is the most common scene from Mithraic myth, other episodes are sometimes illustrated on the monuments, including the god's birth from a rock, the hunt and capture of the bull, and the banquet with the sun god.

The Museum's Mithras Plaque

The Museum's relief shows the customary bull-slaying scene. Mithras is astride the bull, his cloak swirling behind him, and he delivers the fatal blow as he pulls the bull's head back with one hand. His dog tears at the neck of the bull, while the snake rises up to meet the point of the blade and a scorpion also assists. Busts of Sol, with a radiant crown, and Luna, cradled in a crescent moon, hover in the background.

The plaque has three holes on each of the long sides, presumably for attachment to another object. It may have been hung in a *mithraeum*, or possibly in an adherent's home.

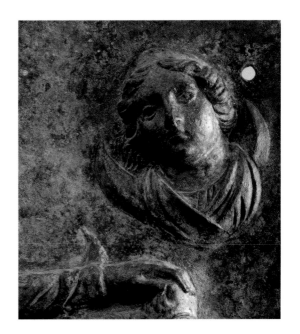

DISCUSSION QUESTIONS

◆ Describe the figure depicted in this plaque. What is he wearing? Is he dressed in a toga, the typical male Roman attire? What does his clothing suggest?

◆ Look at the various animals in the plaque. What is each doing?

◆ There are two busts floating in the background. Can you identify who they represent? If so, how?

◆ Where might such a plaque have been hung?

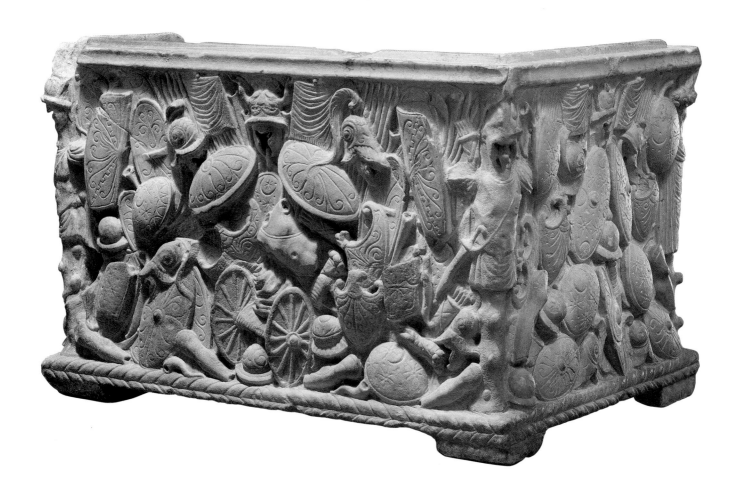

23. *Cinerary urn with arms and war trophies*

Roman, Julio-Claudian, 1st half of 1st century A.D.

Found near Anagni, southeast of Rome, in 1899

Marble; overall: 14¼ x 21¼ x 16⅛ in.

(36.2 x 54 x 41 cm)

Purchase, Philodoroi Gifts, 2002 (2002.297)

and Gift of Ariel Herrmann, 2002 (2002.568)

POINTS TO CONSIDER

- A proper burial was necessary to ensure the safe passage of the soul of the deceased into the afterlife.

- Family ties and ancestors were very important to the Romans. Therefore the remains of family members were kept together in tombs that held the ash urns and/or sarcophagi of many generations.

- In the Roman Republic and the first century of the Roman empire, cremation was a common funerary method.

- Funerary urns were typically inscribed with the names of the deceased. They might be decorated in many different ways; some were shaped like vessels, others like altars. Some had relief decorations. Some were decorated with scenes that related to the life of the deceased.

- The Museum's ash urn has lost the inscription that would have identified the deceased. However, the decoration of the box with arms and war trophies suggests that the dead person was in life an important soldier.

Roman Beliefs about the Afterlife

Roman polytheists did not believe in a bodily life on earth after death. However, some Romans apparently believed that the soul lived on after death, even though the body did not. The soul joined the community of the *di manes*, the spirits of the dead. The immortality of the soul required that the deceased be remembered by the living. Thus the regular performance of funerary cult was essential.

The Practice of Cremation at Rome

Cremation, or burning of the dead body and preservation of the ashes, was a common method of burial in the Roman world from the regal period until the second century A.D. It was part of a solemn funerary ritual, since the Romans believed that one could pass into the afterlife only after a proper burial. The first step in such a burial was the washing of the body by family members. A coin was then placed in the mouth of the deceased to pay Charon, the mythological ferryman, who would row the soul across the rivers of the underworld. A procession then carried the body outside the city walls to be cremated. Paid mourners and musicians often joined this procession of family and friends.

After the body was burned on a pyre, the ashes were gathered in an urn that was buried in the ground, placed in a mausoleum, or set in a niche in the wall of a subterranean communal tomb called a *columbarium* (from *columba*, meaning dove or pigeon). Such tombs might contain the remains of generations of family members, and survivors were expected to visit them on days devoted to honoring the dead to offer them cult and to dine in their presence.

Funerary urns could come in many shapes. Some mimicked the shape of vessels, while others looked like woven baskets. See for example, the cinerary urn in the form of a basket included in *Art of the Classical World*, no. 422. (This urn probably represented a weaving basket and thus held a female burial, since weaving was one of the skills that all Roman women were expected to have.) Also illustrated in that publication is a cinerary chest with a funerary banquet (no. 423), showing the deceased reclining on a couch and being served food and wine. Still other ash urns resembled altars or small tombs. Usually these urns carried inscriptions identifying the deceased, although sometimes these inscriptions were placed below them. The urns could be made of many materials, from glass (see no. 427) to terracotta to marble.

Tomb Architecture

Like many ancient peoples, the Romans forbade burial of the dead within the city walls. Instead, burials took place in *necropoli* (cities of the dead) that lined roads leading away from towns. Many families erected elaborate tomb complexes to commemorate their dead and to catch the attention of passersby. Since these were essentially display monuments rather than functional buildings, they came in many different forms.

For example, some Roman tomb architecture evolved out of the *tumulus* tombs of the Etruscan city of Cerveteri, which were squat, cylindrical, and covered with mounds of earth. The mausolea of Augustus and Hadrian, which consisted of large circular stone drums with earth on top, followed this model.

During the Republic and early empire, when cremation was a common form of burial, ash urns might be placed in the niches of *columbaria* because these niches and portrait busts of the deceased resembled the dovecotes in which the birds lived. In the empire, many tombs were above-ground barrel-vaulted structures that were used for generations and might contain sarcophagi as well as ash urns. Tombs shaped like houses came into widespread use in the middle empire. Many of these tombs had elaborate interiors where the family could gather for reunions to commemorate the dead.

Tombs could take fanciful shapes as well. Notable late Republican tombs still standing at Rome include the pyramid-shaped tomb of Caius Cestius and the tomb of the baker Marcus Vergilius Eurysaces, a trapezoid decorated with what are either cylindrical grain measures or machines for kneading dough, as well as relief scenes showing the baking of bread. Eurysaces also included relief portraits of himself and his wife, as is common on freedmen's tombs of the late Republic and early empire. Please refer to the funerary relief with the busts of a man and a woman, image 30, in the Daily Life section.

The Museum's Funerary Ash Urn

The Museum's rectangular ash urn is missing its lid and most of its front, including the inscription recording the name of the deceased. However, the container's relief decoration likely tells us the occupation of the deceased. The surviving sides are crowded with high-relief carvings of piles of weapons, armor, and trophies of war: greaves,

shields, helmets, chariot wheels, and banners all can be distinguished.

Depictions of military equipment like this are not typically seen on private monuments. They are more common on imperial monuments that commemorate battles, such as triumphal arches. The quality of the carving, as well as the subject matter, make it likely, then, that this urn was commissioned for a high-ranking Roman army officer.

DISCUSSION QUESTIONS

• Look carefully at this marble box. Describe the decorations you see carved on it.

• This box served as the funerary urn for the ashes of a person who had been cremated. What do the decorative motifs carved on this box suggest to you about the occupation of the person whose remains were buried in this box?

• Where do you think this box might have been kept?

• Compare this ash urn with the cinerary urn in the form of a basket illustrated in *Art of the Classical World*, no. 422. Does that shape offer any clues to the identity of the deceased?

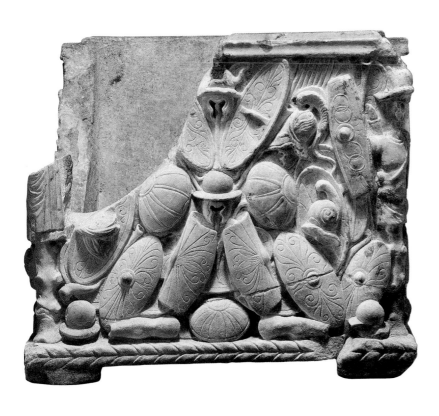

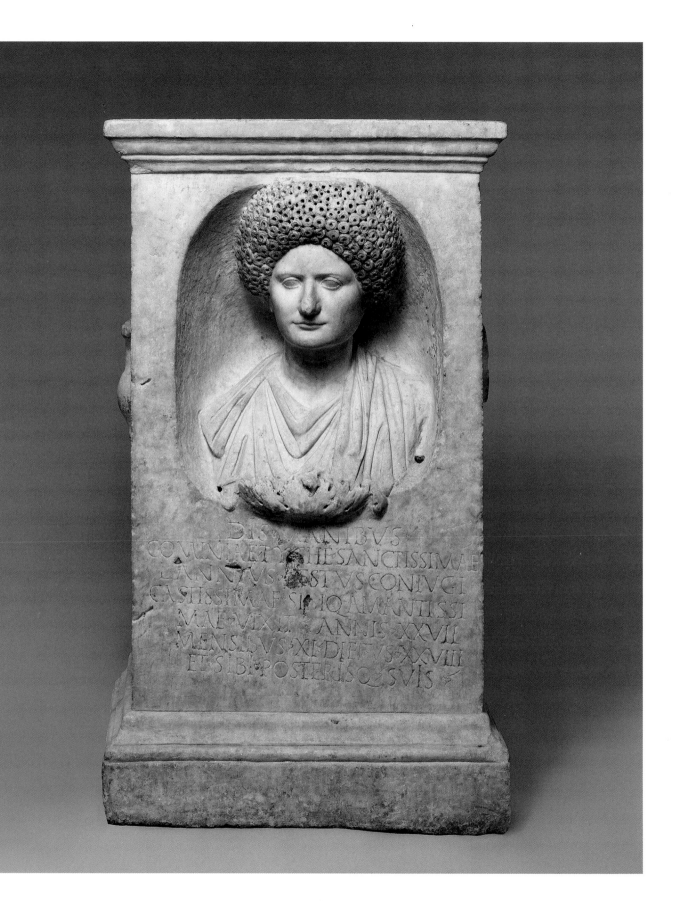

24. *Funerary altar (cippus) of Cominia Tyche*

Roman, Flavian or Trajanic, ca. A.D. 90–100
Known in the 16th century in a
house near the Roman Forum; later
Palazzo Barberini
Marble; H. 40 in. (101.6 cm)
Gift of Philip Hofer, 1938 (38.27)

POINTS TO CONSIDER

- In the first century A.D., deceased family members were often commemorated by funerary altars that might be decorated with an inscription and sometimes with a likeness of the dead person. Sacrifices were not made at these commemorative monuments as they would have been at regular altars.

- Cominia Tyche, who is represented on this altar, is shown as a woman with very specific features. Her portrait is not idealized but rather shows her as she actually looked.

- The Romans were great followers of fashion. If a particular hairstyle became popular with the women of the imperial court, whose portraits represented them wearing it, it would have been imitated by women all across the empire. Changes in hairstyles over time help us to date the portraits of those who wear particular styles, even if their monument does not bear a date.

- Funerary altars did not always represent the deceased. Compare the Museum's Julio-Claudian funerary altar illustrated in *Art of the Classical World*, no. 421. Here the deceased are commemorated by an inscription, while the elaborate relief decoration of the altar, with its heavy garland suspended from rams' heads, mimics the decoration of public sanctuaries. The three types of bird, an eagle (the bird of Jupiter), swans (birds of Apollo), and songbirds (signifying bountiful nature), are all associated with monuments erected by Augustus, the first emperor.

Roman Altars as Commemorative Funerary Markers

For a discussion of Roman beliefs about death, please refer to the introduction to image 23.

In Roman religion, many religious acts involved sacrifices to honor or seek the guidance of the gods. These sacrifices often were made on altars, which were erected wherever divinities were worshipped. In the early Imperial period, altars began to be used as burial markers, although it is unlikely that sacrifices were actually made at them. Next to cinerary urns, funerary altars were the most typical form of grave monument produced in Rome and its environs in the first and early second centuries A.D. Some were carved only with inscriptions; others, like this one, featured portraits of the deceased as well as inscriptions.

The Museum's Funerary Altar

This funerary altar served as a marker in the family plot of a communal tomb that was probably on the outskirts of Rome.

The Latin inscription on this altar slopes off toward the bottom proper left side, so it must have been carved without the use of horizontal guidelines. It can be translated as follows:

> To the spirits of the dead.
> Lucius Annius Festus [set this up]
> for the most saintly Cominia Tyche,
> his most chaste and loving wife,
> who lived 27 years, 11 months, and 28 days,
> and also for himself and for his descendants.

The inscription is typical for a woman in Roman society. Since women did not usually have a public role, it emphasizes not actions she took in life but rather the characteristics which the Romans considered to be those of an ideal wife.

Above the inscription, set into a shallow niche, is a bust-length portrait of the deceased woman, whose name indicates that she had Greek or servile origins. The bust is cradled in an **acanthus** leaf. This signifies that she is dead. The portrait of Cominia is not that of an idealized beauty; rather it is of an individual woman. Cominia is shown with a round, unwrinkled face, thin lips, and a rather prominent nose. Her hair, piled high along the top and sides of her head, is a mass of carefully carved round curls. The center of each curl has been deeply drilled, creating a dramatic interplay of light and dark effects that contrasts with the smoothness of her skin. Such an elaborate coiffure may be a wig. The sides of the funerary altar are carved with a pitcher and a libation bowl, or *patera*, respectively. These vessels allude to the practice of pouring liquids in commemoration of the dead and thus are commonly represented on funerary altars.

Dating of Roman Portraits through the Use of Hairstyles

Cominia Tyche's elaborate hairstyle helps us to date the monument to around A.D. 90–100, since it imitates the coiffure adopted by women attached to the court of the later Flavian emperors. Images of imperial women were widely disseminated both in portrait busts set up in public places and on coins that were distributed throughout the empire. Thus a Roman woman could readily adopt a fashionable imperial hairstyle, even if she had never seen the empress in person.

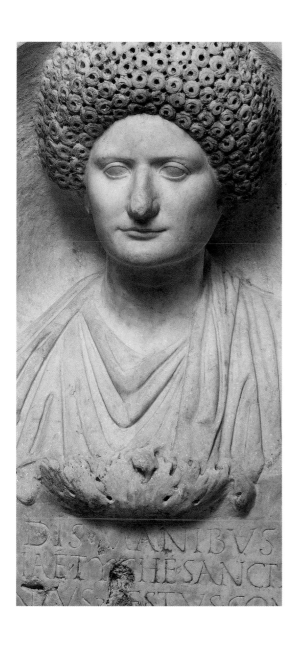

+ Describe the appearance of the woman in this funerary portrait. Does it surprise you to learn that she was not yet twenty-eight years old at the time of her death? Why or why not?

+ Look closely at Cominia Tyche's hairstyle. The carving of the curls is much more three-dimensional than the carving of her clothing. How do you think the artist has achieved this effect?

+ What characteristics of Cominia Tyche are described in the funerary inscription? Why do you think it was important for a Roman woman of this period to possess these qualities?

+ Does this funerary inscription tell us anything about what Cominia Tyche did in life?

+ As you can see from the altar of Cominia Tyche as well as from the cinerary urn (image 23), the Dionysian sarcophagus (image 25), and the freedmen's relief (image 30, in the Daily Life section), the Romans memorialized their dead in many different ways. What are the different ways that deceased family members are commemorated by various societies today?

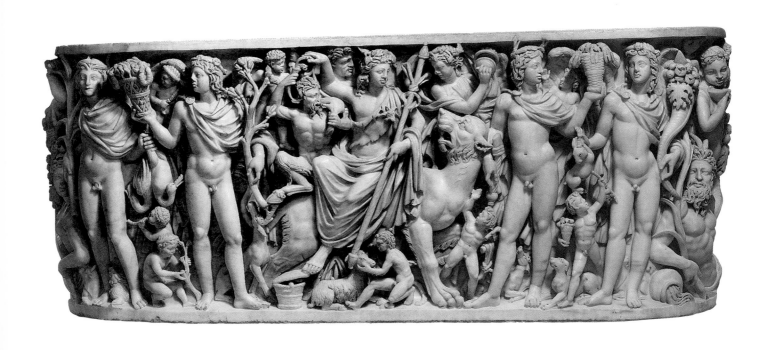

25. *Sarcophagus with the Triumph of Dionysus and the Four Seasons*

Roman, Late Imperial, ca. A.D. 260–270

Marble; overall: 34 x 85 x 36¼ in.

(86.4 X 215.9 X 92.1 cm)

Purchase, Joseph Pulitzer Bequest, 1955

(55.11.5)

(See also poster)

POINTS TO CONSIDER

- In the second century A.D., Romans began to inter their dead in sarcophagi rather than cremating them. We are not sure why this change occurred, but it cannot definitively be linked to any changes in the view of the afterlife.

- Sarcophagi were produced in both the Roman West and the Greek East, and different styles developed depending on the point of production.

- Sarcophagi could be decorated in many different ways: carved with garland swags of fruits and flowers, supported by putti; with scenes from the life of the deceased, or from mythology. Pattern books with popular scenes were circulated throughout the Mediterranean and were used by craftsmen to compose the composition for these sarcophagi.

- Some people probably commissioned their own sarcophagi, while others may have bought a finished box with a generic design.

- The most popular mythological themes on sarcophagi related to sudden death, eternal sleep, or the cycle of death and rebirth.

- In the late empire, Roman sculptors moved away from the naturalistic proportions and logical spaces that had been popular earlier and adopted a more stylized, abstract style of carving.

A Change in Roman Funerary Practices

For a discussion of Roman beliefs about death, please refer to the introduction to image 23.

Beginning in the second century A.D., inhumation (burial of the dead body) became more popular than cremation, starting as a fashion among the more affluent levels of Roman society. The reasons why are still not completely understood. Some scholars speculate that the change in burial practices is connected to changes in views of the afterlife, but there is no explicit evidence.

A Roman Industry: Sarcophagus Production

Sarcophagus production became a lucrative industry throughout the Mediterranean, and centers of production, with distinctive styles, developed in Italy, near Athens, and in Asia Minor. Sarcophagi produced in the West were carved only on three sides, since

they usually were set against a wall or niche inside a tomb. In the East, where sarcophagi often stood outside on the streets of a **necropolis**, all sides were carved. The expense of the most elaborately carved sarcophagi must have greatly impressed passersby.

Motifs Used to Decorate Roman Sarcophagi

Whether produced in East or West, and whether mass-produced or individually commissioned, sarcophagi were decorated using similar sets of motifs. These probably were derived from pattern books. Popular decorations included carved garlands of fruits and plants, imitating the leafy swags that decorated public buildings, altars, and funerary monuments. Scenes from Greek mythology, depicting sudden death, eternal sleep, or immortality, were also popular. Later, biographical sarcophagi narrated the career of the deceased as a soldier, physician, and so on. Sometimes sarcophagi were given lids in the form of a *kline*, or funerary couch, with a carved effigy of the deceased reclining on top.

The Museum has many other examples of sarcophagi on view and illustrated in *Art of the Classical World*. Several are mythological: Theseus and Ariadne (no. 455), Selene and Endymion (no. 456), and the contest of Muses and Sirens (no. 469). Also treated in that publication are a **strigilated** sarcophagus with lions' heads (no. 466), a sarcophagus with garlands (no. 468), and a sarcophagus lid with a reclining couple (no. 467).

The Museum's Dionysus and the Four Seasons Sarcophagus

The Museum's elaborately carved and well-preserved *lenos*, a sarcophagus with rounded ends that resembles a bathtub, is carved in high relief with a crowd of human and animal figures. Originally it would have had paint and gilt highlights to make it even easier to view. In the front center panel, carved in high relief, we see Dionysus, god of wine, seated on his panther in a procession celebrating his triumphs in the East, a possible analogy for the soul's triumph over death. (Dionysus was associated with a better fate after death and thus was a popular subject on sarcophagi.) He is flanked by four equally prominent figures representing the Four Seasons (starting with Winter on the left); these symbolize the cycle of life and suggest recurring rebirth. The background of the composition is teeming with smaller-scale and more shallowly carved human and animal participants in the wine god's *thiasos*, or ritual procession.

Each of the ends of the *lenos* is carved with a reclining personification, Mother Earth with a satyr and a youth on one end, and a bearded male, probably a river god, and two youths on the other. The back has scratchy circles that suggest it was used for practice carving.

The marble for this sarcophagus originated in Asia Minor. However, since only three sides are carved, a Western fashion, the marble apparently was shipped to Rome for carving. The marble probably would have been placed in a tomb where family members could come to dine in honor of the dead.

It is impossible to know whether the subject depicted had any particular significance for the undoubtedly affluent person who commissioned it. At least one other known sarcophagus has the same composition of Dionysus flanked by the Four Seasons, which suggests that this composition was copied from a pattern book.

Please refer to *Art of the Classical World*, no. 464, for a very different version of the Triumph of Dionysus that decorates a silver handle from a serving dish.

The Figural Style of the Seasons Sarcophagus

Although the characters in this composition derive from the canon of the Greek mythological world, they are not carved in a classical style, that is, with the strict attention to proportion and realistic anatomy that typify faithful copies of Greek prototypes (see, for example, the statue of Venus, image 17). Instead, the figures are fleshy, with doughy muscles and seemingly boneless bodies. Their heads are also overlarge, and the most important figures (Dionysus and the Seasons) are shown as larger than the other characters, emphasizing their importance in the composition. These stylistic characteristics are typical of sculpture of the later Roman empire, innovations that would be carried into early Christian art. Despite the anatomical distortion, the carving is masterful, with the deep undercutting of the high-relief figures creating striking effects of light and dark.

The Sarcophagus in Its Context

A sarcophagus such as this one would most likely have stood in a niche or against a wall, along with other sarcophagi or ash urns belonging to the same family, inside a larger tomb structure. In the high and late empire, such structures often resembled houses. Living family members would visit the tombs on appropriate days (such as the birthday of the deceased, for example) and have banquets inside the tomb chambers to honor the dead—some tomb buildings even had working kitchens. As the family dined in the chamber, illuminated only by the light of candles or oil lamps, the deeply carved figures on the sarcophagus must have seemed to dance and revel, both impressing the living and honoring the dead.

DISCUSSION QUESTIONS

- Take a quick look at the overall scene on the sarcophagus. What do you think is going on here? Is the mood happy or sad? Why do you think so?

- The four standing male figures wear nothing but cloaks. Each holds certain objects in his hands. What is each holding? What do you think these objects symbolize? What do you think these figures stand for?

- Do the standing male figures have realistic-looking bodies? Why do you think they all look alike?

- One of the figures represented on this sarcophagus is the god Dionysus. Can you tell which one? How?

- Does this seem to be a scene of worship?

- How many figures can you see on the sarcophagus? Are some of them not in human or animal form? Describe them.

- How many different kinds of animals do you see? What kinds of animals are they? How are they involved in the action?

- On a visit to the Museum, stand at least eight feet away from the sarcophagus. Which is/are the most important figure(s) in the composition? How can you tell?

- Walk all the way around the sarcophagus. How does the back differ from the front? Where do you think the sarcophagus was meant to be placed? Why?

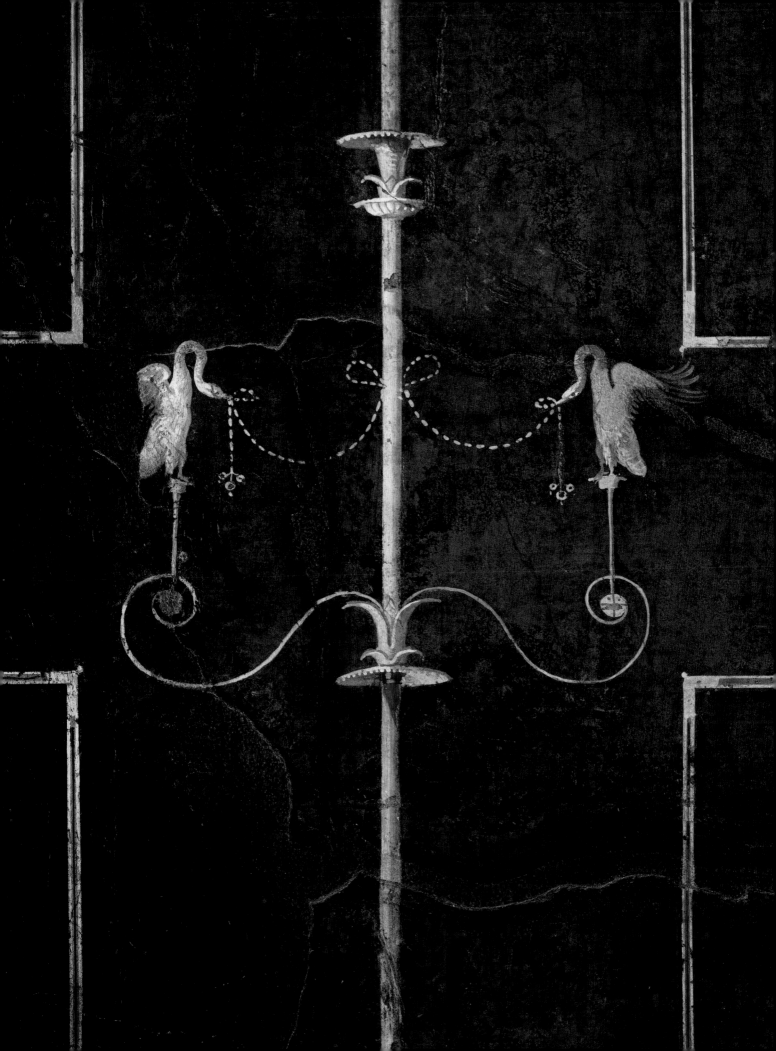

*W*e know a great deal about the lives of the ancient Romans. Our sources of information include literary works written by historians, satirists, and playwrights, as well as private documents such as personal letters, business contracts, and shopping lists written by average citizens of the empire. There is also a rich archaeological trove. Architectural remains, including wall paintings, mosaics, decorative arts, portrait sculptures, and historical reliefs, as well as pottery, jewelry, bronzes, glass, and so forth, all give us insights into Roman daily life. Although the material evidence has survived from the ancient world on a random basis, what remains helps us to understand the lives of ancient Romans from all socioeconomic strata. Inevitably, our picture of Roman daily life is incomplete, but it is enriched by new discoveries every year not only from Rome and Italy but also from the provinces of the Roman empire.

When we talk about daily life in ancient Rome, we therefore need to keep in mind both the limitations of our evidence and the vast area from which it comes. Just as Roman art in the provinces could differ in some ways from that of the capital in reflecting local styles, so the lives of people in the provinces might differ in substantial ways. Nonetheless, some broad outlines can be drawn. The purpose of this overview is to familiarize the reader with subjects that are not covered in the individual entries, supplying background information about Roman government, institutions, society, and so forth that will help readers to understand where the individual objects fit into the whole of Roman daily life.

Government under the Republic

Between 509 and 27 B.C., Rome was a Republic. From a Roman perspective, this meant that after the last Roman king was deposed, authority within the state was shared by two elected magistrates called *consuls*. That authority was called *imperium* by the Romans and entailed the legally sanctioned ability to command a Roman army and compel Roman citizens bodily. The rest of the executive responsibilities of the Republic were distributed among a number of other magistrates.

In theory, Republican Rome in some ways was a direct democracy. The Roman people passed all legislation and comprised the final court of appeal in capital cases. In practice, however, it was an oligarchy, in which the Senate, an advisory body of 300 or so hereditary advisors to the magistrates, exerted enormous influence over the magistrates and the citizen assemblies of Rome.

Government under the Empire

Although Augustus claimed to have restored the Republican form of government, his reign actually marked a return to autocratic rule for the Roman state. The emperors were the primary holders of *imperium*, although temporary grants might be made to governors or others under specific circumstances. During the empire, the social origins and role of the Senate changed. Gradually, wealthy aristocrats from the provinces of the empire were recruited into a Senate of about 600 members who had to satisfy a property qualification. Roman senators no longer came exclusively from Italy or the city of Rome.

During the Imperial period, the Senate still met to debate and discuss the great issues of the day, but it no longer had the initiative in the direction of foreign affairs or military matters. Its role was really to ratify the policy decisions and the selections of magistrates made by the emperors.

The Army

The Roman army was very influential in the development of Roman society. From its earliest origins, Rome relied on conquest by its citizen soldiers to help it grow from a small village into the capital of a huge empire. The army of the early Republic was composed of citizen property owners, but gradually eligibility was broadened to include people without property or jobs who wanted to make a career as a soldier. Thus a professional army developed. The territory controlled by Rome continued to expand until the early Imperial period. Thereafter, for the most part, the army directed its efforts toward protecting established borders.

When not at war, soldiers helped to build public works such as roads and aqueducts. At the end of the enlistment term of twenty or twenty-five years (longer for noncitizens), soldiers were often given land in the province where they had been stationed, and noncitizens were granted citizenship. A Roman naval diploma (image 32) commemorating the end of a term of service is featured in this resource.

Roman Roads

The extensive road system of the Roman empire originated from the military routes of the Republican army and from early trade routes. The first emperors vastly extended the road system, and provincial governors and municipal benefactors also built roads within their own spheres of power. These roads greatly enhanced the movement of people, goods, and information all across the empire.

Social Structure

One's place in Roman society was determined by three attributes (or their absence): wealth, freedom, and Roman citizenship.

Senators

The senators of early Rome were a hereditary order of wealthy landowners within Roman society. Since their land was worked by others, these men were expected to devote themselves to unpaid public service as magistrates, priests, judges, and/or senators. Service in the Senate normally lasted for life.

Equestrians

The equestrian order possibly evolved from the ranks of men who owned enough property to be able to own a horse and thus to serve in the Roman cavalry. Over time it was used to identify men of means who chose not to serve in the Senate, but rather to employ themselves in trade, business, banking, and the fulfillment of public contracts. They constituted, in effect, a business class. In the empire, in order to dilute the power of the senators, emperors increasingly appointed equestrians to public office.

The senatorial and equestrian orders comprised the upper socioeconomic order of Roman society during the Republic and empire.

The Poor

There was no middle "class" in ancient Rome, as we understand the term. There was a huge gap in the standard of living between the senatorial and equestrian orders and the masses of the poor. In terms of legal rights, however, the poor citizens were better off than slaves. During the early Republic, the poor were called plebeians, although some members of this order eventually became rich themselves.

Broadly speaking, throughout its history ancient Rome was an agricultural society, and most of the inhabitants of the empire lived at subsistence level. (As Rome became rich during the third century B.C., a class of urban poor also emerged.) Most people lived in the same place their entire lives, lacking either physical or social mobility.

Freedmen

For a discussion of freedmen, please see the funerary relief with the busts of a man and a woman (image 30).

Slaves

At the bottom of the Roman social hierarchy were slaves. Although firm statistics are difficult to come by, it is possible that, as a result of Rome's wars of conquest during the middle Republican period, almost one-third of the population of peninsular Italy were either slaves themselves or the descendants of slaves by the late Republic. Even moderately wealthy people would have owned at least a few household slaves.

There were many different types of slaves, and their conditions of servitude might vary widely. Agricultural slaves, for example, were essentially beasts of burden. Some well-educated slaves, however, might tutor the children of the master or assist him in business. Unlike slaves in other societies, Roman slaves were encouraged to marry and have children in order to continue to supply slaves in times of peace.

Unlike all other slave-owning peoples of the ancient world, the Romans allowed their slaves to save money earned through bonuses, and even eventually to buy their freedom. This system encouraged the productivity of slaves—they had to pay their master a fixed sum, but anything above that they could keep, a fine incentive to work hard.

Some slaves were freed by their masters in their wills. However they attained their freedom, these freed slaves and/or their children were then incorporated into the Roman citizen body.

Patronage

During the Republic, wealthy senators typically served as the so-called patrons of members of the lower orders, providing money and services to selected individuals who then became their clients. In return, the client was expected to show deference and support to his patron, going to the patron's house each morning to greet him and attend to him while he conducted public or political business. The social status and political clout of a Roman noble was reflected in the number of his clients.

Occupations

The economy of the Roman empire was predominantly based upon agriculture. The vast majority of the population worked every day on the land. The three major crops were grain, wine, and olives; these and other agricultural products were exported all over the Roman world.

Perhaps during the early Republic, individual citizens owned small plots of land to farm. Certainly the Romans of the late Republic believed that they were descendants of self-reliant small farmers. In reality, however, by the mid-Republic most of the land in Italy was controlled by a few wealthy landowners, who employed tenant farmers or slaves to cultivate their fields and tend to their flocks.

The bounty of Roman agriculture made possible a degree of urbanization that would not again be equaled until modern times. As noted, members of wealthy landowning families lived off the wealth generated from their estates and served in nonremunerative public service professions such as the Senate. Other men, such as members of the equestrian order, made vast sums of money in business, trade, or tax collection on behalf of the state.

Medicine, law, architecture, and teaching were considered honorable occupations. Lawyers, at least, could make a great deal of money in their profession.

Below the professional class and those who prospered from the produce of the land were people who engaged in physical labor to earn a living. These included shopkeepers, craftsmen, bakers, food sellers, laborers, clothes cleaners, weavers, dyers, cobblers, etc. Though these manual laborers were often regarded with scorn by the members of the higher orders, their activities were absolutely necessary to support the splendid lifestyles of the very rich. People engaged in such activities might be slaves, freedmen or freedwomen, or citizens. Legal and socioeconomic status were two separate things.

Trade

For a discussion of trade in the Roman empire, please see the entry on the transport amphora (image 33).

The Family

Rome was a patriarchal society. Extended families lived together under one roof and under the control of the *paterfamilias*, the "father of the family" who exercised *patria potestas* (the father's power) over his wife and children. He had the right to dispose of an unwanted infant by exposing it to the elements, to arrange marriages for his offspring, to disown a child, or force a daughter to divorce. If he divorced his wife, his offspring stayed with him. If a father died, guardians were appointed for his daughters of any age, even if they were married, and for any minor sons.

For a discussion of Roman marriage and the lives of Roman women, please see the entry on portraiture of Roman women (images 26–29).

Education

For a discussion of education, please see the entry on the stylus, inkwell, ink pen, and **papyrus** (images 36–39).

Death and Burial

Please refer to the cinerary urn, the funerary altar, and the sarcophagus discussed in the section on Roman Myth, Religion, and the Afterlife (images 23–25).

The City

City Planning

Rome was a city that grew haphazardly from its early foundation. However, many Roman cities, particularly those that arose out of military settlements, were rigidly organized on a grid pattern, based upon the layout of Roman military camps. The main north and south street was called the *cardo*, and the main east-west street was the *decumanus*.

The Forum

The focal area of any Roman town was the forum, an open square or marketplace around which the major public and civic buildings of a town were grouped, and a place where the inhabitants could gather on important occasions. The forum had political, judicial, and commercial uses. Because of Rome's size, the city boasted several fora, built adjacent to each other. A typical forum in a smaller city, such as Ostia, the port city of Rome, was a long rectangular courtyard that contained a variety of public buildings, including temples, basilicas (a kind of aisled hall that was used as a law court and a meeting place for businessmen), public offices, and sometimes inns and restaurants.

The open space of the forum was decorated with honorific monuments. Usually colonnades ran along two or more sides of the forum so that townspeople could walk protected from the sun and rain. One of the temples was usually dedicated either to the Capitoline Triad, the three most important deities of the Roman state (Jupiter, Juno, and Minerva), or to a past deified emperor.

The Insula

There were relatively few private houses in the city of Rome. Most people lived in a type of apartment house called the *insula* (island), which was four or five stories high, built of brick-faced concrete, and arranged around a central courtyard that all the inhabitants could use. The ground floor, with wide doorways, usually housed shops or eating establishments. Above were private apartments of various sizes. Many were cold and small. There was no private plumbing, but inhabitants could visit public latrines and great bath complexes as well as many smaller baths (*balneae*) that were available in urban areas.

The Domus

More people lived in private homes outside of Rome. The *domus* (house) was typically very private and inward-facing. Rooms were grouped around an *atrium*, an open courtyard with a hole in the roof to catch rainwater in a sunken basin below. The hearth was originally located in the *atrium*, and the statues of the household gods and the funerary masks of ancestors were kept there. If more space was available, the house usually included a colonnaded garden area around which the more private rooms were arranged. Most of these rooms were quite flexible in use. Very often an extended family lived in a single *domus*; in fact, the Latin word *familia* refers to all the people living under one roof, including slaves of the family.

The Baths and Their Architecture

The public baths were one of the most common and important building types in the ancient Roman world, functioning in large measure as social hubs in their communities.

Free or inexpensive for their users, many of whom did not have internal plumbing at home, the baths offered visitors a chance to swim, exercise, stroll, read, and generally to enjoy leisure time with friends

Roman bath complexes, with their series of great domed and vaulted rooms, were also a new building type, though Greek antecedents of a very different character are known. In its full-blown imperial manifestation, the typical Roman bath was a rectangular, symmetrically balanced complex with parallel sets of changing rooms and sweat rooms for men and women and a central block of bathing rooms—including a swimming pool (often open to the sky), a cold plunge bath, an area of lukewarm water, and a hot-water bath—as well as exercise grounds, gardens, lecture halls, and libraries. The hot baths were heated by a central furnace, and the floors were raised on brick supports so that hot air could be pumped beneath them and up the walls to heat the room (the **hypocaust system**). The interiors of the baths were lavishly decorated with black and white floor mosaics depicting marine themes, richly marbled walls, and statues, often Roman copies of Greek athlete statues. The largest bath complexes, such as the Baths of Caracalla at Rome, could hold 3,000 people.

Water Supply

Roman public baths had running water, thanks to the skill of Roman architect-engineers, who designed a sophisticated system of aqueducts to bring fresh water to the city from many miles away. The most extensive of the aqueducts, which worked on the basis of gravity, were constructed under imperial auspices. The aqueducts, which were so well built that many

remain standing today, supplied water to the baths, to private homes of the affluent, and to the ubiquitous fountains from which the inhabitants drew drinking water, and whose cooling sprays helped to "air condition" the city. Aqueducts also irrigated gardens around the city. Once water from an aqueduct moved from its originating spring to its destination town, it was stored in water towers and piped to fountains, private houses, and public baths, with fountains receiving top priority in case of drought.

Rome had a system of sewers to carry off rainwater and water from the public baths, and public latrines were situated throughout the city.

Other Municipal Services

The first emperor, Augustus, established fire and police departments at Rome. Unfortunately, the city of Rome was crowded and noisy, and perhaps these conditions combined to make it quite violent. There was no street lighting after dark, and wealthy citizens were advised to walk about at night only with a bodyguard.

Shopping

Most apartment blocks had *tabernae*, or one-roomed shops, on the ground floor opening onto the street. Many of these shops made and sold food. For example, bakeries had counters near the street to sell bread, and grinding mills and ovens in the back. Fish shops had water tanks for the live catch, ovens for cooking them, and counters to sell them. Shops selling oil and wine had counters with huge open-mouthed jars set into them to hold the provisions, which were then ladled out to buyers. Rome even had a sort of mall in the Market of Trajan, a multi-level complex that included a covered market hall, a warehouse, administrative offices, and nearly 150 shops that opened off the arcaded hemicycle.

The Urban Masses

Imperial Rome had perhaps one million inhabitants. Many had come to the city from rural areas when they were replaced on farms by slave workers. Jobs might be very difficult to find, and prices were high. There was no pension system, unemployment insurance, or medical plans, so social security was nonexistent for the urban poor. Some people living within Rome became the clients of wealthy patrons, whom they provided with political support in return for handouts. Others relied on a grain dole that the government instituted in the late Republic and continued during the empire.

Entertainment

For a discussion of the popularity of sporting events in the Roman world, please see the entry on the gladiator cup and the beaker with a chariot race in this section (images 34, 35).

Theater was popular, especially a kind of burlesque skit called mime. Though actors lacked social standing, they often had huge followings and became very wealthy. Acts with tumblers, jugglers, magicians, puppeteers, and performing animals were also in demand, as was pantomime.

Individual sporting activities were popular. Physical exercise for men, which in the Republic had been encouraged as a way of staying in shape for military service, gradually became valued simply as a way of keeping fit. Popular sports included boxing, wrestling, track and field, and a variety of ball games. Hunting, fishing, and gambling with dice were popular as well.

Many businesses and trades established social clubs. In addition to providing facilities for socializing, these dues-supported organizations often helped to pay for the burials of deceased members. Some of the businessmen's societies were very affluent and had luxurious facilities.

Romans also traveled for leisure. People flocked to the traditional Greek athletic games like the Olympics, for example, and traveled to see the splendid temples of Greece and the pyramids of Egypt. Affluent families maintained vacation villas away from Rome so that they could spend the hottest months of the year in the mountains or at the sea. The area around the Bay of Naples was an especially popular spot. The great orator Cicero, for example, had three villas there (as well as three others elsewhere—and he was not a terribly wealthy man!), while Julius Caesar, Marc Antony, and the emperor Augustus each had a villa in the area. For a discussion of villas, refer to the entry on the Boscoreale wall paintings (image 40).

A "Typical" Day in the Life

With only oil lamps for light, most Romans were awake and active only from dawn to dusk. They divided this period into twelve hours, even though days in the winter were of course much shorter than those of the summer. The way the day was spent differed according to one's place in Rome's highly stratified society.

Among the upper orders, dressing for the day was a rather involved process. Male citizens wore a toga, a very awkward round garment that usually was put on with the assistance of a slave. Members of the senatorial and equestrian orders might wear special boots, but the vast majority of Romans wore simple sandals.

For a matron of means, dressing was a somewhat more complicated endeavor. Hairstyles were extremely elaborate during many periods of the empire, and to dress the hair properly required the assistance of a female slave who also helped the lady of the house to apply her makeup. The Roman

wife dressed in an under-tunic and a long garment, usually white, called a *stola*, which signified her status as matron. Over this was worn a *pallium*, or cloak, which could come in many hues.

Men who were important patrons might spend part of the morning at home to receive the visits of their clients. Then they would go off to perform their official duties in the Senate or the law courts. Their wives usually spent the morning overseeing the slaves as they carried out housekeeping duties, which were relatively simple since there was little furniture in most Roman houses.

At mid-day, husband and wife often convened for lunch. Afternoons were sometimes spent at the public baths. Dinner, which would have been consumed very early in the day by modern standards, was the most ample meal of the day, and for the affluent might consist of many courses of meats, fish, vegetables, fruits, sweets, and wine.

For a less affluent family, there were probably no slaves to help with dressing, shopping, or cleaning. The husband would spend his morning in service at his patron's house, or he went off to his job in a store or workshop. These establishments stayed open until dark, so he would not be able to go to the baths until much later in the day. There was no weekly holiday (like our weekends), though religious festivals, with their attendant rituals, were sprinkled throughout the calendar. For a discussion of Roman festivals, please see the overview in the section on Roman Myth, Religion, and the Afterlife.

Roman Architecture

Among the greatest achievements of the Romans were innovations with respect to building techniques that enabled them to construct structures like aqueducts, amphitheaters, bath complexes (*thermae*),

basilicas, and apartment houses (*insulae*) throughout the Roman world. These architectural forms, and the social functions that they represented, were essential to the creation of a genuinely Roman culture in the empire beyond the city of Rome from the later Republic through the second century A.D. Some of the buildings made possible by the Roman revolution in building techniques still stand today, including the great amphitheater at Nîmes (France), the palace of Diocletian at Split (Croatia), Hadrian's Wall (across northern England), and the baths of Lepcis Magna (Libya).

Many of the fundamental principles of Roman architecture were based upon those of the Greeks and the Etruscans, for example, the use of the standardized architectural systems, the Doric and Ionic orders, to determine the form of columns and the elements they supported, the entablature and the pediment. But Roman architects used existing conventions in new ways and also developed many new building forms.

The diversity of Roman institutions led to the development of a wide variety of specialized building types: religious, commercial, domestic, recreational, honorific, and military. Some of these building types had achieved a canonical form by the reign of Augustus; others, such as the baths, continued to develop through the empire.

The development of these new building types was made possible by Roman exploitation of the principle of the arch and by the use of concrete as a primary building material.

The Arch
The arch and its extension, the **barrel vault**, are very strong and economical architectural forms, capable of supporting great weight and spanning broad spaces without the need for supporting columns. The Greeks had known about the arch, but they preferred post-

and-lintel construction. However, at least by the later Republic, Roman builders were using various kinds of vaults, as well as the dome, to roof their structures. They even invented a new kind of monument, the triumphal arch, which was decorated with reliefs that commemorated important military events.

Concrete

The Romans did not invent concrete, but they learned to exploit its possibilities in inventive ways beginning in the third century B.C. Roman concrete consisted of small stones mixed with mortar, which was made of sand and *pozzolana*, a volcanic material that helped the mortar to set under water. Concrete could be cast in a variety of shapes, and it was the essential material of vaulted architecture. The concrete structure could be faced with stucco/plaster, kiln-baked bricks, or, in more opulent buildings, with marble.

Concrete could be made using unskilled labor and thus was cheaper than building with stone blocks; and it made possible the creation of large vaulted or domed spaces without the need of supporting columns. Materials could be mass-produced and then assembled on the site. Today one can still see the remains of Roman arch-and-vault or domed concrete construction all over the Mediterranean world, from the substructures of Domitian's palace on the Palatine Hill, to the aqueducts running along the hills into the cities, from the Colosseum to the great dome of the Pantheon, a temple to all the gods. Brick-faced concrete was also used to build the great apartment blocks that survive today at Ostia, Rome's port city.

Temples

Both Greek and Etruscan architecture influenced the form of Roman temples. A typical Greek temple was a rectangular building with a pedimental roof, surrounded on all sides by columns atop several steps. The Etruscans modified this prototype to build temples set on much higher podia, with steps and columns only in front, and with wide-spreading eaves. The Romans essentially adopted the Etruscan model, most notably in the Capitolium, the three-chambered temple dedicated to Jupiter, Juno, and Minerva that crowned the Palatine Hill. Some Roman temples had columns all around them, with the back and side columns engaged in the walls of the temple.

There was also a tradition of circular temples in both Greece and Italy. Roman builders adopted this type as well, raising the cylinder on a high podium and ringing it with columns. The Temple of Vesta in the Roman Forum, which housed the sacred flame tended by the Vestal Virgins, was a cylindrical temple. Some of these temples were made out of marble; others were made out of concrete faced with stone.

The Basilica

Another uniquely Roman building was the basilica, which functioned as a law court and a place for money exchange. It was a long rectangular hall, often with a semicircular apse at one end, divided into a high roofed central aisle, the nave, with lower aisles flanking the nave, and lit by clerestory windows on the sides. The aisles were separated by rows of columns. The facade was ringed by a two-story colonnade. The basilica form would serve as the prototype for early Christian churches.

Baths

These are discussed above, in the section of this overview devoted to the city.

Buildings for Entertainment

The main buildings for mass entertainment were the theater, the amphitheater, the stadium, and the circus.

A theater had three elements: the auditorium, or *cavea*; the **orchestra**; and the stage building. The *cavea*, where audience members were seated, was

semicircular and divided by staircases into wedges. Most Roman theaters were originally built against slopes, as Greek theaters had been; but the Theater of Marcellus (13 B.C.), one of the earliest permanent theater buildings that was allowed at Rome, had fully built-up seating that rested on vaulted substructures.

The amphitheater, used for gladiatorial combats and beast fights, was similar in format to a theater but was a total ellipse with seats all around the arena. The oval area in the middle was used for the fights. There was no precedent for such a building type in ancient Greece, since gladiatorial contests were not known in the classical Greek world. Vespasian's Colosseum, the first permanent amphitheater in Rome, was built on great vaulted substructures and used vaulted interior passageways to efficiently transport up to 50,000 spectators to their seats through seventy-six entrances. Once in their seats, the audience members would be shielded from the sun by a huge awning, the *velarium*, which stretched over their seats. Animals and props were kept beneath the floor of the arena and were brought to the surface by a series of complex mechanisms and trapdoors.

The construction of the Colosseum (and of other amphitheaters) was made possible by the use of light, strong arches and resilient, flexible concrete. This concrete substrate was faced with travertine, which was unfortunately pirated by builders in the post-antique era. The exterior of the building was decorated with nonstructural **engaged columns** of the three canonical Greek orders, Doric on the lowest level, Ionic on the second, Corinthian on the third, and flat Corinthian pilasters on the top level. This facade decoration linked the structure to the classical world, even though architecturally it was completely Roman.

The circus was the arena used for chariot races, the most popular sport in the Roman world. It was long and narrow with one curved end; the long sides were lined with seats. Often at least one side was built into the side of a hill. The teams of horses started at the flat end and ran seven laps around the arena, turning at the curved end around a median wall called the *spina*.

Utilitarian Buildings

Structures such as bridges, aqueducts, and sewers were purely functional, and yet they also represent high architectural achievement; for example, aqueducts such as the Pont du Gard near Nîmes still impress us today. Their construction was made possible through the use of concrete and the arch.

Honorific Monuments

Monuments commemorating important historic events crowded Rome and other cities of the empire; while we tend to think of them mostly in terms of their relief scenes of historical events, they are important as architectural structures as well. Great military victories were commemorated by honoric columns as well as sculptures and inscriptions. The most prominent of such monuments, though, was the triumphal arch, usually dedicated to the emperor; it consisted of a vaulted passageway supported on pilasters and with an attic, a frieze at the top that was decorated with a narrative relief or carved with an inscription. Arches might have one or three passageways; those which stood at crossroads might be four-sided. Rome's Forum sports three triumphal arches, dedicated to military victories by Titus, Septimius Severus, and Constantine.

Defensive Architecture

The walls that protected Rome and other cities were imposing constructions in their own right. When Rome was threatened by the invasions of the third century A.D., the emperor Aurelian ringed the city with a handsome set of walls built of brick-faced concrete that was punctuated at intervals by guard towers and gateways. The circuit largely survives today.

Funerary Architecture

For a discussion of funerary architecture, please see the entries for images 23–25 in the section on Roman Myth, Religion, and the Afterlife.

Architects

While Roman sculptors and painters were almost without exception treated as anonymous craftsmen (they often were slaves, and they worked in teams), some architects acquired considerable status in the Roman world. For example, we know that Severus and Celer were the architect-engineers who designed Nero's extravagant Golden House. Apollodorus of Damascus, who had been Trajan's military engineer during the Dacian Wars, also designed the Forum of Trajan and its adjacent curving market complex. The emperor Hadrian himself was an architect, designing his mausoleum, the Temple of Venus and Rome, and a luxurious sprawling villa complex at Tivoli. In fact, according to the third-century A.D. senator and historian Dio Cassius, Hadrian executed Apollodorus because he had criticized the emperor's architectural designs.

Roman Historical Relief

In the Greek world, public buildings were often embellished with relief sculptures, such as the metope sculptures and the Ionic frieze that decorate the Parthenon in Athens. Roman sculptors continued the tradition, but with one important change. The subject matter of Greek relief was devoted to great events that had supposedly happened in the past. For example, although the Parthenon was erected in part to celebrate the Athenians' victory over their great enemy the Persians, the reliefs showing combat depicted idealized Greeks fighting Amazons and centaurs, not defeating the Persians. The sculpture thus functioned as an analogy to real historical events.

Roman relief sculpture, in contrast, commemorated specific recent historical events and individuals with meticulous descriptive detail. The relief sculpture on the Arch of Titus, for example, depicts the triumphal procession of Roman soldiers with the spoils, including the menorah from the great temple, which had been obtained through the sack of Jerusalem in A.D. 70. The Column of Trajan, dedicated in A.D. 113, shows the successful wars of the emperor Trajan against the Dacians in what is now Romania. The sequence of war is depicted from the departure of the first troops to the final triumph of Trajan in a continuously spiraling narrative of more than 100 scenes. The emperor himself is shown multiple times in the frieze, which reinforces the sense of time passing.

Portraiture

For a discussion of portraiture, please see the overview to the section Power and Authority in Roman Portraiture, as well as the individual object entries.

Statuary as Décor in the Roman World

The artworks produced in classical-period Greece were both commemorative and aesthetic objects. Most large-scale sculpture was created for public display: statues were erected in public places to commemorate the gods, heroes, generals, statesmen, and athletes. Statues were dedicated to the gods to seek favor or to give thanks for favors granted. Funerary monuments were erected to remember the dead for eternity. Even private arts, such as painted vessels, were at root functional objects.

Beginning in the Hellenistic period, the notion of art as décor was born, and private individuals began to own statues for the first time. This taste

quickly spread to the Roman world, where a much broader segment of society began to acquire art both as decoration and as status symbol. Beginning in the late Republic, wealthy Romans with means decorated the gardens of their vacation villas with sculptural replicas of famous Greek originals whose subject matters were considered to be appropriate to the setting. Similarly, Roman baths were embellished with replicas of Greek statues of athletes, which were deemed fitting for complexes with athletic facilities. The Roman copying industry fed this interest. We owe much of our knowledge of Greek art to the private art collecting of the Romans, since it led to the production of multiple replicas of favored Greek originals. The statue of Venus (image 17) included in the section on Roman Myth, Religion, and the Afterlife is an example of a replica of a Greek original that was probably used outside its original religious context.

Painting

We know that the Romans made portable paintings, often depicting great military battles and victories, on wooden panels, and that these were displayed in public buildings or carried in triumphal processions. However, because of the perishability of wood, none of these paintings have survived other than Egyptian mummy portraits, which are treated in the entry on Roman women (images 26–29).

We also know that a great number of hand-painted illustrated books, either in the form of papyrus scrolls or of codex books with leaves, were produced. Again, however, almost none of these books survive.

Our knowledge of Roman painting thus comes almost entirely from the common practice of painting the interior walls of houses while the plaster was still damp (*fresco*), a technique that bonded the paint with the wall surface and thus made it very durable. Such wall decoration was a custom of great antiquity throughout the Mediterranean. In the case of Roman painting, preferred styles changed over time in a progression that art historians have classified into four different styles.

The First Style is sometimes called the Masonry Style because the decorator painted the walls to give the illusion that they were faced with marble slabs of different colors. The First Style originated in the Hellenistic world in the late fourth century B.C. and was used in Roman homes in the last two centuries of the Republic.

For a discussion of Second Style and Third Style painting, please refer to the entries on the Boscoreale and Boscotrecase frescoes in this section (images 40–42).

In the Fourth Style, which emerged in the mid-first century A.D., the illusionism of the Second Style and the lacy decorativeness of the Third Style were synthesized. With the A.D. 79 destruction of Pompeii and Herculaneum, whose houses provide the most coherent evidence of wall painting fashion that we have, the official progression of artistic styles comes to an end, though houses from later centuries continued to have painted walls.

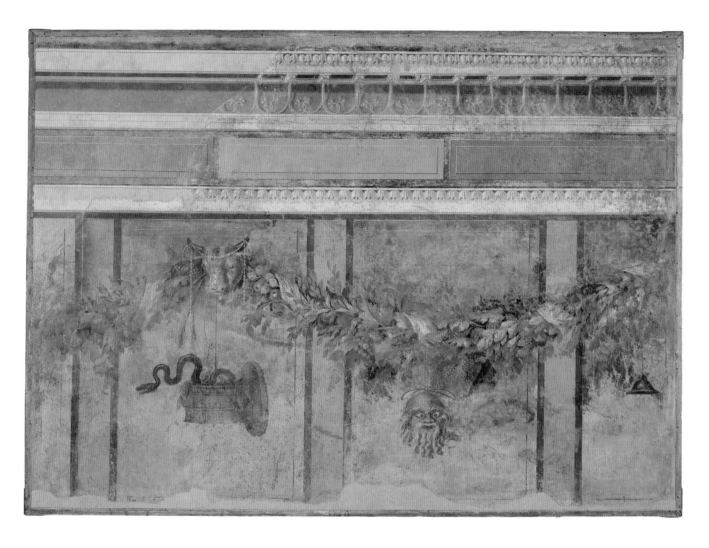

Fragment of a fresco with garlands and objects related to Dionysiac rites, Roman, Late Republican, ca. 50–40 B.C.
From the Villa of P. Fannius Synistor at Boscoreale (exedra L). Rogers Fund, 1903 (03.14.4) (image 41)

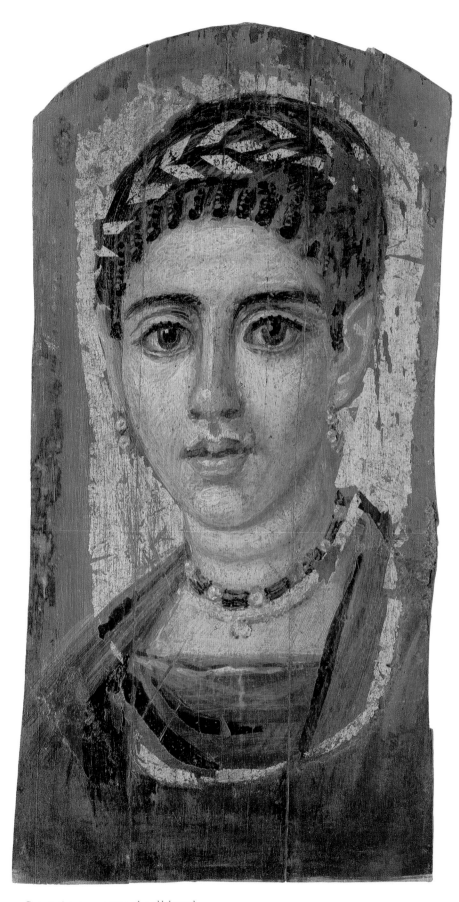

27. Portrait of a young woman with a gilded wreath

26. *Portrait bust of a Roman matron*
 Roman, Julio-Claudian, ca. A.D. 20–50
 Bronze; H. 9 ½ in. (24.1 cm)
 Edith Perry Chapman Fund, 1952 (52.11.6)

27. *Portrait of a young woman with a gilded wreath*
 ca. A.D. 120–140
 Said to be from the Fayum
 Encaustic, wood, gilding; 14 ⅜ x 7 in.
 (36.5 x 17.8 cm)
 Rogers Fund, 1909 (09.181.7)

 On view in the Museum's galleries of Roman Egyptian art

28. *Portrait bust of a veiled woman*
 Roman, Mid-Imperial, Severan,
 ca. A.D. 200–230
 Said to be from the Greek Islands
 Marble; H. 26 in. (66 cm)
 Fletcher Fund, 1930 (30.11.11)

29. *Portrait bust of a woman*
 Roman, Mid-Imperial, Severan,
 ca. A.D. 200–230
 Marble; H. 25 ⅝ in. (65 cm)
 Rogers Fund, 1918 (18.145.39)

POINTS TO CONSIDER

- Each of these four portraits depicts a high-status woman who follows the fashions of the relevant imperial court while still maintaining her individuality.

- Compared to men, Roman women led fairly circumscribed lives. However, compared with classical Greek women, they had considerably more freedom to move about in society. They were allowed to attend dinner parties and public events like chariot races, for example.

- In Roman eyes, the chief role of a woman was to bear healthy heirs for her husband and to run an efficient household. She was expected to be loyal, dutiful, and pious.

- According to legal tradition, Roman women were expected to be under the guardianship of a man, whether father or husband, at all times, and they were not supposed to own property or engage in financial transactions. However, in reality many women did act for themselves in economic matters.

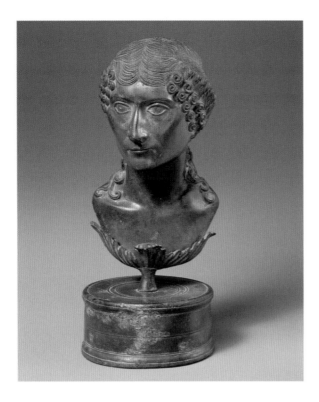

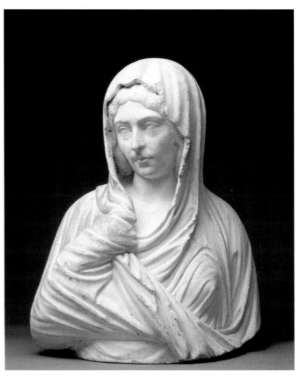

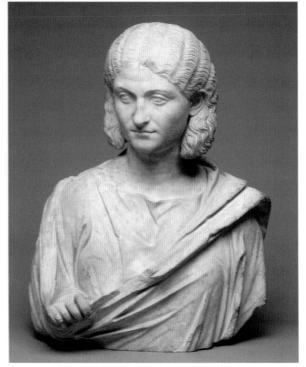

26. *Portrait bust of a Roman matron*
Roman, Julio-Claudian, ca. A.D. 20–50
Bronze; H. 9½ in. (24.1 cm)
Edith Perry Chapman Fund, 1952 (52.11.6)

28. *Portrait bust of a veiled woman*
Roman, Mid-Imperial, Severan, ca. A.D. 200–230
Said to be from the Greek Islands
Marble; H. 26 in. (66 cm)
Fletcher Fund, 1930 (30.11.11)

29. *Portrait bust of a woman*
Roman, Mid-Imperial, Severan, ca. A.D. 200–230
Marble; H. 25⅝ in. (65 cm)
Rogers Fund, 1918 (18.145.39)

- Like the portraits of Roman men, portraits of women tracked the fashions and hairstyles of the imperial court closely, even in provinces like Egypt and the Greek East.

- Over time, certain changes took place in marble portrait style; the bust became longer, until almost a half-statue was carved; and the irises and pupils of eyes began to be incised with a chisel rather than being painted.

- Not all portraits were lifesized, and they could be made in bronze as well as marble.

- The rich tradition of Roman panel painting survives in the painted Roman mummy portraits from imperial Egypt. Unlike traditional Egyptian mummies, which used stylized masks to represent the face, Roman-era mummies had realistically painted portraits that captured the appearance of the subject at the time of his or her death.

The Lives of Roman Women

Interest in the lives of Roman women has increased dramatically over the last fifty years. Because much of what we know about women's lives in the ancient world comes from men, scholars have had to be careful about the conclusions they have drawn from literary texts. Moreover, most of the texts refer only to upper-class women.

Nevertheless, certain basic facts can be ascertained. The main purpose in life for a Roman woman was to bear legitimate heirs for her husband and to manage her household. Women lacked political rights, either to vote or hold office, though some women of the imperial court wielded considerable political influence behind the scenes. In general, the economic, educational, and political opportunities enjoyed by men were denied to Roman women.

Roman Marriage

Roman marriages were usually arranged for the participants by older family members for political or business reasons, and in order to produce an heir; marriage for love was not the norm. Girls were commonly married around the age of twelve, while their husbands were at least a few years, and often decades, older. No legal steps needed to be taken for a marriage to be valid. If a man and woman lived together with the intention of staying together, they were considered married. The wedding ceremony was also regarded as evidence of this intention.

Both husband and wife had the right to divorce and remarry. If the intention to form a lasting union ended, the marriage was considered to be over; no public notice was necessary. Remarriage was common and acceptable.

In economic affairs, according to law, almost all women, even as adults, were required to have a male guardian, preferably a father or husband, to act for them in financial affairs. However, there were two exceptions to this rule. For one, the emperor Augustus, in an attempt to boost the Roman birthrate, decreed that freeborn women with three children (or freedwomen with four), who did not have a father or husband, could act for themselves in economic matters. In addition, the Vestal Virgins, powerful priestesses who guarded the sacred hearth of Vesta in the Roman Forum, always were allowed to conduct their own business. In reality, by imperial times many women acted on their own in matters of business, and the notion of male guardianship was the legal theory but not always the social practice.

The ideal *matrona* (married woman) was expected to devote herself to the well-being of her husband and children by running an efficient household while upholding, and imparting to her children, the traditional Roman virtues of duty and loyalty. Although she might have received an elementary education, she was not supposed to work outside the home. A well-born woman might gain a public role through philanthropy, however—for example, one Eumachia had a building erected at Pompeii for the guild of fullers and was immortalized by an inscription and a statue commemorating her generosity.

Many poorer women held jobs outside the home as wet-nurses, midwives, craftswomen, or market traders. They were also expected to run their households, of course.

Roman Women Compared with Greek Women

Despite their disenfranchisement and limited career options, Roman women did have considerably more freedom than the women of classical Greece. They could go out to dinner parties with their husbands and attend the theater and the games (although they were segregated at gladiatorial contests, the sexes sat together in the circus).

Hairstyles of Roman Imperial Women

Like Roman men, well-born Roman women were commemorated in portraits. In the Republican period, portraits of women had more idealized facial features than those of men. In the Imperial period, however, portraits of women, like men's, tended to mimic imperial trends. For women, this meant copying the hairstyles of the empresses, many of which were extremely elaborate and required hours to assemble, even with the assistance of maids and hairpieces. Such a coiffure proclaimed the high status and wealth of a woman who could afford the leisure, and the staff, to wear it.

1. Bronze Portrait Bust of a Roman Matron

The Museum's underlifesized bronze bust of a woman (image 26) is set in a round base with an acanthus plant growing out of it. Often acanthus symbolized death and the afterlife, but sometimes acanthus supports appear in portraits created during the subject's life. Thus here the support may simply be a decorative, rather than a symbolic, element.

The woman's rather thin head is turned slightly to the right. She has large, almond-shaped eyes with incised irises and pupils and strongly molded eyebrows, a prominent nose, and a small mouth with thinly pursed lips. Her hair is center-parted and is arranged so that two rows of curls frame each side of her face. She wears a long braid of hair in back, and strands of loose hair fall across her shoulders.

This particular coiffure is associated with Agrippina the Elder, a granddaughter of Augustus, the wife of the popular general Germanicus, and the mother of the emperor Caligula (whose portrait is in the Power and Authority in Roman Portraiture section, image 5). However, it is likely that this is a private portrait, influenced by imperial styles. The adoption of such a hairstyle by the subject suggests that she approved of the Julio-Claudian dynasty and identified with it. The portrait may have been set up in a commemorative shrine within the family house.

2. Painted Mummy Portraits from Roman Egypt

Painted mummy portraits from Roman Egypt, which are in the collection of the Museum's Department of Egyptian Art, represent the melding of two traditions: mummification and the Roman interest in realistic portraiture.

Painted mummy portraits are virtually the only panel painting surviving from the Greco-Roman world because these pictures, depicting historical events and myths, as well as still lives and portraits, were painted on wood, an organic material that decomposes rapidly in wet environments. However, thanks to the arid Egyptian climate, a substantial corpus of funerary portraits, painted on wood between the first and third centuries A.D., survives.

History of Roman Egypt

Egypt came under the rule of the Macedonian Ptolemaic dynasty following its conquest by Alexander the Great in the fourth century B.C. Thereafter a Macedonian elite ruled the country from the new capital, Alexandria, which became a cultural and intellectual center of renown. During this period, traditional Egyptian customs, including mummification and burial practices, continued as before. Coffins were decorated with stylized, idealized images of the deceased.

After Octavian defeated Cleopatra and her Roman consort Marc Antony at the Battle of Actium in 31 B.C., Egypt became a Roman province, ruled by a prefect, or governor, appointed by the emperor. The change from Ptolemaic to Roman rule probably did not have much impact on the lives of most Egyptians, as a Greco-Egyptian elite continued to hold most administrative power.

Mummy Portraits in Roman Egypt

In the course of the first century A.D., however, the appearance of mummy portraits produced for the Greco-Egyptian upper classes did change. The traditional idealized masks were replaced by highly individualized, realistic painted portraits. They were usually painted in **encaustic**, a mixture of hot wax and pigment, on thin wooden panels that were set into the linen wrappings of the mummy. In hairstyle, clothing, and jewelry, the appearance of these portraits followed contemporary Roman court fashion. Just as with Roman portrait busts, these fashion details make it possible to date the portraits quite precisely. Apparently these portraits were not made for display during the sitter's life; comparison of the images with CAT scans of the remains inside these mummies makes it clear that the portraits represent the deceased at the age of death.

The Museum's Mummy Portrait

The Museum's mummy portrait (image 27) is painted in encaustic on a thin wooden board. Its subject is

a young woman with an oval face, large round eyes with prominent lashes and straight eyebrows, a long nose, full lips, and prominent Venus rings (folds of flesh that were regarded as a sign of beauty) on her plump neck. The artist painted pink highlights on her creamy skin. She gazes directly out at the viewer, her lips slightly parted. She wears a dark tunic and a mantle of a purplish hue. Her black hair is wound in braids at the top of her head; small corkscrew curls ring her brow. She wears hoop earrings with pearls, a gilded necklace with a suspended crescent pendant (called a *lunula*), and a necklace of pearls alternating with long green (emerald?) beads. She wears a schematically depicted gold wreath of leaves in her hair. The background of the painting is also gilded.

The portrait has been dated to the time of Hadrian based on the hairstyle, jewelry, and clothing, although the corkscrew curls are perhaps a local variant on the Roman court coiffure. The youthful appearance of the woman reflects her age at death and is a reminder of the short life expectancy in ancient times.

3. Two Portraits of Women from the Severan Period

These contemporary portraits (images 28, 29) demonstrate how Roman portrait style had evolved over time. The length of the busts has been extended almost to waist level (compare with the bronze Julio-Claudian head, image 26), and the irises and pupils of the eyes have been incised, a fashion that began in marble sculpture in the second century A.D. The hairstyles of the women follow the court fashion favored by Julia Domna, wife of the emperor Septimius Severus, whose center-parted hair was separated into thick parallel pleats and gathered in back in an enormous bun. In the case of the veiled woman (image 28), the hair covers her ears, while

the other woman's hair is pulled behind her ears, a somewhat later variant on the hairstyle.

The two portraits are posed similarly; both turn and look to the right, and both have the right hand raised. The turn of the head is reminiscent of the pose in the marble Caracalla portrait from the same time period, discussed in the section on Power and Authority in Roman Portraiture (image 10).

However, there are differences between the two portraits. The veiled sitter appears to be a young woman, as her face is unlined. Her cloak is pulled over her head, which is slightly lowered; her gaze is cast upward. With her right hand she reaches to touch her veil, a gesture, called *pudicitia*, meant to convey a sense of her modesty and fidelity, in Roman eyes the most important qualities a woman could possess. To cover her head is also a gesture of piety. The figure seems to be lost in thought, and this sense of an inner life gives a quality of immediacy to the image. This is typical of the period, when artists tried to convey a sense of psychological depth in their subjects. The folds of her drapery and the strands of her hair have a flattened, linear quality.

The sitter in the other portrait has a slightly fuller face, and there are traces of lines on her cheeks and forehead. She gazes directly to the right. Her right hand clutches the hem of the cloak drawn over her left shoulder. The carving of her garments and her features is more three-dimensional than that of the veiled woman. Thus, though the two portraits are quite similar, each represents a distinct individual, and their execution reflects two different styles of carving.

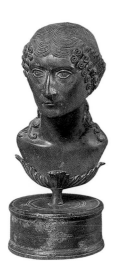 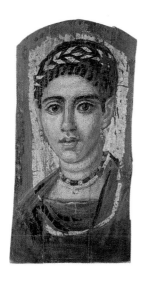 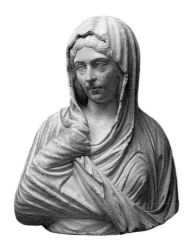 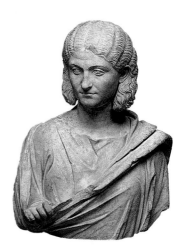

DISCUSSION QUESTIONS

- Consider these four portraits as a group. Which do you think is the most realistic? Why? What do they have in common? What are the differences?

- Which of these women looks the most "modern" to you? Why?

- Do you think the different media in which these portraits were made accounts for the differences among them? How?

- Why do you think the Romans had sculpted busts of their family members made? Do we do anything similar today? What is it? Why do we do it?

- What social class(es) do you think the women in these portraits belonged to? Why?

- Describe the different hairstyles worn by each of these women. What do you think is the importance of the different ways of dressing the hair?

- What age do you think most of these women are? Do you think this tells us something about the life expectancy of the average Roman woman? Or does it tell us about how they wanted to look for their portraits?

- Do you get a sense of the psychological state of any of these women? Which ones? Why?

- Compare these portraits with Cominia Tyche's in the section on Roman Myth, Religion, and the Afterlife (image 24). Whose hairstyle is the most elaborate?

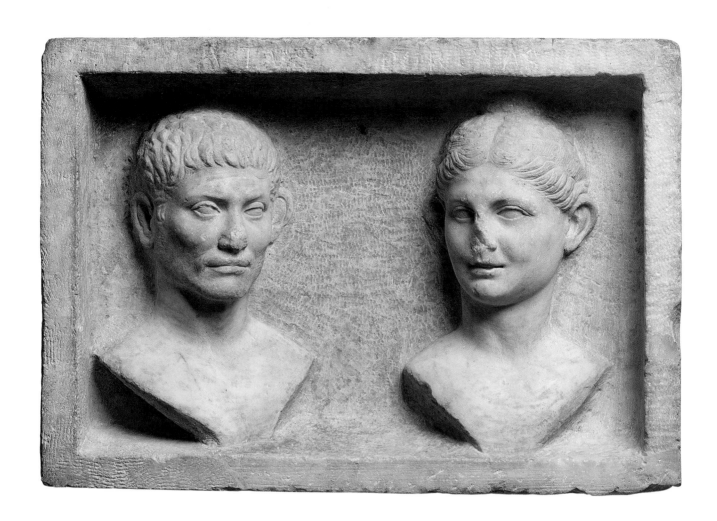

30. *Funerary relief with busts of a man and a woman*
Roman, Early Imperial, Augustan,
ca. 13 B.C.–A.D. 5
Marble; overall: 20 x 28⅛ x 5⅜ in.
(50.8 x 71.4 x 13.7 cm)
Rogers Fund, 1909 (09.221.2)

POINTS TO CONSIDER

• Romans often freed their slaves as a reward for meritorious service. Slaves could also buy their freedom. These **freedman** and/or their children were incorporated into the Roman citizen body.

• In the late Republic and early empire, freedmen commissioned relief portraits of themselves and family members to embellish the facades of their tombs. These portraits grew out of the same impulse that led aristocratic families to keep portrait busts of their ancestors on view. The freedmen reliefs often showed members of the same family and were inscribed with the new names they had been given upon obtaining their freedom.

• The young man and woman depicted in this funerary relief are shown as portrait busts, not as actual people. In reality, only patricians could have portrait busts in this period.

• The couple's fashionable hairstyles and idealized faces reflect the type of portrait image popular during the reign of the emperor Augustus, which helps to date this relief.

Freedmen

An order defined not by economic status but by legal status within the Roman state was that of the freedmen. Freedmen or freedwomen were individuals, formerly slaves, who had been granted freedom by their owners for one reason or another and thereby were granted most, though not always all, of the rights of freeborn Roman citizens. At least some of these former slaves became quite prosperous.

Funerary Monuments of Roman Freedmen

In the late Republic and early empire, freedmen began to commemorate themselves by commissioning carved relief portraits of themselves and their family members to be placed on the facades of their tombs. (To read about the kind of tombs that the freedmen might have been buried in, please see the entry for image 23 in the section on Roman Myth, Religion and the Afterlife.) In these reliefs, husbands and wives often were depicted together, in a kind of artistic recognition of the legal status of marriage that they had obtained once they were freed. If they had freeborn children, these were featured as well, publicizing their status.

The funerary reliefs of freedmen could range from full-length portraits to shorter busts that emulated the three-dimensional portrait busts that patrician Romans used to commemorate their dead family members. Often the freedmen are depicted wearing the toga, the symbolic sign of Roman citizenship; freedwomen wear the *palla* as a similar sign of status.

The Museum's Freedmen Funerary Relief

The Museum's relief, characteristic of a group of tomb sculptures known from Rome, represents the busts of a man on the left and a woman on the right. They are carved as if they are actual portrait busts, as the body of each is carved just down to shoulder level, and then tapers at the top of the chest, with no clothing indicated. The heads turn slightly toward each other, which may be meant to suggest that they are married. The outer ear of each is carved in very high relief, while the inner ears are in very shallow relief. Both appear to be around thirty years of age.

The man's hair is combed forward in short waves that lie on his forehead, a hairstyle similar to that of men in the Augustan period. The woman's center-parted hair is waved back from her face and pulled into a bun on the top of her head. It is possible that in fact the bun would have been at the nape of her neck; the artist here is confined by his less-than-three-dimensional space. The lips of the woman are slightly parted. Although the faces are lifelike, these are not actual portraits but instead idealized portrait types,

in emulation of the idealizing image adopted by the first emperor, Augustus. (See the discussion of the Augustan portrait type in the Power and Authority in Roman Portraiture section, images 3 and 4.)

The relief does not seem to be finished. Chisel marks are visible on the background and the framing molding. However, the relief had been painted, and substantial traces of red paint remain in the background. On the top lip of the frame is the inscription "Brutos Porcias." This brief inscription, with its suspect Latin, was almost certainly added to the relief long after it was made, perhaps in an awkward attempt to identify the couple as the famous Republican figure Brutus and his wife. In fact, freedmen usually took the names of their former masters after they were freed, and they took pains to inscribe their names on their monuments. The lack of an inscription on this relief suggests that it was carved separately and set into the tomb wall, perhaps below the relief itself.

DISCUSSION QUESTIONS

• Describe the two people represented in this relief. How old do you think they are? What are they wearing? Do you think that the artist was looking at real people when he made this portrait?

• Do you think the two people in this relief have any relationship with each other? What do you think that relationship is?

• Do you think this piece is unfinished? Why or why not?

• This monument decorated the tomb of two people who were former slaves but who had attained the status of freedman and freedwoman, with most of the rights of Roman citizens. Why do you think they chose to decorate their tomb with their portraits? Is this similar to the way we decorate the gravesites of our family members?

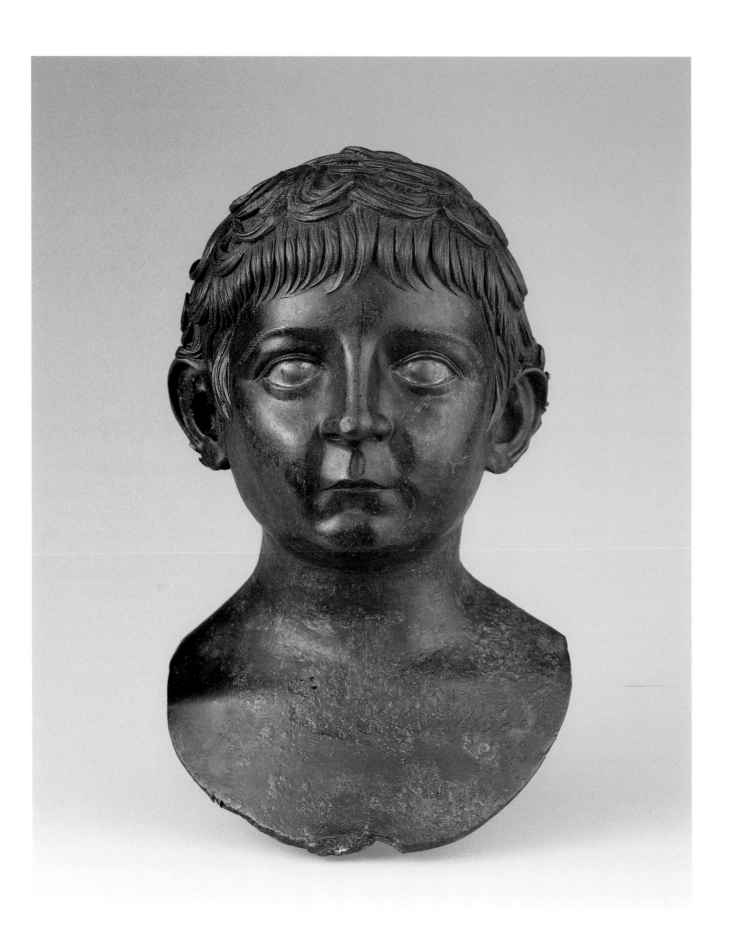

31. *Portrait bust of an aristocratic boy*

Roman, Julio-Claudian, ca. A.D. 50–58
Bronze with silver and copper inlaid eyes;
H. 11 ½ in. (29.2 cm)
Purchase, Funds from various donors,
1966 (66.11.5)

POINTS TO CONSIDER

• Classical Greek sculptors tended to represent children with the proportions of miniaturized adults, instead of depicting them with the large heads and plump limbs of actual small children. Starting in the later fourth century B.C., artists began to depict children more naturalistically, and this realism continued in the art of the Roman period.

• The representation of children in sculpture became widespread during the reign of the emperor Augustus, who encouraged Romans to have larger families in order to keep the population stable and rewarded those who did so.

• The costly material and fine quality of this bronze portrait of a small child have led some scholars to believe that it represents a member of the imperial family, most likely the emperor Nero as a child. Though Nero did have a youthful official portrait type, the child in the Museum's portrait appears to be much younger. He must have belonged to a wealthy family, however.

Children in the Ancient Roman World

The attitude of the ancient Romans toward children has long interested scholars. In Rome, a law said to have been laid down by Romulus, the founder of Rome, supposedly decreed that parents were required only to "bring up all their male offspring and the first-born of the girls" (Dionysius of Halicarnassus, *Antiquitates Romanae*, 2.15.1). While several Roman authors mention infanticide, and the so-called Twelve Tables (451 B.C.), Rome's earliest law code, permits the exposure of "deformed" children, it is unclear how common this practice really was.

It is also uncertain how emotionally involved parents were with their children, whether boys or girls. However, the frequent depiction of children in Roman art, as well as the commemoration of dead children in funerary contexts, suggests that many parents were deeply attached to their offspring.

In classical Greek art, children were often depicted as small adults, with bodily proportions that did not reflect the large heads and chubby bodies that typify infants and small children. In the second half of the fourth century B.C., however, artists began to adopt a more realistic style that accurately portrayed the physique and facial features of children. This change was part of a trend toward greater naturalism in Greek art. Greek artists brought this naturalism

with them when they began to work at Rome in the later Hellenistic period.

As far as we know, the widespread depiction of children in Roman art began in the Imperial period. The first emperor, Augustus, had a keen interest in promoting large families among his subjects in order to sustain the population. In addition, he wanted to promote the imperial dynastic succession. Therefore statues and relief sculptures commemorating youthful members of the imperial family were widely distributed. In the private sphere, families were interested in promoting their dynastic continuity as well, and portraits of their children were commissioned by those who could afford them.

The Museum's Bronze Bust of an Aristocratic Boy

The Museum's well-preserved bronze portrait of a small boy, perhaps four years old, is a vivid example of an accurately depicted child. The head is lifesized, and is worked for insertion into a herm (tapering pillar or column) of wood or stone. The child has a plump round face, large eyes, and a small mouth with thin lips. Still intact are the inlaid silver "whites" and copper irises that would have given the eyes of

the burnished bust a vividly lifelike quality. The boy's slightly protruding ears, as well as his hairstyle, with locks brushed forward over the brow, curled over the ears, and left tousled on top, are similar to those of members of the Julio-Claudian imperial family.

This resemblance, as well as the quality of the workmanship, have led some scholars to suggest that this portrait represents Nero, the last emperor of that dynasty, as a small child. Nero, unlike any of his predecessors, had five official portrait types that documented important dates in his life, and there are extant several images of him in his earliest portrait type. However, he was already thirteen years old when he was adopted by his great-uncle/stepfather, the emperor Claudius, and this is clearly a much younger child. Perhaps it represents a child whose parents were admirers of the Julio-Claudian dynasty and wished the portrait of their child to reflect that allegiance. In the absence of an inscription, the identity of the Museum's fine bust remains uncertain.

DISCUSSION QUESTIONS

- Describe the facial features of the little boy in this portrait. Do you think he looks like a real little boy? Why or why not? What mood do you think he is in?

- How old do you think the child represented in this portrait is? Why?

- Do you think that this child was an important member of his family? Why or why not?

- Compare this bust with the bronze portrait statue of an aristocratic boy illustrated in *Art of the Classical World*, no. 405. Which boy do you think is older? Why? Compare their features and hairstyles. Do you think they might be related? Why or why not?

- Do you have any portraits of yourself? Who has made them? What materials are they made of? What purposes do they serve?

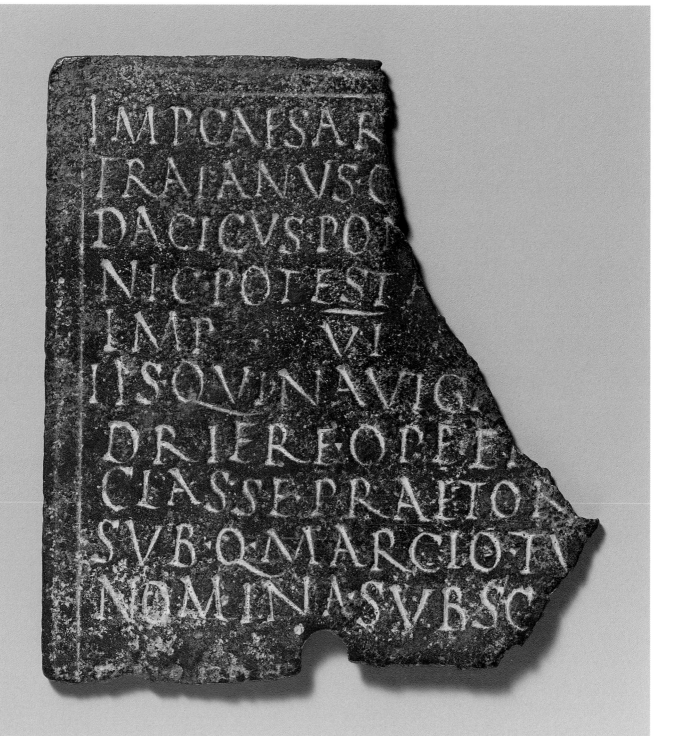

IMP CAESAR
TRAIANVS C
DACICVS PO
NIC POTESTA
IMP VI
IISQVINAVIG
DRIEREOEE
CLASSE PRAETO
SVB Q MARCIO T
NOMINA SVBSC

32. *Diploma for a sailor from Trajan's fleet at Misenum*

Roman, Mid-Imperial, Trajanic, A.D. 113–114

Bronze; overall: 3 ¹⁄₁₆ x 2 ¾ x ¹⁄₁₆ in.

(7.8 x 7 x 0.2 cm)

Rogers Fund, 1923 (23.160.52)

POINTS TO CONSIDER

- The Roman navy was first developed in the later Republic, and it proved crucial for the maintenance of the substantial imperial territories amassed by the end of the first century A.D.

- Originally only Roman citizens of means could serve in the armed forces. Later, however, in order to get enough soldiers and sailors, men were recruited from the imperial territories, and they served as *auxilia*. Upon honorable discharge at the end of a twenty-five-year term of service, they were awarded Roman citizenship with its benefits of protection under Roman law, voting rights, and the legitimization of their marriage and children.

- Such a discharged auxiliary received a bronze diploma comprising two sheets of bronze that could be hung up for display, confirming his formal discharge and bestowing on him Roman citizenship.

A Brief History of the Roman Navy

In the early years of the Roman Republic, little need was seen for a navy. Only in 311 B.C. were two officials (*duoviri*) appointed whose responsibility it was to build and maintain warships. However, when Rome came into conflict with Carthage over the island of Sicily in 264 B.C., the Romans realized that they needed a navy, and from scratch they built a fleet that defeated the mighty Carthaginian navy in five out of six engagements during the First Punic War.

During the late Republic, Rome's allies in Italy and Greece contributed the most effective naval contingents to the Roman navy. However, after winning the Battle of Actium in 31 B.C., the first emperor, Augustus, decided to establish permanent Roman naval forces. These consisted of a fleet to guard the northwest coast of Italy and Gaul; two fleets to protect the Italian coast, one based at Ravenna and one at Misenum; a small fleet at Alexandria; and probably one at Seleucia. Later fleets would be added in the Black Sea, in Africa and Britain, and on the Rhine, Danube, and Euphrates rivers. The Roman navy's duties included transportation of troops, support of land campaigns, protection of coastal towns, and dealing with pirates and hostile barbarian forces.

The Recruitment of Auxiliary Troops

In the early Republic, the Roman armed forces had been recruited from within the city itself, and there was a property qualification for service. By the time of the empire, however, there were not enough citizens within Italy to provide sufficient recruits for both the army and navy. Thus Rome began to enlist soldiers from its imperial territories; these soldiers and sailors comprised the *auxilia*. Although the term of service was long (twenty-five years, at least half the lifetime of most soldiers), the recruits were promised Roman citizenship once they completed their military service. In addition, for the first time men without property were now allowed to serve in the armed forces. The state paid for their weapons and also gave them a stipend. By such measures, the Roman emperors were able to sustain a more or less consistent number of recruits for the army and the navy for the first 250 years of the empire.

The Significance of the Bronze Diploma

Upon the completion of his term of service, an honorably discharged auxiliary soldier or sailor was presented with a pair of small folding bronze tablets, called a *diploma*, which confirmed his service and discharge. The text of the Museum's diploma indicates that its recipient had served in the Trajanic fleet at Misenum, across the Bay of Naples from Pompeii (see the map for the location of Pompeii).

- The bronze diploma represents a document of discharge for a naval auxiliary man. What changes in his life does it commemorate?

- Why do you think such a diploma was important? Do our high school diplomas have the same sort of significance today? Why do you think people often frame their diplomas?

- Many Roman documents were written on perishable materials such as papyrus. What do you think is the significance of receiving a bronze diploma?

- Think about what kind of documents are important to you. What are they? Where do you keep them? What kinds of materials are they made of?

Obverse (above) and reverse (below), shown actual size

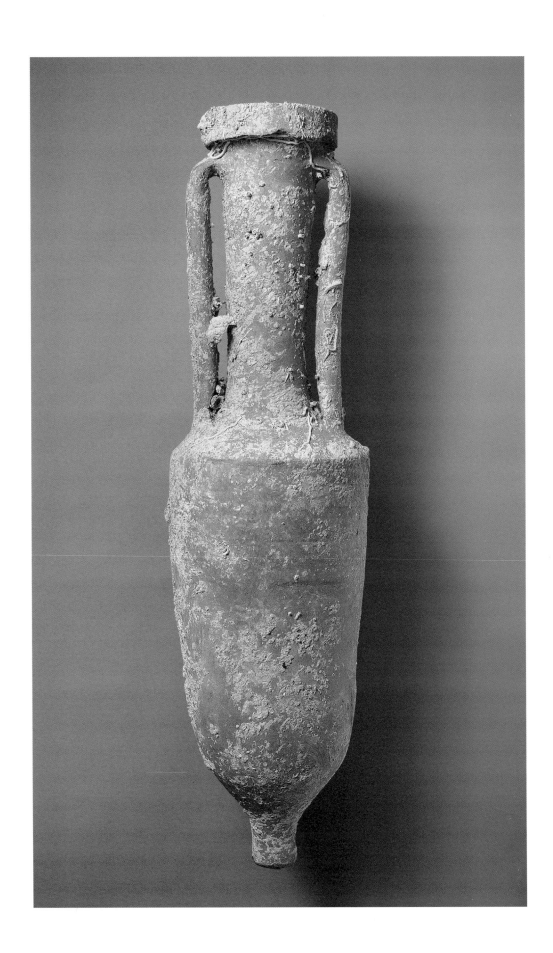

Roman, Republic, ca. 100 B.C.

Terracotta; H. 40 ½ in. (102.9 cm)

Gift of Captain Jacques-Yves Cousteau,

1953 (53.70)

- The advent of underwater archaeological studies after World War II has led to the discovery of many ancient shipwrecks and their cargoes. Study of what the ships carried has helped scholars to understand the nature of trade and commerce in the ancient world.

- Most goods were shipped in amphorae, terracotta two-handled vessels. Products shipped around the Mediterranean in amphorae included wine, olive oil, grain, olives, dates, resin, dyes, and ores.

- In the late Republic, wine from Italy was highly prized throughout the Mediterranean world. The Museum's amphora comes from a shipwreck off the southern coast of Gaul, whose natives eagerly imported Italian wine and dinnerware.

Trade and Transport in the Roman World

The ancient Romans constructed a comprehensive and durable paved road system that linked the provinces and was used to move troops and goods around the empire. Many of these roads, such as the famous Via Appia leading from Rome, partially survive today.

For the transport of bulky goods such as grain, wine, and olive oil, though, the Romans relied on transport by ship. Trade routes crossed the Mediterranean Sea, as grain from Egypt was carried to Rome, wine from Italy was sent to North Africa, and olive oil from Asia Minor was transported to Egypt. Analysis of the ancient shipwrecks that were a by-product of such extensive maritime trade has provided a great deal of evidence about ancient trade—and this research has been made possible by the relatively recent advent of underwater archaeology.

Underwater Archaeology

The self-contained underwater breathing apparatus, or SCUBA, was developed in 1939 for military use. A few years later, the French naval captain Jacques-Yves Cousteau refined it for use in underwater archaeology. The subsequent exploration of ancient wrecked ships and their contents around the Mediterranean Sea has

provided archaeologists with a wealth of information about commerce in the ancient world. It has also yielded an abundance of artworks, including bronze statues, that were lost while being transported, thus greatly enhancing our knowledge of ancient art.

Amphorae: The Perfect Storage Vessels

Amphorae, simple wheel-thrown ceramic jars with two handles, were the all-purpose storage containers of the Greco-Roman world. Though they were made in many different styles and types of decoration, they typically had a narrow mouth that could be plugged, thick walls, and a tapered foot to make them easy to stack on their sides for space-efficient storage or transport. They were small enough to be carried by one or two people.

Amphorae were used in antiquity to transport a wide range of goods, and analysis of their contents provides abundant and important data about the nature, range, and scale of Roman trade. Residues found inside recovered amphorae indicate that the most important commodities shipped around the Roman world were olive oil, wine, marine products, fish sauce (*garum*—a distinctive Roman seasoning), and preserved fruits. Each commodity was given a distinctive type of amphora so that the vessel's contents could be identified at a glance. Amphorae sometimes were labeled with painted inscriptions to identify the contents. Amphorae might also be stamped with the name of the potter. Study of amphora stamps has helped to establish the origins of a given commodity and its distribution patterns.

The Museum's Wine Amphora

In 1952–53, Captain Cousteau and a French academic colleague, Fernand Benoît, investigated two shipwrecks, one on top of the other, off the southern coast of France, near Marseilles. One ship, dated to about 230 B.C., is probably of Greek origin; the other is Roman and is dated to about 130–80 B.C. The wine cargoes of both ships were carried in amphorae. Greek wine amphorae have an ovoid body and a short neck, while Roman amphorae are taller and thinner; both kinds were found at the site. The Museum's wine amphora is of the Roman type, indicating that it came from the second ship. Between them, the ships could have carried approximately 7,000 amphorae!

Captain Cousteau donated one of the recovered amphorae from this shipwreck to the Museum in 1953. When full, the Museum's Roman amphora would have held about 5.25 gallons of wine.

In this shipwreck, many of the Roman amphorae had seals of *pozzolana* (volcanic mortar) bearing stamps that may refer to famous Campanian wine growers of the period. It is believed that the ship sailed from southern Italy with a cargo of Campanian wine and black-glazed pottery, bound for Gaul, where there was a great demand for Italian wines during the second and first centuries B.C. The ship sank off the coast of Gaul for reasons unknown.

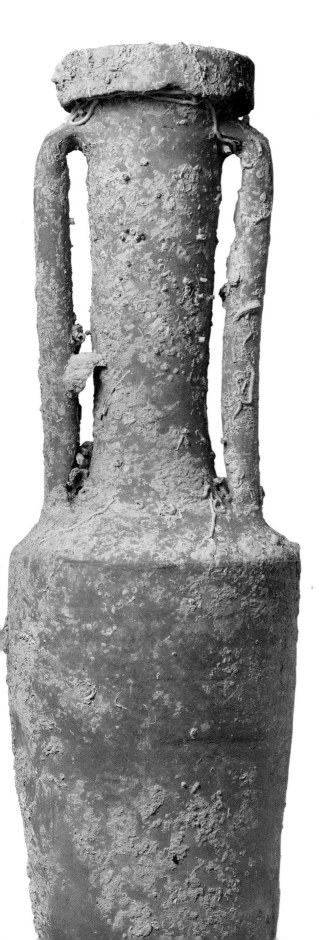

DISCUSSION QUESTIONS

♦ Look at the shape of the Roman amphora. Do you think this would have been an easy vessel to carry? How do you think it was stored? Why do you think it had such a tapered foot?

♦ Why do you think it is important for our knowledge of the ancient world that an everyday object like this amphora is preserved?

♦ Why do you think a plain pottery storage jar is displayed in a museum of art?

♦ The two ships that were found in the expedition by Captain Cousteau contained over 7,000 amphorae between them. What does this tell us about the importance of sea trade in Roman life? What does it tell us about the importance of wine?

♦ Think about the ways in which we transport food today. How are our methods similar to those used by the ancient Romans? How are they different?

♦ This shipment of Roman wine was on its way from one part of the Mediterranean world to the other. Think about the food you eat, the clothes you wear, electronic devices that you use. Are most of these things locally made? Which ones come from far away? Why do you think we get some of these things from far away? What does that tell you about the importance of trade today?

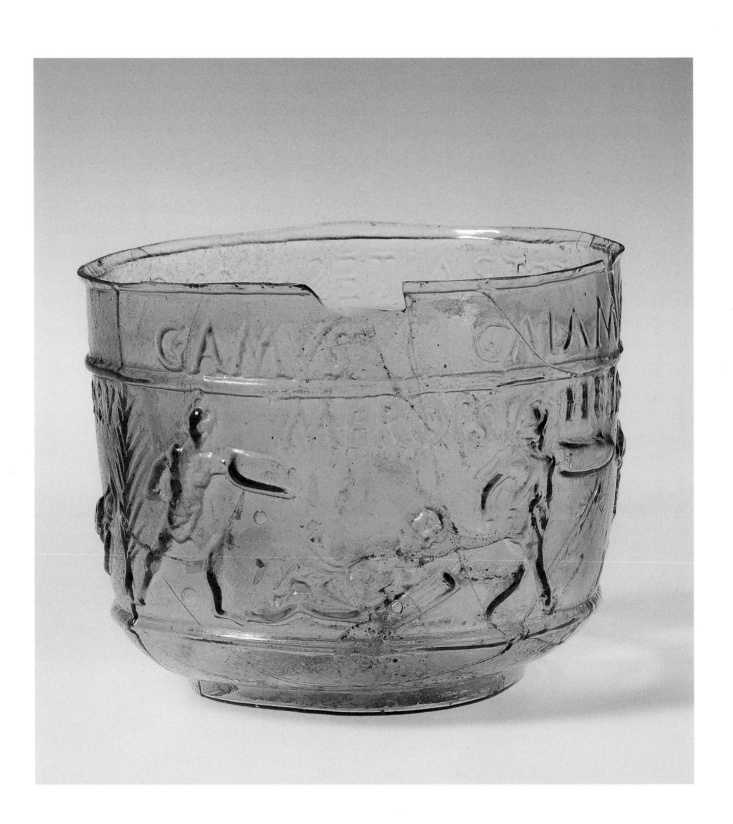

34. *Gladiator cup*
Roman, Early Imperial, ca. A.D. 50–80
Said to have been found at Montagnole
(near Chambray), France, in 1855
Mold-blown glass; H. 2⅞ in. (7.3 cm),
DIAM. 3⅛ in. (7.9 cm)
Gift of Henry G. Marquand, 1881
(81.10.245)

35. *Beaker with chariot race*
Roman, Late Imperial, 4th century A.D.
Free-blown and cut glass; H. 4¼ in.
(10.8 cm)
Fletcher Fund, 1959 (59.11.14)

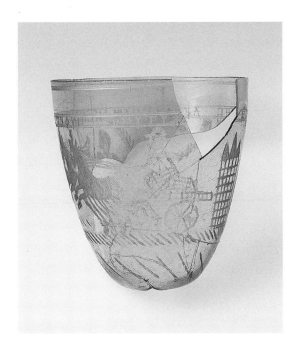

POINTS TO CONSIDER

• The development of the technology of glass-
blowing in the first century B.C. meant that glass
vessels could be mass-produced cheaply. Rome
became a center of the new glass technology and
exported vessels all over the Mediterranean world.

• As Rome expanded its territories during the
Republic and empire, it also exported its cultural
institutions, such as a love of spectacles including
chariot racing and gladiatorial contests.

• Gladiatorial contests developed out of funer-
ary games staged in honor of the dead, but they
eventually lost their religious context and were
staged as popular entertainments for the public.
Gladiators were mostly slaves or prisoners of war.
Yet they could attain celebrity status with the
public and, if they survived enough bouts, could
eventually gain wealth and freedom.

• Just as today one might receive a souvenir hat
or jersey at a sporting event, one could obtain a
souvenir of a Roman athletic competition. Mass-
produced glass cups commemorating specific
chariot races, gladiatorial contests, and individual
athletes have been found in great numbers in the
northern part of the Roman empire.

Spectacles in the Ancient Roman World

The public entertainments enjoyed by ancient Romans were in many ways similar to the kinds of leisure activities that people enjoy today. Spectacles originally were held only in conjunction with religious or funerary events, but rapidly became associated with entertainment. The most popular included chariot racing, gladiatorial contests, and theatrical events. All of these events were free to the public, open to those of all orders and of both sexes. During the empire, they were funded by the state. Of these spectacles, chariot racing was the most popular.

Gladiatorial Contests

The earliest known gladiatorial combats took place at the funerals of Etruscan warriors. These combats were introduced to Roman audiences during the third century B.C. In the later Republic, private promoters staged these costly contests as a way of gaining popularity with the public. In the empire, these spectacles were put on at Rome by the emperor and in the provinces by magistrates, all with the help of a promoter who owned gladiators and hired them out. Often these games were massive; some during the empire featured 5,000 gladiatorial bouts.

Amphitheaters, a Roman architectural innovation and the predecessor of our modern sports stadium, were built all around the empire to accommodate the staging of local games. The Colosseum, dedicated at Rome in A.D. 80, was the largest and most splendid amphitheater in the empire, seating 45,000 spectators.

Most gladiators were slaves, although condemned criminals were also forced to compete. Gladiators were given special training in schools organized by the promoters. They learned how to fight using different kinds of weapons and different techniques of hand-to-hand combat. Successful gladiators could win great fame. In fact, some members of the senatorial and equestrian orders were attracted to gladiatorial careers by the glamour and power of the sport. The emperors Augustus and Tiberius enacted legislation to prevent members of these orders from becoming gladiators, as it remained an infamous profession. Nevertheless, the popularity of gladiatorial combat was so great that even a Roman emperor, Commodus, eventually entered the arena to fight as a gladiator.

Types of Gladiators

There were four principal types of gladiators, each distinguished by different types of armor and weapons. The *retiarius* had little armor, only a shoulder guard and an arm guard. His main weapon was his net, but he also carried a dagger and a trident. The *murmillo* and the Samnite were similarly armed, with an oblong shield, visored helmet, and a short sword of Spanish origin called the *gladius*. The *murmillo*'s helmet was distinguished by a crest. The *thraex* (Thracian) wore a brimmed helmet and high greaves over quilted trousers, as well as an arm guard. He carried a round shield and a curved sword. The different types of gladiators were frequently depicted in art, as well as on their tombstones.

The Museum's Molded Glass Gladiator Cup

The Museum's molded glass cup (image 34) is a souvenir from a gladiatorial contest. Though glass had been produced in the ancient world starting in the second millennium B.C., it was extremely rare until the technology of glassblowing was developed in the early first century B.C. Blowing glass enabled craftsmen to mass-produce glass cheaply, and it revolutionized

production. A huge glass industry developed very rapidly at Rome in the first century A.D., and Roman glassware was widely exported.

Mold-blown glass developed as an offshoot of free-blowing. A craftsman created a reusable two-part mold, usually of baked clay, and carved designs into it; these would appear in relief on the finished product. A gob of glass was then blown into the mold to impress the shape and patterns upon it.

The Museum's cup shows us four pairs of gladiators in combat, each identified by a Latin inscription near his head. The names given are Gamus, Merops, Calamus, Hermes, Tetraites, Prudes, Spiculus, and Columbus. Some names match those of famous gladiators of the Julio-Claudian period. The victors are always on the left, and their names

appear prominently in the band that runs around the top of the cup. The names of their defeated foes are inserted into the scenes themselves. Spiculus stands over a fallen Columbus with his shield outstretched and sword poised, while Gamus stands in a similar pose near Merops, who leans on his left shield arm and raises his sword defensively in his right. Calamus, in the same pose as Spiculus and Gamus, stands facing Hermes, whose sword is outstretched. Tetraites confronts Prudes, who turns away as he attempts to retrieve the shield he has dropped behind him.

Mass-produced cups like these, depicting scenes of chariot races, gladiatorial battles, and athletes, have been found in substantial numbers, but almost entirely in the northwestern provinces of the Roman empire, even though the people and events shown

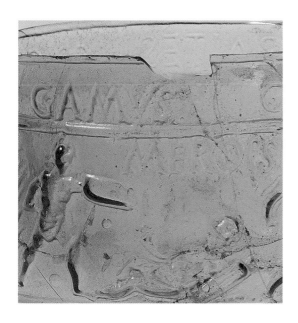

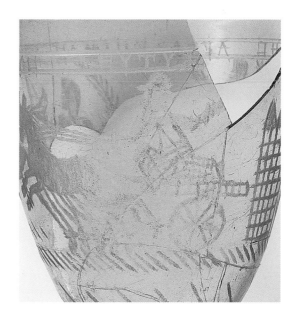

seem to be Italian. The discovery of many cups of this type in the northwestern provinces is testimony to the rapid spread of Roman cultural institutions outside of Italy. The archaeological evidence suggests that these cups were made as souvenirs for only a short time, although the games remained popular into the fourth century A.D.

The Museum also has in its collection a fragmentary beaker painted with gladiators and animals. It is illustrated in *Art of the Classical World*, no. 442, and shows pairs of matched gladiators and wild beasts in combat. Above the gladiators, traces of their names are painted in Greek. For an example of a gladiatorial souvenir for an elite fan, see the gem with an intaglio of a gladiator fighting a lion, illustrated in no. 443.

The Museum's Beaker with Chariot Race

Even as pressure, largely from Christians, grew in the fourth century to ban gladiatorial contests, chariot racing remained popular, and it, too, spawned a souvenir industry.

A free-blown beaker in the Museum's collection (image 35), dated to the fourth century A.D., is hand-engraved with the representation of a charioteer racing his *quadriga*, or four-horse chariot, in front of a small, latticed structure that may represent a *spina*, the barrier that separated the two directions of racing in the hippodrome, or horse-racing arena. An inscription in Greek, which suggests that this beaker was produced in the Eastern Roman Empire, names the charioteer Euthych[ides], who is known from other chariot cups, and his four horses. Only three of their names are legible—Arethousios, named after a famous stream; Neilos, or the River Nile; and Pyripnous, Fire-Breather.

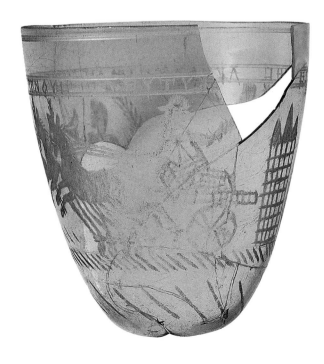

DISCUSSION QUESTIONS

• Why do you think that Roman athletic competitions originally were associated with religious observances or funerals? Do Americans have athletic contests that are associated with holidays? Which ones can you name?

• Look closely at the gladiator cup. Can you identify the different types of gladiators that are represented there? How? How many different types of gladiators do you see? Can you tell who is winning each combat? How? Do you think they are all competing at once, or do you think the contests are being held one at a time?

• Have you ever been to a baseball game or other sporting event where you received a souvenir? Did other people receive the same kind of souvenir?

• Souvenir cups like this have been found all over the Roman empire. Do you think they were individually made or mass-produced?

• Are there ways in which our modern sporting competitions resemble those of the ancient Romans? How are they different?

• Modern American athletes are both famous and highly paid. How is that different from the status of the ancient gladiators?

• Gladiators risked their lives every time they went into the arena, but they were slaves who usually had no choice about competing. Can you think of any modern sports where the athletes risk their lives to compete? Why do you think they would do this since they are not compelled to do so?

• The images of famous athletes of Roman times were put on souvenir cups. Can you think of places in American life where we find the images of athletes reproduced?

ADDITIONAL EXERCISE ON A VISIT TO THE MUSEUM

Compare the mass-produced gladiator cup with the hand-blown and hand-painted beaker with gladiators and animals. How are the scenes similar? How are they different? Which cup is easier to "read"? Which cup do you think would have been more valuable? Why?

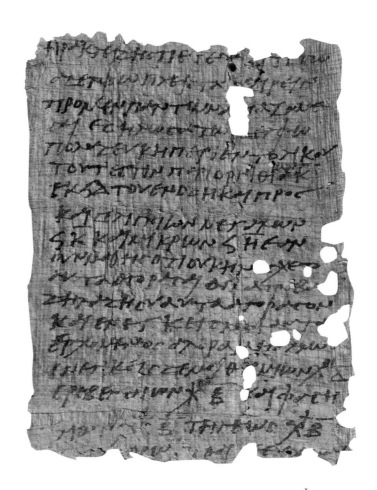

Image 39

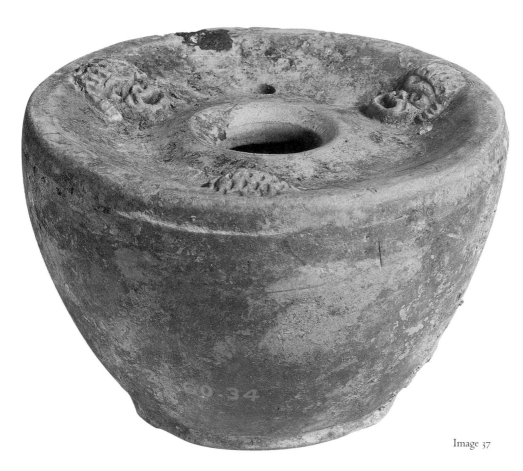

Image 37

36. *Stylus*
Cypriot, Classical or Hellenistic,
4th–1st century B.C.
Bronze; L. 4⅞ in. (12.4 cm)
The Cesnola Collection, purchased by
subscription, 1874–1876 (74.51.5495)

37. *Inkwell*
Roman, Imperial, 1st–2nd century A.D.
Said to be from Rome
Terracotta; H. 2 in. (5.1 cm),
DIAM. 2¹⁵⁄₁₆ in. (7.5 cm)
Stamped on the bottom: CN·HE
Fletcher Fund, 1926 (26.60.34)

38. *Ink pen*
Roman, Imperial, 1st–2nd century A.D.
Said to be from Rome; found together
with the inkwell (image 37)
Bronze; L. 2¹⁵⁄₁₆ in. (7.5 cm)
Fletcher Fund, 1926 (26.60.35)

39. *Papyrus with shopping list in Greek*
Roman, Egypt, early 3rd century A.D.
Papyrus; 4⅛ x 3⅛ in. (10.5 x 8 cm)
Gift of M. Nahman, 1925 (25.8)

POINTS TO CONSIDER

- It is difficult to know how widespread literacy was in the Roman world. Schools were fee-based, and it is not clear how many children (boys had a better chance than girls) were able to complete elementary school.

- Unlike modern society, status in the Roman world was not necessarily equated with literacy. Many of the most educated people at Rome were slaves who taught Greek and Latin to the children of their rich masters.

- Papyrus, produced from an Egyptian water plant, was the most common writing material in the Roman world. Because of its perishability, however, large numbers of papyri survive only from Egypt, whose climate was dry enough to preserve it.

- For school exercises, most students wrote in ink on papyrus or on whitened writing boards, or on waxed wooden leaves that were inscribed with a pointed penlike tool called a stylus. After use, the wax was smoothed out with the blunt end of the stylus so that it could be written on again.

Ancient Roman Education and Literacy

It is difficult to determine how many people in the ancient Roman world could read and write. There was no system of universal education, and all schools were fee-based. Aristocratic families often hired literate, Greek-speaking tutors to train their children, who were expected to be fluent in both Greek and Latin.

However, at least elementary-school education was probably available to all but the poor in most towns of any size. The majority of students were boys, but some girls did attend school.

Typically, there were three levels of instruction available, beginning at about age seven. Children transferred to different teachers at age twelve and again at fifteen, although the vast majority of children probably had only an elementary education. At the elementary level, reading, writing, and basic mathematics were studied. At the middle level, the focus was on language and poetry. At the higher levels, students studied rhetoric and philosophy as preparation for careers in public life.

Literacy must have been relatively widespread, since laws were inscribed in public places, graffiti were ubiquitous, and we have an abundance of papyrus letters and documents preserved from ancient Egypt.

Roman Writing Materials

Roman students needed pen and ink or a stylus (a wood or metal writing tool) as well as waxed or whitened writing tablets for their studies. Most students probably used wooden stylus tablets, whose recessed surface was covered with wax. These were written on with a wood, bronze, iron, or even ivory stylus, which impressed the letters into the surface of the wax with a sharp point. The other end of the stylus was flattened so that it could be used to smooth out the wax, erasing the writing so that the tablet could be reused.

The Museum's stylus (image 36) predates the Roman period but is typical of the form.

Whitened sheets of wood, so thin that they could be folded, were also used for writing. These were written on with reed or metal pins and ink, which was made from a mixture of pine-pitch resin

soot, gum, and water. The ink was stored in stopped inkwells. Inkwells could be made with a variety of materials, from terracotta to precious metals.

The Museum's inkwell (image 37) is decorated on the upper face with a relief of three theatrical masks. Theater was a major entertainment in the ancient world, and since plays were written down the decoration is an appropriate one for a writing aid. Originally the Museum's inkwell had a stopper to keep the ink inside in a liquid form. The letters on the underside of the base are probably a form of potter's mark. The bronze pen (image 38) was found with the inkwell.

Roman Papyrus

Papyrus, fabricated from a plant indigenous to the Nile Delta in Egypt, was the most common writing material used in the Greco-Roman world. Most of the surviving texts written on this "plant paper" also come from Egypt itself, because the dry, sandy soil of Egypt has served to preserve thousands of documentary papyri as well as precious literary texts.

The vast majority of the surviving Egyptian papyri are written in Greek, which was the administrative language of the Eastern Roman Empire except in military matters, for which Latin was used. Most of the surviving Greek papyri are documentary in nature: letters, legal papers, petitions, lists, and receipts. These documents have yielded an immense amount of information about the daily lives of Greco-Roman Egyptians. The sheer number and variety of the documents, which touch on almost every aspect of daily life at all socioeconomic levels of Egyptian society, suggests that levels of literacy in Roman Egypt may have been higher than elsewhere in the Roman empire.

The Museum's papyrus (image 39) represents one such document out of tens of thousands. It is a letter

written by one Heraclides to his brother Petechois instructing him to shop for certain food items, including poultry, bread, lupines, chick peas, kidney beans, and fenugreek, at certain prices. It is likely that this letter was written by the sender, but it is possible that it was dictated to a scribe.

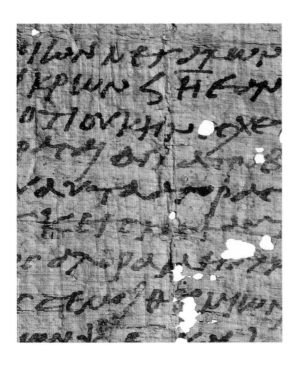

• Look at each of these materials for writing. Are any of them similar to the things you use to write with or on? Which ones? Which ones are different? How?

• Egypt has a very dry climate, and this has helped to preserve many texts on papyrus from Roman times. Do you think that the lack of preserved writings on papyrus from the city of Rome itself implies that the Romans were illiterate? Why or why not?

• The papyrus shopping list/letter is written in Greek, even though it was found in Egypt, which was a province of the Roman empire at this time. What does this suggest to you about the languages used in the ancient world? Do you use a language other than English for reading or writing? Even though the United States is primarily an English-speaking country, do you sometimes see signs in other languages?

• Look at the papyrus letter. Can you identify any letters that are similar to the ones in our alphabet? Which ones? Do any of the words look familiar to you?

Image 38 (left) and image 36 (below), shown actual size

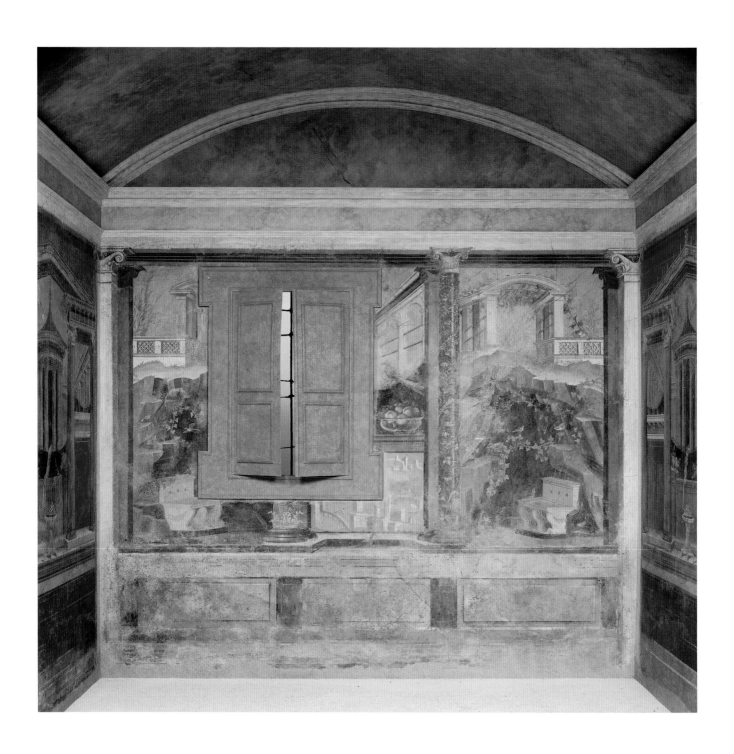

40. *Frescoes from a cubiculum nocturnum (bedroom)*
Roman, Late Republican, ca. 50–40 B.C.
From the Villa of P. Fannius Synistor at Boscoreale (room M)
8 ft. 8½ in. x 10 ft. 11½ in. x 19 ft. 7⅛ in. (265.4 x 334 x 583.9 cm)
Rogers Fund, 1903 (03.14.13a–g)

41. *Fragment of a fresco with garlands and objects related to Dionysiac rites*
Roman, Late Republican, ca. 50–40 B.C.
From the Villa of P. Fannius Synistor at Boscoreale (exedra L)
Overall: 77 x 107 in. (195.6 x 271.8 cm)
Rogers Fund, 1903 (03.14.4)

Pictured in full on page 139

POINTS TO CONSIDER

• The volcanic explosion of Mount Vesuvius in A.D. 79 buried the southern Italian city of Pompeii and its environs in a layer of ash that preserved buildings virtually intact until their rediscovery in the eighteenth century. Since then, archaeological excavation of the cities and their houses has provided historians with vast amounts of information about the lives of their inhabitants in the early empire.

• The preserved houses from Pompeii show us that Italians of the first century B.C. and A.D. painted their walls with frescoes depicting architectural vistas, mythological episodes, scenes of daily life and religious observance, still lifes, and decorative motifs.

• Art historians have identified four chronological styles of Roman wall painting.

• The Museum's collection includes the bedroom walls from a luxury villa from Boscoreale, near Pompeii. These walls were painted in the Second Style, in which the artist creates the illusion of three-dimensional space on the wall through the use of perspective to present architectural vistas.

• An *exedra*, or alcove, of the same house was painted with garlands and objects related to the worship of the god Dionysus. We do not know whether these were meant to be purely decorative or whether they had some religious significance.

• The decoration of the walls was meant to convey the wealth and sophistication of the villa's owner through the elegant details and the costly pigments used.

The Eruption of Mount Vesuvius and Its Consequences

The region around the Bay of Naples (Neapolis) in Campania, south of Rome, became popular late in the Republic as a vacation spot for wealthy Romans. However, in A.D. 79 the area, including the prosperous middle-class towns of Pompeii and Herculaneum, was destroyed by the volcanic eruption of nearby Mount Vesuvius. Most residents escaped, but the eruption buried dwellings and their contents in deep layers of volcanic ash and lava. The eruption was described vividly in a letter written by Pliny the Younger, a nephew of Pliny the Elder, who was the author of a voluminous *Natural History* (in thirty-seven surviving books), which includes chapters on the history of art that are invaluable to modern art historians. As admiral of the Mediterranean fleet at Misenum, the elder Pliny had attempted to witness the disaster first-hand and was killed in the eruption.

Pompeii remained buried until its rediscovery in 1748. Systematic archaeological excavation began in 1861. The excavation of Pompeii, Herculaneum, and the surrounding region has given archaeologists a vivid view of Roman daily life in the early empire.

Roman Wall Painting Decoration

The ancient Romans decorated the interior walls of their houses with paintings executed on wet plaster, a technique known as fresco. Art historians have distinguished four chronological styles of Roman wall painting. Depending on the function of the room, walls might be painted with imaginary architecture, still lifes, mythological scenes, or purely decorative motifs. Many of these motifs were derived from pattern books carried by the artists.

The *Cubiculum* from Boscoreale

The Museum's *cubiculum*, or bedroom, comes from the villa of P. Fannius Synistor, excavated at Boscoreale, a site near Pompeii that was known in the first centuries B.C. and A.D. for its many aristocratic country villas. Built by wealthy Romans as summer retreats, these villas were often luxuriously decorated. In contrast to their public lives at Rome, where senators adopted an austere Republican lifestyle, in their private villas they sought to emulate the luxury of the old Hellenistic royal courts. Thus the gardens of their villas might be decorated with copies of famous classical statues or with statues of Dionysian characters, while the walls of the villas were painted with opulent frescoes.

The walls of the villa of P. Fannius Synistor were painted sometime around 50 B.C. in the so-called Second Style, in which the artist attempted to "open out" the wall into an imaginary architectural vista including landscape elements. The artist painted architectural elements that were meant to look like real three-dimensional objects, and scenes that were meant to create the illusion of spatial vistas beyond the confines of the wall, using perspective recession and painted cast shadows to fool the eye.

The frescoes of the red bedroom (image 40) have been reconstructed in the Museum to give an impression of the original appearance of the room. These frescoes are among the most important to have survived from antiquity, and they are of the highest quality. The extensive use of cinnabar and vermillion, extremely costly pigments, on the walls attests to the affluence of the villa's proprietor. The mosaic floor is modern, but is based on photographs and descriptions made shortly after the discovery of the villa in 1900. The design on the mosaic floor, supplemented by the details of the ceiling and walls, served to set the actual sleeping area in the back of the room apart from the entrance area.

The walls of the *cubiculum* give an unprecedented illusion of spatial depth. There are three main areas: the back wall; the side walls of the bedroom alcove; and the long walls of the front of the room. The two long side walls are mirror compositions of each other. The lower part of each wall is painted as if it were clad with marble revetments. On the painted "projecting" ledge along each wall are painted lifesized red Corinthian columns with gilded capitals and bases and spiraling foliage tendrils. They serve to divide the wall space into vertical sections. Behind these fictive columns, colonnades and buildings with balconies and towers recede into the space, alternating with depictions of shrines, gardens, and statuary. It is as if the wall has been dissolved and the guest in the bedroom is looking through a window at the buildings beyond.

The side walls at the back of the room are delineated on each side by a painted floor-to-ceiling pilaster, decorated with projecting square bosses that cast painted shadows. Beyond these pilasters a cylindrical temple, called a *tholos*, stands in an open-air sanctuary, surrounded by a colonnade with a triangular pediment. In front of the *tholos* is painted an altar with an offering of succulent fruit. Although the *tholos* is one of several religious buildings prominently represented on the walls, these buildings do not seem to have any active religious function but rather are purely decorative.

The rear wall of the *cubiculum* contains the only window in the room, which is original to the villa and preserves its original metal grille. To the right of the window, the artist has painted a small rocky grotto adorned with ivy and graced by a fountain and songbirds. Atop the rocky outcropping, ripe grape clusters dangle from an arched trellis. A painted parapet supports a still life of a glass bowl filled with fruit, above which perches a parrot. The back wall is also decorated with a small yellow monochrome vignette called a "sacral-idyllic" landscape. The artist has painted the scene of a miniature Roman seaside town populated by shadowy fishermen, figures walking over an arched bridge, houses, and temples, all depicted in an impressionistic fashion with quick, sketchy brushstrokes that create the illusion of light and shadow.

Throughout the *cubiculum*, the lighting is consistent. Details are rendered as they would be if lit by the one window in the room, while painted shadows are cast toward the entrance to the room.

The overall effect of the wall paintings is a sumptuous one. The viewer is meant to imagine that a luxurious villa sprawls beyond the walls of the room itself and to be impressed by the wealth and taste of the owner. Successive owners of the villa must have appreciated the quality of these paintings, for they were never painted over in the century that elapsed between their creation and the burying of the villa.

The Museum's Boscoreale Garland Fresco

This panel (image 41) comes from the *exedra*, or alcove, of the same villa. Here, the artist has painted the background as if there were real slabs of scarlet marble revetment with architectural moldings above it, and green slabs above the moldings. Against this background are painted garlands of laurel leaves, pomegranates, sheaves of wheat, and pinecones, supported by bulls' heads that appear to be nailed to the walls. Garlands such as this were often used in real life to decorate altars or funerary monuments, as well as colonnades. (A carved frieze of ox skulls and garlands, for instance, decorates the interior of the altar enclosure of the Ara Pacis, a monumental altar commemorating the Peace of Augustus, in Rome.) Objects relevant to the cult of Dionysus, the god of wine, dangle from the garlands: the mask of a bald, bearded satyr; a cymbal; and a wicker basket (*cista mystica*) with a snake crawling out of it. The fictive cornice is supported by bronze serpents with goat

heads. The fragment comes from a left-hand wall; the painted light source is from the left to give the illusion that the wall and objects received actual daylight from the entrance.

Dionysus was very popular in the Hellenistic period, and the walls and gardens of Roman villas were filled with allusions to him. They may still retain a religious significance in the context of this painting.

For illustrations of other wall paintings from Boscoreale, please refer to *Art of the Classical World*, nos. 376-80.

DISCUSSION QUESTIONS

- Why do you think the Romans decorated the walls of their houses? Why do you think the owner of this villa wanted decorations like this in his/her bedroom?

- Does the artist treat these walls as a flat surface? If not, what techniques or devices are used to open up the wall and create an illusion of three-dimensionality?

- What colors has the artist used? Are they realistic? Do they help to organize the composition in any way?

- Look at one of the long side walls of the *cubiculum*. What architectural elements do you see? Are they arranged in a logical way? Do these look like real buildings? Why or why not?

- Have you seen similar kinds of architectural elements in the Museum? Where?

- Describe the landscape depicted on the back wall of the room. What kinds of natural and man-made elements do you see? How many birds are there?

- Look at the still life of a bowl of fruit. Can you identify any of the kinds of fruit that are in it?

- Take a close look at the yellow painted section on the back wall. Describe what you see. Is the style similar to or different from the other paintings of architecture? Do you see human figures in this yellow landscape? Describe some of their activities.

- Look at the window on the back wall. Do you think the window was added after the wall had been painted? Why or why not?

- Now look at the fresco with garlands (image 41). Can you identify any of the different fruits in the leafy garland swags?

- Describe the layout of the fresco with garlands. How many horizontal sections is this portion of wall divided into? How many vertical sections? How does the artist's use of colors help us to see the different sections?

- Of course, in reality we are looking at a flat painted surface. How has the artist created an illusion of projecting objects?

- What objects are shown dangling from the swags? These objects are related to the cult of the god Dionysus. Why do you think this Roman home-owner wanted to have objects related to the god Dionysus painted on his walls?

- Where is the light coming from in this painting? How can you tell?

- Do you think these images had a religious significance for the Roman home-owner? Why or why not?

- How are the walls of your bedroom at home decorated? What materials have been used?

Image 40, detail

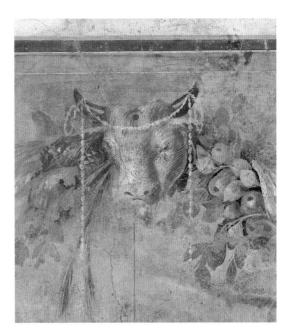

Image 41, detail

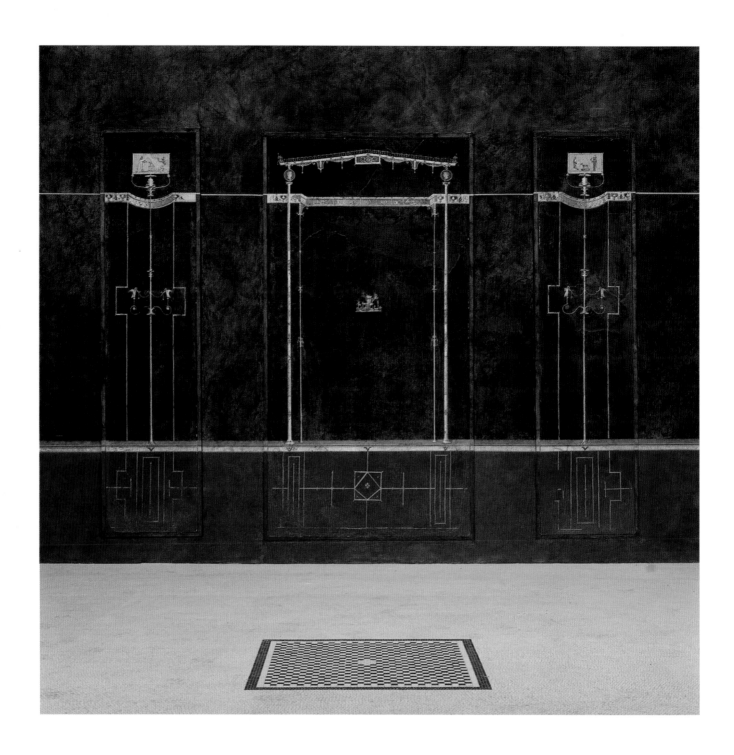

42. *Ten fragments of fresco incorporated in a reconstruction of a* **cubiculum nocturnum** *(bedroom), known as the Black Room*

Roman, Augustan, last decade of 1st century B.C.

From the villa of Agrippa Postumus at Boscotrecase

91¾ x 45 in. (233 x 114.3 cm)

Rogers Fund, 1920 (20.192.1–10)

POINTS TO CONSIDER

- After the emperor Augustus came to power, the illusionistic Second Style of wall painting was succeeded by a fashion in which architectural forms became elongated and delicate rather than simulating real architectural elements. The wall no longer opened out illusionistically into three dimensions; instead, small landscapes and other scenes were placed in the center of a wall whose flatness was emphasized.

- The Museum's panels from the imperial villa at Boscotrecase are painted in the Third Style. Some of the imagery in them relates to the political success of Augustus in conquering Egypt and thereby becoming the sole ruler of the empire. They include scenes with Egyptian gods as well as representations of swans, the sacred birds of Apollo, the god to whom Augustus attributed his victory in Egypt.

Roman Wall Painting and the Third Style

Toward the end of the first century B.C., the Second Style of Roman wall painting was superseded by the so-called Third Style (ca. 20 B.C.–A.D. 20). In the Third Style, artists no longer tried to create the illusion of the wall as a window that opened onto a landscape or cityscape vista with solid-looking buildings and objects. Instead, the wall was usually painted a monochrome background color to emphasize its flat surface, and then decorated with elongated, insubstantial columns and candelabra embellished with delicate plant and animal forms. These columns often framed mythological scenes, landscapes, or figures that seemed to float in the middle of the wall. Some walls have central panels with a large simulated painting. The style is sophisticated and elegant.

Vitruvius, the late-first-century B.C. architect and writer, was appalled by the decorative nature of Third Style painting. In his book *De Architectura*, he wrote: "Imitations based upon reality are now disdained by the improper taste of the present. ... Instead of columns there rise up stalks; instead of gables, striped panels with curled leaves and volutes. ... Slender stalks with heads of men and of animals [are] attached to half the body. Such things neither are, nor can be, nor have been. ... For pictures cannot be approved which do not resemble reality" (7.5.3, 4).

Despite Vitruvius' condemnation, the Third Style proved to be widely popular, particularly among members of the imperial family and their friends.

The Museum's Roman Wall Paintings from Boscotrecase

The Museum possesses seventeen fine Third Style paintings from a villa at Boscotrecase, near Pompeii, which was owned by Agrippa, a close friend and adviser of the emperor Augustus, and later by his widow Julia, the emperor's daughter. (For a discussion of the survival of wall paintings from the Bay of Naples, please see the entry for images 40–41.) Agrippa's son Agrippa Postumus became the owner of the villa in 11 B.C., following his father's death. The frescoes were probably painted during renovations begun at this time. These paintings are very similar to a series of walls found in the Villa Farnesina in Rome, and may well have been executed by artists from Rome.

Some of the paintings from Boscotrecase are large-scale mythological scenes; please refer to *Art of the Classical World*, nos. 402–403. The Black Room, illustrated here, was one of a series of south-facing bedrooms in the villa that looked toward the sea. The fragments of this room's walls in the Museum's collection are decorated with attenuated architectural motifs that frame small floating landscapes. A low red podium is the base for impossibly slender columns that support a pavilion roof and a narrow cornice painted to give the illusion of shallow niches. On the back wall, a small landscape floats inside the columns of the pavilion. The columns are flanked by slender candelabra with leafy projections on which perch swans, the bird of Apollo, patron god of the emperor Augustus. Swans also appear as decorations on public imperial monuments erected at this time, such as the monumental Altar of Peace (Ara Pacis) in Rome.

The candelabra support yellow plaques with Egyptianizing scenes, a reminder of the Roman annexation of Egypt after the death of Queen Cleopatra in 30 B.C. After Egypt became part of the empire, a rage for all things Egyptian exploded at Rome, extending to the decoration of private homes. The delicate designs, obviously not intended to be real architectural elements, reinforce a sense of the wall as being simultaneously flat and of infinite depth.

The villa of Agrippa Postumus at Boscotrecase was a private imperial residence. Nonetheless, the imperial family chose to allude to its military success in these decorations.

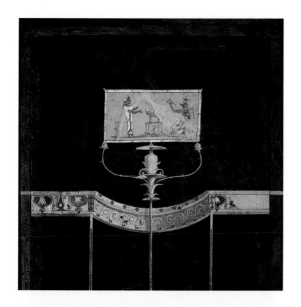

DISCUSSION QUESTIONS

- Describe the layout of this panel. Do you get the sense that these are real architectural elements?

- What birds do you see?

- Can you identify the central vertical object that supports the yellow rectangle?

- Describe the figures in the yellow painted panel. Do their dress and pose look Roman to you?

- Why do you think the walls of the Black Room contain Egyptian motifs? What clues, if any, do these motifs give us about the identity of the villa's owners?

EXERCISE

Compare these wall paintings with the ones from Boscoreale (images 40–41). What similarities do you see between the designs of the two sets of walls? What differences? Which set of walls looks more "real" to you? Why or why not? Which decoration do you prefer? Why?

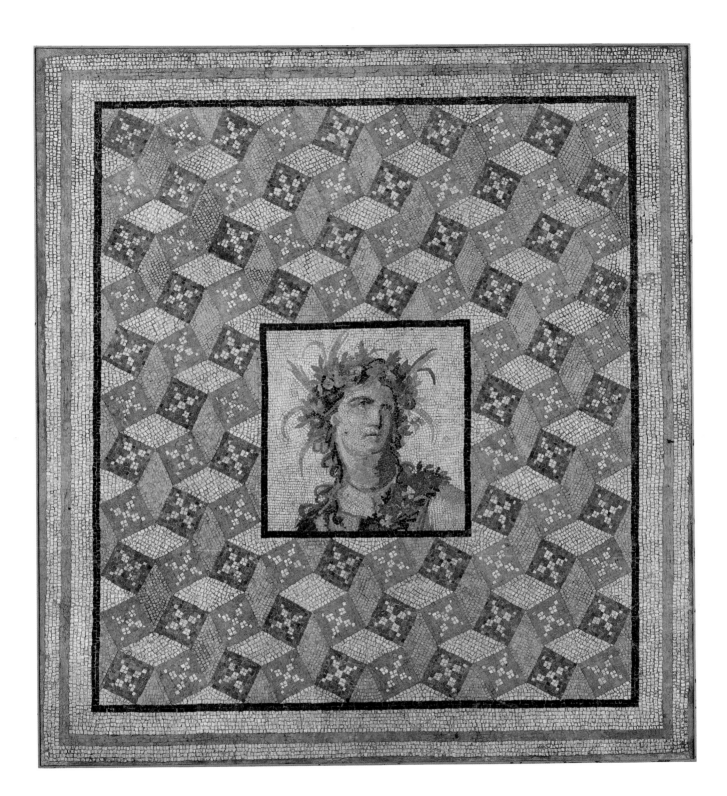

43. *Tesselated floor panel with garlanded woman and geometric pattern*
Roman, Mid-Imperial, 2nd half
of 2nd century A.D.
Mosaic; 89 x 99 in. (226.1 x 251.5 cm)
Purchase, Joseph Pulitzer Bequest, 1938
(38.11.12)

POINTS TO CONSIDER

- Beginning in the early first century B.C., the floors of Greek homes were often covered with multi-colored pebbles arranged in geometric and floral designs, a technique called mosaic.

- By the third century B.C., designs had become more sophisticated. Often a central design, or *emblema*, would be made with small, finely cut stones, or tesserae, and would resemble a painting. It would be placed in the center of a floor mosaic that had larger stones and a simpler design.

- Romans of the late Republic began to use mosaics in their floors. In one famous example found at Pompeii, the so-called Alexander mosaic, a Hellenistic painting was copied for the floor of a villa. Other famous paintings were copied in mosaics.

- During the empire, mosaics were mass-produced, often in black and white designs, for the floors of homes and bath complexes. The Romans also began to use mosaics with glass tesserae for the decoration of walls and ceiling vaults.

- The subject matter of mosaics was often tailored to the use of the room. For example, marine themes were commonly used in the baths.

The Technique of Mosaic

The use of pebbles arranged in simple geometric designs as paving for floors dates back to the eighth century B.C. in the Near East, while the earliest Greek pebble floors with patterns are dated to the fifth century B.C. These early mosaics usually had simple designs, which could be geometric or figural, and used only two shades of pebbles, dark and light. They were primarily used in private homes.

By the end of the fourth century B.C., designs had become more sophisticated, and a wider range of colored pebbles was used. Artists began to use tessellated mosaic (*opus tessellatum*), in which pieces of stone or marble were cut into cubes and fitted together in a bed of mortar. Within a century, artists were cutting pieces of stone of many colors and assorted sizes and arranging them in elaborate compositions with shadings of color that simulated painting (*opus vermiculatum*). Sometimes these pictorial mosaics, called *emblemata*, were set into the middle of a floor and surrounded by a coarser mosaic with a simpler, often geometric, pattern.

Mosaics in the Roman World

Roman mosaics with elaborate central designs began to appear by the later second century B.C. Among famous examples is the so-called Alexander mosaic, a reproduction of a late-fourth-century B.C. painting of Alexander the Great, the Macedonian king, fighting the Persian ruler Darius at the Battle of Issus in 333 B.C. This monumental narrative mosaic was found in a Pompeian private home. A similarly ambitious painting-like mosaic, depicting a Nile River landscape, was found at Praeneste, near Rome, and dates to the late Republic. Simpler floors with bigger stones and only two or three colors were the norm for less affluent homes.

During the empire, mosaics were mass-produced, usually in overall black and white designs and without *emblemata*, for villas, apartments, and bath complexes. Overall geometric or floral designs, or dark figures against a light background, were the most popular motifs. The floors of the vast Roman complexes were often decorated with marine scenes. The Romans also extended the use of mosaic to the decoration of walls and vaults as well as to fountains and outdoor grottoes. Many of these mosaics used tiny glass tesserae and had more in common with wall painting than with floor mosaic in the designs that were created. Baths and tombs were the most common structures to be decorated with wall and vault mosaics. This type of decoration would also prove to be popular on the walls of early Christian churches.

The Museum's Mosaic

In the Roman period, Daphne-Harbiye was a popular resort where wealthy citizens from Antioch (in southeastern Turkey) built their holiday villas, just as rich Romans constructed opulent villas around the Bay of Naples. The Princeton Archaeological Expedition to Antioch and Syria in the late 1930s found the remains of several handsomely decorated houses and villas at Daphne. The Museum's mosaic was found in an olive grove. (A second mosaic, found with it, is now in the Baltimore Museum of Art.)

This rectangular panel represents the entire decorated area of a floor. The central *emblema* (panel) contains the bust of a woman who wears a wreath of flowers around her head and a floral garland over her left shoulder. She looks to her left. She is sometimes identified as Spring, but she may represent a more general concept of worldly abundance and opulence. Such a design would have been appropriate in a house devoted to the "good" life.

The *emblema* is surrounded by a geometric pattern of squares and lozenges that give the illusion of being three-dimensional forms. Both the figure and the border are composed of beige, muted green, and muted red tesserae. The dating of the mosaic is based in part on the fact that it was made using somewhat larger tesserae than those that were preferred during the first half of the second century A.D.

DISCUSSION QUESTIONS

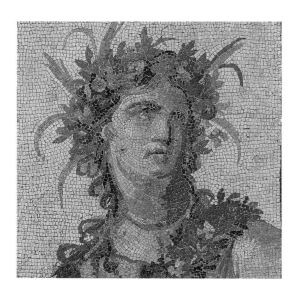

- Why do you think that ancient Greeks and Romans covered their floors with pebbles arranged in designs?

- Describe the different geometric forms in the border of this mosaic. How does the artist make them look three-dimensional? Does this device remind you of a more modern artist with whom you might be familiar (such as Escher)?

- Describe the figure in the central panel. Do the flowers she wears give you a clue to her identity? Who do you think she is?

- Do you think this is a portrait? Why or why not?

- What kinds of floor coverings do we use today? Are any of them similar to mosaics? In what ways?

44. *Fragment of a large platter or tabletop*

Roman, Julio-Claudian, 1st half
of 1st century A.D.
Cast and carved cameo glass;
overall: 9½ x 20¾ in. (24.1 x 52.7 cm)
Gift of Henry G. Marquand, 1881
(81.10.347)

POINTS TO CONSIDER

- The technology for casting or molding glass was developed in the second millennium B.C. by the Egyptians and Mesopotamians, but it was costly and slow, and so glass was used chiefly for small luxury vessels.

- The technology of glassblowing seems to have developed in the first century B.C., and it meant that glass could be mass-produced cheaply and easily in a great variety of sizes and shapes.

- By this time, Rome had become the dominant city in the Mediterranean world and, accordingly, craftsmen flocked there from all over the empire to establish workshops. Rome became an important center for glass production.

- In addition to mass-produced blown glass, Roman craftsmen also produced handmade pieces using complicated techniques. One of these techniques was cameo glass, in which different colors of glass were fused together in layers and then carved, producing a white image against a dark background in imitation of carved stone cameos.

- The cameo fish plate gives the beholder the impression of marine creatures swimming in the dark sea.

The Manufacture of Glass

The technology for making glass first appeared in Egypt and Mesopotamia in the second millennium B.C., and spread to the Italian peninsula in the first millennium. These early glasswares were not blown; rather, they were cast or formed on a core, a much more labor-intensive process. Glass was used in Etruria and Magna Graecia during the Republic, but it only became widespread at Rome in the mid-first century B.C. As Rome became the major city of the Mediterranean in the late Republic, craftsmen of all types flocked there from around the region, and this influx included glassmakers.

At some point, the technology of glassblowing developed, and it made possible the quick and cheap mass production of glass. As a result, glass flooded the Roman world. Glassware was used for tablewares, perfume containers, funerary urns, transport vessels, the **tesserae** for mosaics, and even windowpanes. The popularity of glass was so great for products such as cups and bowls that it replaced the terracotta vessels that had previously been used.

Although blown glass was the most popular and widespread type, Roman glassmakers continued to use more labor-intensive processes, such as casting, for luxury glasswares.

Cameos and Cameo Glass

Carved cameos became fashionable in the courts of the Hellenistic East, and they continued to be popular at the Augustan and Julio-Claudian courts. These were ornaments carved out of sardonyx, a form of quartz that occurs naturally, with layers of white stone alternating with color. By carving back from the surface of the gemstone, the artist could craft a white relief decoration against a darker background (or the reverse, if desired).

Cameo glass was a luxury form of glassware that attempted to duplicate in glass the effect achieved by gemstone cameos. Cameo glass was a Roman innovation. The technique is not completely understood by modern scholars, but it involved the combining of two different colors of glass to form layers, with the light overlay color being cut down so that the dark background color would come through.

The preferred color scheme for cameo glass was an opaque white layer over a dark translucent blue background, although, on rare occasions, multiple layers of glass were applied, resulting in stunning polychromy. Such glass was very difficult to produce and thus very expensive.

The Museum's Cameo-Glass Plate

The Museum's cameo fragment, possibly from a serving platter or tabletop, is notable both for its size and for its marine theme. Originally it must have been about 42 inches in diameter, making it one of the largest examples of ancient cast glass known. The background glass is deep purple, reminiscent of the "wine-dark sea" described by the poet Homer in the *Iliad*. The purple glass has been overlaid with patches of white opaque glass carved into marine animals such as the scallop, crab, squid, and clam that seem to swim on the surface of the piece. To make this object, it is likely that pieces of overlay in the approximate size of each sea creature were heated and fused onto the large piece of background glass, then carved individually.

The Museum's fragment is said to have been found on the island of Capri, where the emperor Tiberius lived in a luxury villa for the last decade of his reign. Certainly the imagery of the piece is appropriate for a seaside villa. And, if the fragment belonged to a serving dish, the swimming sea creatures are a reminder of the edible delicacies it once may have held.

Other examples of Roman luxury glassware, made using varying techniques and dated to approximately the same period as the glass tabletop, are illustrated in *Art of the Classical World*; please refer to the fragment of a bowl with an erotic scene (no. 388), the skyphos (no. 389), the garland bowl (no. 390), and the opaque blue jug (no. 392).

DISCUSSION QUESTIONS

- Describe the decoration of the plate. What kinds of creatures can you identify? Do they come from the earth, the sky, or the sea?

- Why do you think the background of the plate is purple?

- Do you think this plate was used every day? Why or why not?

- What does the decoration of the plate tell us about Roman interest in, and knowledge of, the natural world?

- Why do you think the development of glass-blowing technology was so important in the ancient world?

EXPANDED EXERCISE FOR THE TEACHER

Refer to the other examples of Roman luxury glass listed above. The techniques by which each is made are explained in *Art of the Classical World*. On a visit to the Museum, discuss with the students these different techniques and the effects achieved in the various pieces of glassware.

45. *Pair of skyphi (drinking cups) with relief decoration*

Roman, Augustan, late 1st century B.C.–early 1st century A.D.

Silver; overall: 3¾ x 8⅛ in. (9.5 x 20.6 cm), DIAM. of bowl 5 in. (12.7 cm)

Purchase, Marguerite and Frank A. Cosgrove Jr. Fund and Lila Acheson Wallace Gift, 1994 (1994.43.1, .2)

POINTS TO CONSIDER

- Silver vessels and utensils were owned only by the wealthy, and they were symbols of status, probably displayed more than they were used.

- The Museum possesses a pair of handled silver drinking vessels, once gilded, which are decorated with playful images of childlike *erotes* frolicking and riding a panther, but also holding downturned torches, a motif with sorrowful connotations. This mixture of happy and sad images suggests that the artisan chose these images from a pattern book because they created a pleasing composition.

- The Museum's cups are very similar to a pair found at an imperial villa at Boscoreale, and they may have been produced by one of the leading workshops of silversmiths at Rome.

- For an example of a skyphos in the same shape but made from fused canes of polychrome mosaic glass that include bands of gold leaf between two layers of colorless glass, see *Art of the Classical World*, no. 389.

The Roman Dinner Party, or *Convivium*

Fine drinking vessels would have had a practical use at the typical Roman dinner party, the *convivium*. The *convivium* was modeled on an Etruscan variation of the classical Greek drinking party known as the *symposium*. A *symposium* was an after-dinner drinking event that was restricted to citizen men, who reclined on couches and listened to poetry, played games, and discussed political events.

The Roman *convivium*, in contrast, was open to citizen women as well as men. The emphasis was on eating rather than the later drinking. There also was an element of social hierarchy in the Roman *convivium*, since a patron often hosted the event for his clients, who were of lesser status. The *convivium* took place in the dining room, the **triclinium**, which had reclining couches, each able to hold three participants, arranged around three sides of the room.

Such parties could be extremely lavish if the host wished to flaunt his wealth by serving rare and costly foods on gold and silver platters. Such ostentatious feasts were often mocked by contemporary writers. For example, Petronius, the first-century A.D. author of the *Cena Trimalchionis*, told the story of three characters' attendance at a dinner given by Trimalchio, a rich freedman who put on a vulgar and extravagant meal.

The Museum's Silver Drinking Cups

Possession of silver was a sign of both social status and wealth. These silver drinking cups, of the highest quality of workmanship, are similar in size and decoration except that one has a single handle and the other has two. These sophisticated silver vessels were probably intended for display as much as for actual use.

Still bearing traces of the original gilt, the two cups are decorated in high relief (repoussé) with *erotes* (personifications of the Greek god of desire) frolicking and playing musical instruments. One *eros* rides a rearing panther, associated with the god of wine, Dionysus. Certainly the revelry of the *erotes* would be appropriate for vessels that were probably used in *convivia*. However, other *erotes* on the cup are shown with down-turned torches, a motif that was commonly used in funerary reliefs to symbolize the extinguishing of life. The motif can also be interpreted as signifying the extinguishing of love. Such a combination of joyful and sorrowful images may be an indication that the artist chose these designs, probably from a pattern book, because they were pleasing to the eye rather than for their iconographic implications.

The high quality of craftsmanship seen in these cups suggests that they were produced by a leading Roman workshop, which may also have produced two very similar cups, part of a set of 109 pieces of tableware, found at an imperial villa near Boscoreale.

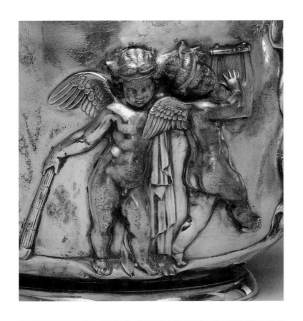

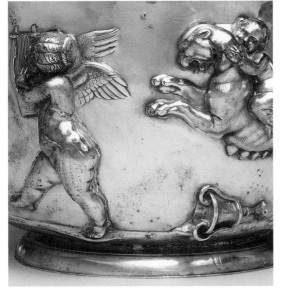

- Look closely at the scenes on the cups. What kinds of figures are represented? What are they doing? What kind of mood do these scenes evoke?

- Do you think the owner of these cups would have used them every day? Why or why not? What kind of occasions do you think they were used for?

- How do you think these cups were made? Do you think they are more valuable than the gladiator cup described elsewhere in this section (image 34)? Why or why not?

LESSON PLANS

LESSON PLAN
THE POWER IN PORTRAITS

Grade level: Upper elementary through high school

Objectives

- Students will look at and discuss Roman art through its portraiture, including how portraiture carried messages of power and authority.
- Students will compare portraiture on Roman imperial coins to the portraits and symbols on the currency of the United States, a country that, in its formative years, identified itself with Rome. They will further explore the legacy of Rome in U. S. architecture.

Images

Image 1	Ring-stone with intaglio bust of Julius Caesar
Image 2	Portrait of a man
Image 3	Colossal portrait of Augustus
Image 4	Cameo portrait of the emperor Augustus
Image 5	Portrait bust of the emperor Gaius, known as Caligula
Image 7	Aurei of the Twelve Caesars
Image 9	Portrait of the co-emperor Lucius Verus
Image 10	Portrait of the emperor Caracalla
Image 11	Portrait of the emperor Caracalla
Image 12	Portrait head of the emperor Constantine I

Materials

Drawing paper
Pencils
Compasses
Crayons or markers

Introduction

Read the Historical Overview and the following excerpted descriptions of images 1–5, 7, and 9–12. (For further information about these images, refer to the section, Power and Authority in Roman Portraiture.)

Image 1: Often in Rome, coin portraits were copied by being carved in relief on gems or sealing ring-stones, such as this one showing **Julius Caesar.** Julius Caesar was the first Roman to issue coins with his portrait.

Image 2: **Republican Romans** wanted portraits that expressed the individual's identity by stressing age and experience in a non-idealized manner. In contrast with the Greek taste in portraiture, in which portrayal of the body was important to the characterization of the person, for the Romans depiction of the facial features was sufficient.

Images 3 and 4: **Augustus,** the first Roman emperor, realized

that his public portrait image could serve as an instrument of propaganda. Prototypical portrait copies were dispersed throughout the Roman world and displayed in public places. Through these statues and busts, as well as through coins with the emperor's image, everyone in the empire was potentially made aware of what the emperor looked like and was reminded of his power and authority.

Stylistically, Augustus followed the Greek example and chose an idealized, classicizing image that, while capturing his individual features, never aged or changed during his fifty years in power.

In the public sphere, Augustus emphasized that he was the first citizen among many equals. He might be represented in any of his roles: in a toga, as a statesman and citizen; wearing armor, as commander of the army; or veiled, as chief priest and responsible overall for maintaining good relations with the gods on Rome's behalf. In the private sphere, it was not uncommon for the emperor to be shown with the attributes of the gods. After his death, Augustus was deified, and public representations of him sometimes showed him with divine characteristics.

Image 5: **Caligula's** portrait type clearly stresses his resemblance to his grandfather Augustus, yet he has characteristics that individualize him as well.

Image 7: Roman imperial coinage, dispersed throughout the empire, bore the image of the emperor and his inscribed name, so his subjects would learn what he looked like. The reverse of imperial coins sent a message from the emperor. It might picture a favored deity, personification, or family member; show an important building that the emperor had erected or commemorate a battle he had won; or advertise imperial virtues. The portrait types on the coins of the **Julio-Claudian emperors** resemble each other in order to emphasize the dynastic ties of the successors to Augustus. Later emperors favored a more realistic type if it suited their propagandistic purposes.

Image 9: Beginning with Hadrian in the early second century A.D., emperors began to wear beards. Hadrian made this choice to show his appreciation of Greek culture, since Greek philosophers, poets, and statesmen wore beards. His successors, such as **Lucius Verus** here, continued the fashion as a way of expressing their dynastic continu-

ity with the past. Also beginning in the second century, sculptors depicted the longer hairstyles by increasing their use of the drill to carve deeply textured locks of hair that created a dramatic contrast with the smoothness of carved flesh. They also began the practice of incising the pupils and irises of their subjects' eyes rather than simply indicating them through paint.

Images 10 and 11: After half a century of bearded emperors who followed the Hellenic model, the emperor **Caracalla** adopted a simple hairstyle. The marble portrait (image 10) shows short-cropped hair and stubbly beard, with head turned dramatically and with furrowed brow. It gives us the impression that this is a man of quick and decisive action.

Image 12: This clean-shaven portrait type shows **Constantine**, the first Roman ruler officially to tolerate Christianity. With bangs brushed over his forehead and an unlined face, the portrait bears a marked resemblance to those of his deified predecessors, reminding viewers of earlier emperors, such as Augustus, and, by association, of their successful reigns. However, the huge, upward-looking eyes and the extreme simplification of the facial planes give the portrait an abstract and detached quality that projects power and belief rather than individuality.

Discussion

Show the students images 1–5, 7, and 9–12 (provided in digital format on the enclosed CD-ROM). Ask them to take two minutes to describe each one in three to four sentences. At least one of the sentences should compare and contrast a portrait to a previous one. After this exercise, show the images again, pausing to discuss each in depth and to draw out information from the students' descriptions. What similarities and differences do they see among the portraits over time? Discuss what these resemblances and changes might signify.

Activities

Have the students imagine that each of them is a Roman emperor or empress. Distribute the drawing supplies and have the student "emperors" design self-portraits by which their fellow students will get to know them, including indications of their status and authority. They should consider the following:

- Is the portrait to be public or private?
- Is it just a head (or bust) or a full-sized statue?
- If it is full-sized, what garments or attributes should be included to show the aspects and responsibilities of being an emperor or empress?
- Will it refer to ancient Greek styles?
- Will it show connections to the portraits being designed by other student "emperors"?

Arrange the portraits in succession around the classroom and have each student write a poem about a classmate's portrait, lauding that particular emperor or empress.

Next, ask each student "emperor" to design both the obverse and reverse of an imperial coin. In preparation for this activity, carefully observe images 1, 4, and especially 7, and read and discuss their accompanying descriptions. You might also look at images of imperial Roman coins online, such as on the Museum's *Timeline of Art History* (www.metmuseum.org/toah). Each student "emperor" should make a list of the features found on the imperial coins, as well as the reasons these features, and should embody these features in his/her own coin design.

Now, have the students make up a list of the features found in United States currency, both coin and paper, and the reasons for these features. They should investigate articles, books, and websites, such as those for the United States Mint (www.usmint.gov/kids/coinNews) and United States Treasury (www.ustreas.gov/education/faq/coins/portraits.shtml).

Compare the two lists and discuss their similarities and differences.

As an extension of this exercise, discuss how "Roman" the United States was at its founding, and how "Roman" it seems today. The section in this resource entitled The Relevance of Rome will provide useful background. Using online resources, books, or field trips, have the students explore the Roman elements (including dependence on ancient Greek culture) of certain local, state, and federal government buildings—whether it occurs in their art and architecture, the governmental concepts the structures embody, or the terminology used to describe them. One possible assignment might be to have each student pick a

state. The students could investigate the government and public buildings of their chosen state's capital to see how "Roman" they seem and report their findings to the class. Which states seem to have the more "Roman" buildings? Can any conclusions about the influence of Rome on the present-day United States be drawn from this data?

Mediations: Discussion for High School Students

Below are two excerpts from the *Meditations* by the Antonine emperor Marcus Aurelius (r. 161–180 A.D.) to be used to stimulate discussion and/or debate in the high school classroom. (These excerpts are available as a pdf on the CD-ROM. Copies may be distributed to the students.)

Marcus Aurelius was educated by many famous teachers, including the orator Fronto. From the age of twelve, he showed an interest in philosophy, and evventually it became a key feature of his life. He was much influenced by a school of philosophy called Stoicism, but his writings draw from Platonism and Epicureanism as well. His philosophical musings on human life and the ways of the gods were recorded in Greek in a personal notebook, and they have come down to us as the *Meditations.* His legacy as a philosopher-ruler survives today.

Some possible questions to consider when discussing these excerpts: What do the quotations indicate about Roman life and culture? What do they say about the importance of history and art? About leadership? Are any of the concepts expressed relevant to your life or the modern world? What qualities does Marcus Aurelius admire in a person in the first quotation? In the second, what does he seem to be saying about the importance of earthly activities?

Book Three, 5

In your actions let there be a willing promptitude, yet a regard for the common interest; due deliberation, yet no irresolution; and in your sentiments no pretentious over-refinement. Avoid talkativeness, avoid officiousness. The god within you should preside over a being who is virile and mature, a statesman, a Roman, and a ruler; one who

has held his ground, like a soldier waiting for the signal to retire from life's battlefield and ready to welcome his relief; a man whose credit need neither be sworn to by himself nor avouched by others. Therein is the secret of cheerfulness, of depending on no help from without and needing to crave from no man the boon of tranquility. We have to stand upright ourselves, not be set up.

Book Four, 33

Expressions that were once current have gone out of use nowadays. Names, too, that were formerly household words are virtually archaisms today; Camillus, Caeso, Volesus, Dentatus; or a little later, Scipio and Cato; Augustus too, and even Hadrian and Antoninus. All things fade into the storied past, and in a little while are shrouded in oblivion. Even to men whose lives were a blaze of glory this comes to pass; as for the rest, the breath is hardly out of them before, in Homer's words, they are "lost to sight alike and hearsay." What, after all, is immortal fame? An empty, hollow thing. To what, then, must we aspire? This, and this alone: the just thought, the unselfish act, the tongue that utters no falsehood, the temper that greets each passing event as something predestined, expected, and emanating from the One source and origin.

Marcus Aurelius Antoninus (121–180 A.D.), *Meditations.* Translated with an introduction by Maxwell Staniforth. (Baltimore, Maryland: Penguin Books, 1969)

LESSON PLAN
ROMAN BELIEFS

Grade level: Middle and high school

Objectives
- Students will discuss the images and symbols the Romans used to depict their gods as well as how they honored them.
- Students will discuss Roman domestic gods.
- Students will discuss the Romans' burial customs.

Materials
> Paper
> Pencils
> Crayons, markers, paints
> Clay

1. Honoring the Gods

Images
> **Image 15** Statuette of Jupiter
> **Image 16** Relief fragment with the head of Mars
> **Image 17** Statue of Venus
> **Image 20** Camillus
> **Image 21** Statuette of Cybele on a cart drawn by lions

Introduction
The Romans believed that each deity had a particular function and areas of influence in the world. Initially, the Roman gods included a mixture of Italic, Etruscan, and Greek deities. As the Romans' territories expanded, they accepted non-Roman gods as well (image 21). It was essential to honor the gods by building temples with altars nearby, where priests and attendants (image 20) made sacrifices. If pleased, the gods would assure victory to Roman armies (image 16), grant the emperor great powers (image 15), and provide agricultural plenty to their people (image 21). For personal devotion and prayers, households might possess statuettes of the Roman gods (image 15).

Discussion
Show the students the images above and after reading the descriptions of these works, lead a discussion about how the Romans viewed their gods. Discuss what features the students think a powerful god of nature would need to protect people from floods, storms, fire, and other disasters. What features would a god of war need to display the powers necessary for success in battle? What about a god who has the power to assure plenty of food? Or provide success in business? Or fame as a singer or artist?

Activities
Ask the students to depict a god of their own choice and creation. They may draw or paint them and should be sure to include symbols or attributes worn or held that convey their power. Alternately, they may write a detailed description of the god. The whole class—or a group of students—might produce a play about these modern gods describing what they do and how they get along.

2. Household Protection

Images
> **Image 18** Statuette of a *lar* (see also one of the posters)

Introduction
Roman families kept paired statuettes of small but powerful deities called *lares* (image 18) in their homes to protect them and their households. *Lares* were guardian spirits that may have represented the ghosts of family ancestors. The family placed statuettes of the *lares* in shrines in the central courtyard of the house. There they could pray to them and make offerings when the family needed help. Often the family worshipped other household gods, such as the *penates*, who guarded the kitchen.

Discussion
Discuss with the students what the *lares* of their homes might look like. What features would show their powers to protect and bring health and happiness? What would a modern household god look like? What abilities would he/she need to guard your kitchen and provide good food?

Activity
When they have discussed and decided on their appearance, ask the students to make a painting or a drawing of their gods and describe the symbols they hold or wear to show their powers. Alternately, they could make three-dimensional forms out of clay.

3. With Your Family Forever: Art for the Tomb

Images

Image 23 Cinerary urn with arms and war trophies
Image 25 Sarcophagus with the Triumph of Dionysus
and the Four Seasons
Image 24 Funerary altar of Cominia Tyche
Image 27 Portrait of a young woman with a gilded wreath
Image 28 Portrait bust of a veiled woman
Image 29 Portrait bust of a woman

Introduction

From the many ancient Roman tombs that archaeologists have uncovered, it seems that some Romans believed that the soul lived on after death. During the Republic and early empire, the Romans frequently cremated the bodies of the deceased, and the ashes were placed in carved urns (image 23). In later times, bodies were placed in sarcophagi (image 25). Often many generations in a family were buried together with portrait busts (images 28, 29), carved altars (image 24), or paintings of family members (image 27). In imperial times, tombs often were above ground and were large enough for living members of the family to gather in order to commemorate their ancestors.

Discussion

Discuss with the students the idea of ancestors and how they might be honored. Perhaps they remember their own ancestors or have heard stories about them. How would they portray their favorite ancestors and/or family members in a painting? What features of these people would they emphasize to show their character? What designs would they place on a funerary urn or sarcophagus to show their ancestors' accomplishments?

Activity

Ask the students to design their own funerary monuments to commemorate an ancestor. Let them choose the kind of monument they would like to make (portrait, ash urn, altar, sarcophagus). After they have completed their drawings, have them discuss why they chose their formats and the particular qualities of the individuals they illustrated.

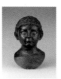

LESSON PLAN
THE ROMAN HOUSEHOLD

Grade level: Middle and high school

Objectives

- Students will identify the members of one hypothetical Roman household.
- Students will explore the relationships within a Roman household.
- Students will research the role of the family and household in Roman society.

Materials

Construction paper
Paper and pencils
Glue sticks

Images

Image 2 Portrait of a man
Image 20 Camillus
Image 23 Cinerary urn with arms and war trophies
Image 25 Sarcophagus with the Triumph of Dionysus and the Four Seasons
Image 28 Portrait bust of a veiled woman
Image 31 Portrait bust of an aristocratic boy
Image 35 Beaker with chariot race
Image 37 Inkwell
Image 38 Ink pen
Image 40 and 41 Frescoes from a villa at Boscoreale

Introduction

In the hierarchical Roman world, the word "status" described the legal and social position of an individual with respect both to that person's household and to the broader civil community of Rome. The individual's place in Roman society was determined by wealth, freedom, and Roman citizenship. The social hierarchy included the senatorial order, the equestrian order, and the rest of the free population. The first two had wealth requirements and were largely hereditary. The senatorial order consisted of wealthy landowners who were expected to devote themselves to unpaid public service. The equestrian order consisted of the officer corps, civil administrators, and businessmen. Below these two ranks was the vast mass of the free urban poor. The status of freedman was given to those who had been released from slavery by their former owners; many of these were economically successful. At

the bottom of the social order were slaves; although they were not free, some slaves rose to great positions of responsibility, managing the master's estates or tutoring his children, for example. Some earned enough money to buy their freedom and to become freedmen/women.

The family (*familia*) was the basic unit of Roman society. The eldest male (*paterfamilias*) was the head of household. He had the authority to control matters of marriage, divorce, property, and economics, and the line of descent passed through him. His wife, children, and other relatives lived with him. Slaves and servants were also part of the household in wealthy families.

The role of a woman in Roman society was to marry, bear children, and run the household. Women did not have the right to vote or own property. They could, however, attend social events or become priestesses; women of the lower orders worked outside the home. There is historical evidence for outstanding and influential women in Roman society.

Roman marriage was monogamous and was usually arranged by the fathers of the couple. Girls were married at around the age of twelve, while boys could be anywhere from a few years to much older. Marriage was undertaken for political or economic reasons rather than for romance; it was intended to produce heirs.

The extent of literacy in the Roman world is difficult to assess; however, it is likely that most children whose families could afford it received at least an elementary education. Higher levels of education were usually available only to boys, many of whom were schooled by private tutors.

Discussion

After reading the descriptions of the images listed above, discuss the works of art using the following questions as a guide:

* What does the image represent?
* Of what material is the object made?
* For what purpose was the object made?
* In the case of the portraits, how have the subjects been represented?
* How would *you* like to be represented?

Activities

Divide the class into groups of six. Have each group form a Roman household complete with name, age, and role of each household member and write a short description of each. For example:

* The *paterfamilias*, a wealthy equestrian who owns and runs a vineyard adjoining his farm-villa at Boscoreale (see images 2, 40, 41)
* His wife, *matrona* of a household with three children (see image 28)
* The older son, an army officer (see image 23)
* The middle son, training to be a priestly attendant (see image 19 and the entry for image 20)
* The youngest son, who is just learning to read (see image 31)
* A slave who tutors the youngest son (see images 37, 38)

* Ask each student to research a certain aspect of Roman daily life that would affect the family members. For example: the house and estate, education, art and music, dress, sports and games, military, and religious practices.

* Create a visual family tree. (Look at images 2, 20, and 28 as examples of individuals who might be included.) Indicate a personal name for each individual. Students might research Roman names in the library or online and use as many first names as they can that are derived from Roman names but that we use today (Julian and Augustus, for example).

* Draw a diagram of the family villa rustica at Boscoreale. Include images 40 and 41 in a written description of the rooms.

* Describe an outing to the chariot races in the Circus Maximus. Include image 35 in the narrative.

* The *paterfamilias* is in ill health. Describe the preparations that are being made for his burial. Include image 25.

WHEN IN ROME: A TREASURE HUNT FOR GRADES 1–4

Instructions for the Teacher

Project images 2, 12, 18, 21, 23, 24, 25, 41, 43, 45 in the classroom (they are available in digital format on the CD-ROM). After you have observed and discussed the images, make copies of the treasure hunt game opposite and distribute them to the students. Ask them to match the picture with the corresponding clue below.

Answer Key

9	My image would be beneath your feet. I wear a wreath of flowers and am surrounded by many cubes of stone in geometric shapes. (image 43)

6	Remember my name and the age at which I died. My curly hair is my best feature. (image 24)

4	Lion power draws my large chariot. I wear a long dress and hold a musical instrument. (image 21)

10	I am a shiny pair for fancy dining! One of my young friends is riding a wild animal. (image 45)

7	Surrounded by my followers and the four seasons, I ride my panther around this large marble container. (image 25)

3	Every home needs a small figure of me. Eat, drink, and dance, and I will protect you. (image 18)

5	This stone box holds my ashes. I want to be remembered for the successes in my life. (image 23)

8	I was once part of a Roman room. My garland is painted rather than real. (image 41)

1	I look rather grumpy and old and am going bald. I am carved of stone. (image 2)

2	I'm larger than life to show my power, although I've lost everything except my head! (image 12)

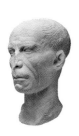
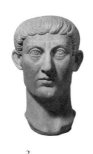

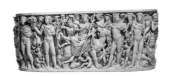

1 2 3 4 5

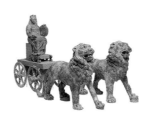

6 7 8 9 10

Look at the pictures above and match their numbers with the clues below

☐ My image would be beneath your feet. I wear a wreath of flowers and am surrounded by many cubes of stone in geometric shapes.

☐ Remember my name and the age at which I died. My curly hair is my best feature.

☐ Lion power draws my large chariot. I wear a long dress and hold a musical instrument.

☐ I am a shiny pair for fancy dining! One of my young friends is riding a wild animal.

☐ Surrounded by my followers and the four seasons, I ride my panther around this large marble container.

☐ Every home needs a small figure of me. Eat, drink, and dance, and I will protect you.

☐ This stone box holds my ashes. I want to be remembered for the successes in my life.

☐ I was once part of a Roman room. My garland is painted rather than real.

☐ I look rather grumpy and old and am going bald. I am carved of stone.

☐ I'm larger than life to show my power, although I've lost everything except my head!

SELECTED RESOURCES

History and General Background

Boatwright, Mary T., Daniel J. Gargola, and Richard J. A. Talbert. *A Brief History of the Romans.* New York: Oxford University Press, 2006.

Many illustrations and maps, as well as a gazetteer, glossary, and timeline, enhance this excellent introduction to the Romans and their history; excerpts from the original writings of a number of well-known Roman writers and politicians augment the narrative. Bibliographic references and an index are included.

Bunson, Matthew. *Encyclopedia of the Roman Empire.* Rev. ed. New York: Facts on File, 2002.

An engaging, A–Z encyclopedia about the Roman empire, from the time of Julius Caesar to the end of the empire in the West, with illustrations, an index, a glossary, and other appendices.

Conti, Flavio. *A Profile of Ancient Rome.* Los Angeles: J. Paul Getty Museum, 2003.

This easy-to-use, well-illustrated overview of all facets of customs and lifestyles in ancient Roman times includes a glossary, index, and timeline.

Cornell, Tim, and John Matthews. *Atlas of the Roman World.* New York: Facts on File, 1982.

This comprehensive, intelligently written overview of the Roman world includes many illustrations, an index, gazetteer, and chronology.

Goodman, Martin. *The Roman World, 44 BC–A.D. 180.* New York: Routledge, 1997.

Martin Goodman provides an extensive and coherent account of Rome in the period from Julius Caesar's death to the reign of Marcus Aurelius. Includes an index, a variety of maps, illustrations, and bibliographic sources.

Heather, Peter. *The Fall of the Roman Empire: A New History of Rome and the Barbarians.* New York: Oxford University Press, 2006.

Professor Heather, an authority on the barbarians, explains the fall of the Roman empire in this fascinating study of its decline. His thesis, that Imperial Rome turned its barbarian neighbors into a hostile and destructive force, is clearly elucidated. Illustrations, a timeline, glossary, and a twenty-page list of "Dramatis Personae" enrich the text.

Kelly, Christopher. *The Roman Empire: A Very Short Introduction.* New York: Oxford University Press, 2006.

This introduction to the Roman empire highlights its steady and unprecedented transformation from city-state to superpower. Though brief, the book includes much of interest about life in the empire, including the demographics that were so important to its survival. A final chapter focuses on the many ways current depictions influence our own conceptions of ancient Rome.

Kleiner, Diana E. E., and Susan B. Matheson, eds. *I Claudia: Women in Ancient Rome.* New Haven: Yale University Art Gallery, 1996.

In this remarkable exhibition catalogue, the authors use art objects to tell the story of women's lives during the Roman empire. Many illustrations, family trees, and bibliographic references enhance the telling.

Mitchell, Stephen. *A History of the Later Roman Empire, A.D. 284–641.* London: Blackwell, 2007.

This historical survey of the later Roman empire covers a period of great upheaval and transformation, from the accession of the emperor Diocletian through the reigns of Constantine and Justinian to the beginnings of medieval Europe and Islamic civilization. Illustrations, maps, timelines, bibliographic references, and an index make this a complete and very useful compendium on the subject.

Stierlin, Henri. *The Roman Empire: From the Etruscans to the Decline of the Roman Empire.* Cologne: Taschen, 2002.

Stierlin uses copious illustrations, plans, and maps to provide an introduction to the architecture of ancient Rome. Aqueducts, amphitheaters, grottoes, arches, homes, and baths are just some of the wonders unveiled for readers. A bibliography, glossary, chronology, and indexes are included.

Welch, Kathryn. *The Romans.* New York: Rizzoli, 1998.

Professor Welch has written a portrait of ancient Rome for the general reader. Filled with glimpses and anecdotes of everyday life, from communal latrines to villas of the wealthy, this book is a vivid account of life in ancient Rome. Many color illustrations, an index, chronology, and bibliography augment the narratives.

Wells, Colin M. *The Roman Empire*. 2d ed. Cambridge, Mass.: Harvard University Press, 1995.

This is a comprehensive and colorful account of the Roman empire written for the general reader. The complex history of the empire as well as the everyday lives of the people, including tales of the lives and loves of the ruling classes, make for compelling reading. Includes a bibliographic essay, index, maps, and illustrations.

Woolf, Greg, ed. *Cambridge Illustrated History of the Roman World*. New York: Cambridge University Press, 2003.

The totality of the Roman world is presented here with vivid illustrations and well-written essays about many facets of Roman life, including technology, medicine, literature, cults, and religion. Many appendices enhance the text.

Daily Life

Adkins, Lesley, and Roy A. Adkins. *Handbook to Life in Ancient Rome*. Updated ed. New York: Facts on File, 2004.

This detailed handbook offers concise entries on all facets of the empire. Includes many maps, illustrations, and an index.

Allan, Tony. *Life, Myth, and Art in Ancient Rome*. Los Angeles: J. Paul Getty Museum, 2005.

The achievements of ancient Rome, long celebrated in art and myth, are well explained in this beautifully illustrated and readable overview. Includes a chronology of the Roman emperors, a list of further readings, and an index.

Casson, Lionel. *Everyday Life in Ancient Rome*. Rev. and exp. ed. Baltimore: Johns Hopkins University Press, 1998.

Casson's fascinating sketches of life in the Roman world tell of wives, lovers, slaves, businessmen, trade, travel, and much more.

Connolly, Peter, and Hazel Dodge. *The Ancient City: Life in Classical Athens & Rome*. New York: Oxford University Press, 1998.

This book explains the development of these two famous cities, their architectural wonders, and every aspect of the lives of their citizens. More than half the book is devoted to Rome, with particular attention to the baths and water supply, one of the significant achievements of the great Roman engineers. Numerous drawings, cross-sections, floor plans, and illustrations complement the text. A glossary and bibliography are included.

Dupont, Florence. *Daily Life in Ancient Rome*. Oxford: Blackwell, 1994.

Professor Dupont truly conveys a "you are there" feeling in this rich account of daily life in ancient Rome. Details on home life, the care of infants, wealth, poverty, slavery, and many other aspects of everyday life are described in this absorbing book. Includes illustrations and an index.

Sebesta, Judith Lynn, and Larissa Bonfante, eds. *The World of Roman Costume*. Madison: University of Wisconsin Press, 1994.

This thorough study of dress during Roman times contains many illustrations, diagrams, and original source materials. One chapter is devoted to the most famous Roman costume of all, the toga; other chapters cover colors, status, religious wear, bridal wear, jewelry, shoes, and more. This book is useful to both lay reader and historian alike.

Time-Life Books. *What Life Was Like When Rome Ruled the World: The Roman Empire, 100 B.C.–A.D. 200*. Alexandria, Va.: Time-Life, 1997.

Court records, letters, inscriptions, and other primary sources are the basis for the information in this readable and well-illustrated guide to life in ancient Rome. Includes a timeline, index, and bibliography.

Toynbee, J. M. C. *Death and Burial in the Roman World*. Ithaca, N.Y.: Cornell University Press, 1971. Reprint ed., Baltimore: Johns Hopkins University Press, 1996.

The afterlife, funerary practices, tombs, funerary rites for the rulers and the ruled are just some of the topics discussed by Professor Toynbee in this absorbing book. Includes many illustrations, bibliographic notes, and an index.

Art and Architecture

Beard, Mary, and John Henderson. *Classical Art from Greece to Rome*. New York: Oxford University Press, 2001.

This provocative book, a history of the relationship between Roman art and its Greek antecedents, both originals and copies, is well worth reading. It is, as well, a meditation on the meanings of this art, when it was made, when it was discovered, and how to think about it now in light of new scholarship and conceptual frameworks. Many illustrations, maps, a timeline, and an index enhance the content.

Dunbabin, Katherine M. D. *Mosaics of the Greek and Roman World*. New York: Cambridge University Press, 1999.

Professor Dunbabin has written a comprehensive account of, and thus a tribute to, this most decorative and durable art. Mosaics, from ancient Greece to Christian times, are discussed in detail. The design of mosaics, their uses, original source materials about them, and a discussion of more recent research, combine to make this a major reference work. Includes many photographs, maps, glossaries, a bibliography, and indexes.

Elsner, Jaś. *Imperial Rome and Christian Triumph*. New York: Oxford University Press, 1998.

Dr. Elsner's interesting study documents the origins of Christian art in Roman art. A detailed timeline provides orientation and context to the thematic chapters. Includes many illustrations and maps, an index, and a bibliographic essay.

Kleiner, Diana E. E. *Roman Sculpture*. New Haven: Yale University Press, 1992.

A well-written, thorough study of ancient Roman sculpture and its importance to the study of Roman history and society. Includes many illustrations, a glossary, index, and a bibliography.

Kleiner, Fred. S. *A History of Roman Art.* Belmont, Calif.: Thomson/Wadsworth, 2007.
> Geographically and chronologically, Professor Kleiner's tour de force captures the art and architecture of the vast Roman empire while seamlessly integrating the religion, writings, people, and overall culture of the far-flung realm. For student and lay reader alike, it includes a glossary, bibliography, and index.

Ling, Roger. *Roman Painting.* New York: Cambridge University Press, 1991.
> This is a thoroughly detailed assessment of wall painting in the Roman empire. Includes many illustrations, a glossary, index, maps, and bibliography.

McCann, Anna Marguerite. *Roman Sarcophagi in the Metropolitan Museum of Art.* New York: MMA, 1978.
> This catalogue is a useful guide to Roman sarcophagi, particularly in the Metropolitan Museum's collection. Includes many fine black-and-white illustrations and informative bibliographic references.

Mazzoleni, Donatella. *Domus: Wall Painting in the Roman House.* Los Angeles: J. Paul Getty Museum, 2004.
> The sumptuous photographs and interesting essays in this engrossing book present twenty-eight famous examples of the finest frescoes in the homes of ancient Rome. Includes bibliographic references and an index.

Ramage, Nancy H., and Andrew Ramage. *Roman Art: Romulus to Constantine.* 4th ed. Upper Saddle River, N.J.: Pearson Prentice Hall, 2005.
> An engrossing introduction to all facets of Roman art, the Professors Ramage have updated previous editions to provide a broad survey from the art of the early Etruscans to that of the time of Emperor Constantine the Great. Many illustrations, diagrams, a glossary, an index, and a bibliography are included.

Sear, Frank. *Roman Architecture.* Ithaca, N.Y.: Cornell University Press, 1983.
> The remarkable architecture of ancient Rome is clearly laid out using diagrams, photographs, drawings, maps, and charts in this comprehensive and readable volume. That many of the aqueducts, roads, arches, and buildings are still standing more than 2,000 years later is testament to the skill of the architects and engineers who designed and built the infrastructure of the empire. A glossary, index, and bibliographic references are included.

Strong, Donald. *Roman Art.* 2d ed. New York: Penguin, 1990.
> This survey of the arts of the Roman empire illustrates the gradual transformation from Etruscan influences and Greek artistic traditions to the distinctly Roman style. Includes a glossary, index, and bibliography.

Walker, Susan. *Greek and Roman Portraits.* London: British Museum Press, 1995.
> A brief, readable introduction to the sculpted portraits of ancient Greece and Rome. Includes illustrations and an index.

Ward-Perkins, John B. *Roman Architecture.* New York: Rizzoli, 1988.
> The extraordinary architectural achievements of ancient Rome are delineated in this well-illustrated volume. Includes a bibliography and index.

Power and Authority

Goldsworthy, Adrian. *The Complete Roman Army.* London: Thames & Hudson, 2003.
> The Roman army, generally considered the most successful fighting force in history until modern times, maintained the vast empire for over 900 years. Examining all aspects of the subject, from soldiers' lives to the battle plans of individual wars, this book provides a thorough grounding in the subject and includes many illustrations, a bibliography, and index.

Matyszak, Philip. *Chronicle of the Roman Republic: The Rulers of Ancient Rome from Romulus to Augustus.* New York: Thames & Hudson, 2003.
> Accounts of the lives of the leaders who created the Roman empire make compelling reading. Many illustrations, plans, timelines, a glossary, bibliography, and index are included.

_____. *The Sons of Caesar: Imperial Rome's First Dynasty.* New York: Thames & Hudson, 2006.
> This history of the Julio-Claudian dynasty is the fascinating tale of one family's legacy. Very readable and well illustrated, this is the saga of Julius Caesar, Augustus, Tiberius, Caligula, Claudius, and Nero, who, in the transition from a republic to an autocracy, devised an imperial system which has had ramifications through the ages. Includes a bibliography, glossary, index, family trees, and maps.

Scarre, Chris. *Chronicle of the Roman Emperors: The Reign-by-Reign Record of the Rulers of Imperial Rome.* London: Thames & Hudson, 1995.
> This history of the Roman emperors brings to life all the famous rulers and some less so. From Augustus to Constantine their reigns and lives are examined. Timelines, illustrations, and contemporary sources add to the fascinating detail. Includes an index and bibliography.

Religion and Mythology

Gardner, Jane F. *Roman Myths. The Legendary Past.* Austin: University of Texas Press, 1993.
> Professor Gardner's interesting and readable overview of the ancient Roman legends examines numerous versions from the ancient authors. Includes many illustrations, an index, and bibliographic references.

Wiseman, T. P. *The Myths of Rome.* Exeter, UK: University of Exeter Press, 2004.
> Professor Wiseman focuses on the Roman myths that are fully entwined with Roman history. The text is strengthened with quotes from original sources in history and poetry, family trees of the ruling elite, and many illustrations. Includes a time chart, bibliography, and index.

Sources

Conte, Gian Biagio. *Latin Literature: A History.*
Baltimore: Johns Hopkins University Press, 1999.
This superb history of Latin literature is
a masterful account of all the major Latin
authors and their works from the third
century B.C. to the eighth century A.D. Very
useful appendices complement the text;
they include comparative chronological
tables of Greek and Roman history and
culture, an alphabetical list of Greek au-
thors and their texts, a glossary of Roman
culture, and a list of rhetorical terms.

Pliny, the Elder. *Natural History.* Translated
by H. Rackham. 10 vols. 2d ed. Cambridge,
Mass.: Harvard University, 1983–95.

Virgil. *The Aeneid.* Translated by Robert Fagles.
New York: Viking, 2006.
Virgil's epic tale of the founding of Rome
is brought to life in Professor Fagles'
remarkable and lucid translation. The
introduction by Bernard Knox and Fagles'
own postscript clarify the text. Includes a
very useful pronounciation glossary as well
as bibliographic references.

Vitruvius. *The Ten Books on Architecture.*
Translated by Morris Hicky Morgan. New
York: Dover, 1960.

Books for Students

Chrisp, Peter. *Ancient Rome Revealed.* New York:
Dorling Kindersley, 2003.
Ancient Rome comes alive with many im-
ages and much information in this unique
book. Transparent pages enable the reader
to reread facts while looking at different
visual interpretations of the same subject.
This is a very good introduction to this
extraordinary civilization done with the
usual Dorling Kindersley thoroughness.

Corbishley, Mike. *Illustrated Encyclopedia of Ancient
Rome.* Los Angeles: J. Paul Getty Museum, 2004.
An interesting encyclopedia for students,
enhanced with illustrations and quotes
from famous Romans as well as a table
of contents that groups the entries into
thematic categories.

Harris, Jacqueline L. *Science in Ancient Rome.*
Danbury, Conn.: Franklin Watts, 1998.
Rather than studying science for its own
sake, the Romans used science from other
cultures to their advantage, developing new
methods in public health and in the art of
building and the use of materials. All this
has been our inheritance, and Jacqueline
Harris presents this information in a
readable, well-illustrated account. Includes
a glossary, bibliography, and index.

James, Simon. *Ancient Rome.* Eyewitness Books.
Rev. ed. New York: Dorling Kindersley, 2004.
Eyewitness Books are an excellent
introduction to any subject and this book
about ancient Rome is no exception, use-
ful for adult and young person alike and
very well illustrated. Includes an index.

Macaulay, David. *City: A Story of Roman Planning
and Construction.* Boston: Houghton Mifflin, 1974.
This is another in David Macaulay's fine
works about architecture. The planning
and construction of an imaginary Roman
city, so carefully drawn and described,
comes vividly to life. Includes a glossary.
For readers of all ages.

Morley, Jacqueline. *A Roman Villa: Inside Story.*
New York: Peter Bedrick Books, 1992.
Diagrams and many drawings reveal what life
was like for those who lived in Roman villas.

Osborne, Mary Pope. *Pompeii: Lost & Found.*
Illustrated by Bonnie Christensen. New York:
Knopf, 2006.
This irresistible book tells the tale of
Pompeii before the eruption of Vesuvius
in A.D. 79 buried the town and many of its
inhabitants. The work of the archaeolo-
gists who have been slowly uncovering the
town over many years is also discussed.
The fresco-like illustrations and palette
enhance the authenticity of the story.

Usher, Kerry. *Heroes, Gods & Emperors from Roman
Mythology.* New York: Schocken Books, 1984.
The legends of ancient Rome reflect how
the Romans saw themselves and their
world. Illustrations, an index, and an ex-
planatory page about some of the symbols
are included.

Watkins, Richard. *Gladiator.* Boston: Houghton
Mifflin, 1997.
The gladiators of ancient Rome are leg-
endary and this book deals with all aspects
of their training and battles, including the
naumachia (sea fights) in manmade lakes
and flooded amphitheaters. Includes an
index, glossary, and bibliography.

Selected Online Resources

Note: Please be aware that the content of
websites may change without notice. It is also
necessary to verify the identity of the supervis-
ing authority of the website; this information
is usually available on the first page. We urge
all teachers to preview Internet sites before
assigning them to students. The sites suggested
below were reviewed in March 2007.

The Metropolitan Museum of Art
www.metmuseum.org

Timeline of Art History
www.metmuseum.org/toah
The Timeline of Art History, part of the
Metropolitan Museum's website, is con-
tinually updated and revised. The section
on Roman art has an excellent overview
of Roman art history with chronologies,
maps, and thematic content.

The British Museum
www.thebritishmuseum.ac.uk/world/rome/
rome.html
This site spotlights works from the Bronze
Age to A.D. 313, from the territory of the
entire Roman empire, with particular at-
tention to Roman Britain. Includes a tour
created for children about the Trojan War.

(www.usmint.gov/kids/coinNews) and United States Treasury (www.ustreas.gov/education/faq/coins/portraits.shtml).

The Field Museum
www.fieldmuseum.org/pompeii/pompeii.asp
A special exhibition, *Pompeii: Stories from an Eruption*, includes information about Herculaneum, Oplontis, Terzigno, volcanism, and images of artifacts from excavations in this region.

The Louvre—Roman Art
www.louvre.fr
This website provides not only an immense database with information about the Louvre's Roman and Etruscan antiquities, but also maps, a timeline, and virtual tours. Be sure to click on the word *English* when first entering the site.

Museum of Fine Arts, Boston
www.mfa.org
"Art of the Ancient World" is the MFA's umbrella phrase for its collection of artifacts from ancient times. Selected highlights from the Etruscan and Roman collections, thematic tours, Etruscan tomb painting, and information about Roman emperors and empresses are available on this website.

Roma 2000
www.roma2000.it/zmunaro.html
This site provides links to monuments and many museums throughout Rome that have important archaeological collections, including the National Museum of Rome (Baths of Diocletian, Octagonal Hall, Palazzo Massimo, and Palazzo Altemps), the Capitoline Museums, and the Villa Giulia National Museum.

The Soprintendenza Archeologica di Pompei
www2.pompeiisites.org
This webpage demonstrates the variety of ongoing work sponsored by the Vesuvian Archaeological Sites' System. Locations include Pompeii, Herculaneum, Boscoreale, Oplontis, and Stabia.

United States Mint
www.usmint.gov/kids/coinNews
United States Treasury
www.ustreas.gov/education/faq/coins/portraits.shtml
Use these websites to find background information on the United States monetary system for the Lesson Plan, The Power in Portraits.

The Vatican Museums
mv.vatican.va/3_EN/pages/MV_Home.html
Offers virtual tours and highlights of the Gregorian Etruscan Collections, featuring fine examples of Etruscan and Roman antiquities.

DVD and Video

We advise all educators to preview these materials before integrating them into lesson plans. Only you can be the judge of what materials are best for your needs. You may elect to show all or parts of a given program.

Ancient Rome: The Story of an Empire that Ruled the World. Vol. 1: *Republic of Rome*; Vol. 2: *Age of Emperors*; Vol. 3: *Building an Empire*; Vol. 4: *The Enduring Legacy* (each vol. 50 min.). New York: The History Channel and A&E Television Network, 1998.
Scholars provide details about Rome's early history, from the Etruscans to the end of the empire.

Ben-Hur. 211 min. New York: MGA/UA Home Video, 1959. Also available on DVD.
During the first century A.D., Judah Ben-Hur, a young Hebrew prince, is thrown into slavery by the Romans after a tragic accident. He eventually wins his way back to his home and family. Judah's love for a slave girl and his triumph over adversity is set against the backdrop of the historic struggle between captives and the mighty empire.

Life, Times and Wonders of Rome & Pompeii. 71 min. Chicago: Distributed by Questar Video, 1994.
The history and culture of Ancient Rome is explored and recreated through computer graphics, film footage, and artworks.

The Roman Empire in the First Century. DVD Arlington, Va.: PBS Home Video, 2001.
The history of the mighty, far-reaching empire in the first century A.D., from the reign of Augustus to the reign of Trajan, from triumph to chaos, is presented through the stories of emperors, poets, plebeians, and slaves.

The Sunken City. 50 min. Series: Ancient Mysteries, New Investigations of the Unsolved. New York: A&E Television Network, 1995.
The port of Ostia was a jewel in the crown of the Roman empire. Once a vital seaport twenty miles from Rome, today it is deserted. When the empire began to fall, Ostia declined with it and, over the centuries, the surrounding waters have risen to engulf the town.

Trajan's Column. 50 min. New York: Trecanni Video Library, 1989.
Relates the history of and describes the famous second-century A.D. marble column erected in Rome by Emperor Trajan.

Who Built the Catacombs? 50 min. Series: Ancient Mysteries. New York: A&E Television Network, 1996.
In this mysterious world, the religious outcasts of the second-century A.D. Roman empire hid and worshipped in secret.

acanthus: a kind of Mediterranean plant with large spreading leaves. It was used as a decorative element on Corinthian capitals and also was a symbol of death.

amphitheater: an elliptical structure with a central arena for the staging of gladiatorial contests and animal combats.

apse: a semicircular space within a Roman building. Typically a basilica would have an apse at one end.

arch: a curved architectural member that spans an opening.

atrium: the central room of a Roman house. It had a hole in the ceiling and a pool in the center of the floor to catch rainwater.

aureus: the most valuable Roman coin, made of gold.

barrel vault: a semicircular ceiling over parallel walls.

basilica: a building type used for law courts and conducting business, which usually stood in the town forum. It consisted of a long rectangular hall with an apse at one end and three aisles separated by columns. The central aisle had a raised ceiling and clerestory windows. Often the exterior of the building was colonnaded.

cameo: a relief carved from a stone that has layers of different colors, such as sardonyx.

capitolium: the main temple for civic worship in Rome and other cities. It was dedicated to the three chief gods, Jupiter, Juno, and Minerva.

cardo: the name of the north-south street in a Roman town laid out on the grid system.

cavea: the rounded space of a theater containing seats for the spectators.

colonnade: a row of columns.

columbarium: a type of communal building to hold ash urns of the cremated. The name comes from the structure's resemblance to a dovecote, since the urns, as well as portrait busts, were placed in niches in the walls similar to the nesting spaces in such a birdhouse.

column: a weight-bearing architectural member that has a base, a cylindrical shaft, and a capital (ornamental top).

concrete: a building material made of small stones or rubble (aggregate), lime mortar, water, and volcanic sand (pozzolana).

consuls: the two chief magistrates of the Roman state, elected annually.

cubiculum: the bedroom of a Roman house.

damnatio memoriae: a decree by the senate that condemned an emperor and ordered that all images of him and references to him be obliterated.

decumanus: the principal east-west street of a Roman town laid out on the grid system.

denarius: the most common Roman silver coin.

domus: a single-family house.

encaustic: a painting technique in which heated wax was mixed with pigment. Used for the painting of mummy portraits in Roman Egypt.

engaged column: a column set into the wall of a building so that only half projects.

fasces: bundles of elm or birch rods bound together with an ax, used as a symbol of the magisterial power to punish.

forum: the center of political and administrative activities in a Roman town. It was a large open space containing government buildings, markets, and temples.

freedman: an emancipated slave with most rights of a citizen. Slaves could sometimes buy their way to the status of freedman, or they might be freed by their owner in his will. Children of freedmen were full citizens.

fresco: a wall-painting technique in which the pigment is applied to newly plastered walls; the paint bonds with the plaster as both dry, creating a very durable surface.

hypocaust system: a device used in Roman baths. The floor of a room to be heated was raised on small brick stilts, and then hot air from a central furnace was pumped under the floors to heat them. The heat would also rise up through the walls to heat the entire room.

iconography: the meaning or symbolism of a work of art.

imperator: general or commander, the root of the word "emperor."

insula: a Roman apartment house, usually with five or six stories. Several apartments on each floor surrounded a central courtyard. Often there were shops on the ground floor. The structures were usually built with brick-faced concrete.

lararium: a shrine to the Roman household gods called *lares*. Every private home had one.

lares: the Roman household gods.

lenos: a sarcophagus shaped like a bathtub, with rounded corners.

mosaic: patterns or pictures made by embedding small pebbles or pieces of stone or glass (tesserae) on floors or walls.

necropolis: a "city of the dead"—a cemetery, always located outside the city walls.

orchestra: the flat space in front of the stage building in a theater where the actors perform.

papyrus: a plant that grows in the Nile River. Its fibers can be processed to make a form of writing paper that was used in Roman Egypt.

paterfamilias: the male head of a Roman family.

patricians: Romans from noble families.

plebeians: the mass of Romans who were not members of noble families

pontifex maximus: the chief priest of Rome. During the empire, the emperor was the pontifex maximus (today it is the term applied to the Catholic pope).

pozzolana: a type of volcanic earth. When mixed with water, it set hard and was not water-soluble. It was mixed with aggregate to make Roman concrete.

princeps: first citizen. A title adopted by the first emperor, Augustus, when he established his sole rule, as a means of suggesting that he was simply the first among equals and ruled in concert with the Senate. In truth, he was the sole ruler.

sarcophagus: a coffin for a dead body, usually made of stone. When inhumation became popular in Rome during the second century A.D., sarcophagus production became a major industry in the Roman world.

Senate: the legislative body of the Roman Republic; it lacked real power in the imperial era.

stadium: a track for chariot racing, elongated with one curved end.

strigil: a curved piece of metal used for scraping the body clean after bathing or exercising.

tessera: one of the cubes of glass or stone that were combined together to make a mosaic.

tetrarchy: a system of rule in the later Roman empire in which four rulers each governed a geographic section of the Roman world.

toga: the principal article of clothing for a Roman male citizen. It was a semicircular piece of cloth that could be put on only with the assistance of attendants.

triclinium: the dining room of a Roman house.

tumulus: a type of round burial mound used by the Etruscans, later adopted on a gigantic scale by the emperors Augustus and Hadrian for their tombs.

vault: a ceiling constructed by using the principle of the arch and extending it.

veristic style: the realistic portrait style of the Republic.

villa: a luxury home outside the city.